Cinematherapy for Lovers

Also by Nancy Peske and Beverly West

Advanced Cinematherapy: The Girl's Guide to Finding Happiness One Movie at a Time

Bibliotherapy: The Girl's Guide to Books for Every Phase of Our Lives

Cinematherapy: The Girl's Guide to Movies for Every Mood

Frankly Scarlett, I *Do* Give a Damn!: Classic Romances Retold

And under the pseudonym Lee Ward Shore

How to Satisfy a Woman Every Time on Five Dollars a Day

Meditations for Men Who Do Next to Nothing (and Would Like to Do Even Less)

Cinematherapy for Lovers

The Girl's Guide to Finding
True Love One Movie at a Time

Nancy Peske and Beverly West

D E L T A T R A D E P A P E R B A C K S

CINEMATHERAPY FOR LOVERS

A Delta Book/January 2003

Published by Bantam Dell
a division of
Random House, Inc. New York, New York

Book design by Virginia Norey

Library of Congress Cataloging-in-Publication Data

Peske, Nancy K., 1962–
 Cinematherapy for lovers : the girl's guide to finding true love one movie at a time /
Nancy Peske and Beverly West.
 p. cm.
 Includes index.
 ISBN 0-440-50927-0
 1. Motion pictures for women—Catalogs. 2. Video recordings—Catalogs.
 3. Love in motion pictures. I. West, Beverly, 1961– II. Title.

PN1995.9.W6 P474 2003
791.43'082—dc21 2002073512

Manufactured in the United States of America
Published simultaneously in Canada

RRH 10 9 8 7 6 5 4 3 2 1

To the storytellers,
who remind us that there's got to be a morning after

Acknowledgments

We would like to thank our editor, Danielle Perez, for her insight and expert stewardship, and a very special thanks to our agent, Neeti Madan, for her unwavering faith, guidance, support, and good humor. We love you, Neeti!

Bev

Thanks to the cherished couch mates in my life, especially Sean McKenna, who always knows the inside scoop, and the gravity-defying Jason Bergund, who has the best toe jump this side of the international dateline, and always helps me glimpse the silver lining. Thanks also to Tommy for being one of the few true originals, to Ellen Rees for her thoughtful guidance and support, and a very special thanks to my partner in crime and creativity, Nancy Peske, my co-author and constant companion on the journey toward happily ever after.

Nancy

Thanks to my friends and family for their love and support. Special thanks to my husband, George, who has rescued me from many a stress fest with takeout, reassurance, and bags of rose petals for my baths, and to Dante, for accepting that just because Mom can veg out in front of movies all day doesn't mean he can watch Shrek six times in a row. Thanks to Betty Baker for helping me find "Pop & Me." And, especially, thanks to my cousin and my cowriter who not only helps me to be a better writer but inspires me to dig deeper and laugh harder, and encourages me to go on mad clothes-shopping sprees after we've downed a bottle of champagne at lunch—Bev, everyone should have a girlfriend like you!

Contents

Introduction

Since movies were invented they have been as much a part of our collective dating and mating game as candy, flowers, Frank Sinatra ballads, and big church weddings. In fact, movies may well be one of the most effective tools for achieving and maintaining romance ever created.

When love is new and we're feeling shy and awkward, movies give us something in common to talk about, and something to think about besides whether or not the ribbed sweater we're wearing makes us look fat.

When we're in the mood to feed the flames, movies help us to ignite or rekindle the sparks of passion. And when we're ready to get serious about someone, movies give us the promise of happily ever after at the end of that long march down the aisle, or warn us about the high cost of letting true love pass us by.

Later on, when we're trying to work through issues together, or rediscover the romance in a long-term relationship, movies put us back in touch with what brought us together in the first place. And when we're going through the stress of planning a wedding or breaking up, or we're in the midst of an emotional winter, far removed from the fires of passion, movies comfort us, letting us know that we're all right on our own, and that love will find us again in the springtime.

So whether you're single and need encouragement to go out there and find your Prince Charming, or dating and wondering whether you've found Mr. Right or just Mr. Right Now, or in a long-term relationship where you both need to talk about your part in a problematic dynamic, this is the book for you. Because when it comes to love troubles, we women know that movies are more than entertainment—they're self-medication that,

when properly administered, can cure anything from the I'll-never-find-a-decent-guy blues to the seven-year itch to whatever-did-we-see-in-each-other amnesia.

As you choose films recommended in **Cinematherapy for Lovers: The Girl's Guide to Finding True Love One Movie at a Time**, you can watch them together with your lover or alone. Some of these films will give you the courage to say and do what's necessary to take control of your love life. Some will help you broach difficult topics with your partner. And others will have you feeling grateful that at least you haven't created the dysfunctional disaster that the lovers on-screen have.

Need a little encouragement to go and meet Prince Charming halfway? Watch *Next Stop Wonderland* and be reassured that despite that seemingly endless stream of frogs you keep meeting, there's a wonderful man just a few lily pads over. Having trouble finding the key to your man's psyche? Watch an Understanding Your Man Movie like *Austin Powers: The Spy Who Shagged Me* and unlock your international man of mystery's secret code. Frustrated by your special someone's inability to make a commitment? Watch a Hook, Line, and Sinker Movie like *Shrek* together and seal the deal.

No matter what your relationship status is, **Cinematherapy for Lovers** will suggest the perfect movie to help you talk about the issues in your relationship, and help you over the hurdles on the road to real life happily ever after. Then again, in our Happily Never After sidebar series, we'll also tell you about movies that may seem to be very romantic, but under the surface have such psychologically dubious messages about relationships that if you take them seriously they'll send you on a detour to the nearest heartbreak hotel. We also include sidebars like Bev's Culinarytherapy, which features appropriate repasts for every romantic occasion; Nancy's Momentous Minutiae, with trivia that under closer inspection tells us a lot about the issue at hand; Hoopskirt Dreams, spotlighting movies that'll inspire you to develop a go-get-'em-gal wardrobe; and much, much more. **Cinematherapy for Lovers** will help you find and maintain a healthy and vital relationship with a couch mate for life, and all by spending a few quality hours of downtime together.

So start the popcorn popping, snuggle up, and solve your every romantic dilemma without ever having to leave your sofa.

Cinematherapy for Lovers

Chapter 1

The New Happily Ever After: Make Your Own Music Movies

If you're feeling like a solo singer in a Captain and Tennille world, and you're beginning to sound a little off-key, retune your instrument with one of these Make Your Own Music Movies, where happily ever after doesn't always involve a march down the aisle into an off-screen married utopia. These movies help us to understand that sometimes a girl's got to do what a girl's got to do in order to reach her own happy ending—which may or may not involve a lace-trimmed white gown, a coterie of gals in blushing and bashful pink, and a guy in a matching cummerbund. And if achieving happiness means leaving your fiancé in the lurch and going off to London, Paris, or Tokyo to discover yourself, or standing your ground solo right here at home, then so be it. These alternative happy endings remind us all that the only lasting happily ever after involves making our own dreams come true, and that the only way to achieve harmony with someone else is to find the melody in our own hearts.

■ *Ghost World* (2001)
Stars: Thora Birch, Steve Buscemi, Scarlett Johansson
Director: Terry Zwigoff
Writers: Daniel Clowes, Terry Zwigoff, based on the comic strip
 Ghost World *by Daniel Clowes*

While riding off into the sunset on a broken-down bus headed for parts unknown with only a hatbox for company may seem like a dubious metaphor for a happy ending, in *Ghost World*, a movie adapted from Daniel Clowes's comic book of the same name, this lonely image is a heartening reminder that if we wait long enough at the bus stop of fate, our destiny will eventually arrive. And while the future is always revealed one local stop at a time, if we maintain our faith in ourselves and our journey, wherever the bus stops we'll always be home.

Enid (Thora Birch) is woefully out of step with the suburban strip mall wasteland that she calls home. She doesn't fit in at high school graduation (in fact, she finds out at gradu- ation that she has to go to summer school in order to get her diploma). She doesn't fit in at the prom, she doesn't fit in hanging out at the local convenience store, she doesn't fit in even in an art class (and she's an artist), and, perhaps hardest of all, she no longer even fits in with the one oasis of companionship she's found in her lonely, teen-angst-ridden desert: her best friend Rebecca (Scarlett Johansson) and their plan to get jobs, find an apartment, and move in together after graduation.

As this first summer of their independence unfolds, everything goes according to plan for Rebecca, who presents a far more socially acceptable picture to the world. Rebecca quickly finds a job in a local coffee bar, a boyfriend, and ultimately, an apartment for her and Enid to move in to. Not so for Enid, whose path turns out to be a long and winding road that does not lead to Rebecca's door, or indeed to anything even remotely resembling normal post-high school teenagedom. Confined to the outskirts of small-town society, Enid experiments with ironical and asymmetrical and sometimes downright startling fash- ion statements, dabbles in random displays of confrontational performance art, and strikes up an intense and insular relationship with some guy named Seymour. Seymour (Steve Buscemi) is a middle-aged fried chicken franchise middle manager, who harbors a passion for collecting vintage records and whose fashion statements are as startling as Enid's only without the sense of irony, and who looks like, well, Steve Buscemi.

As the demand for purpose and direction widens into a deep chasm in Enid's life, her options keep narrowing until she is stuck between a rock and the hard place of her own eccentric worldview. Finally, when all of the obvious choices elude her, Enid at last finds the courage to turn her back on the claustrophobic horizons of small-town normalcy, and board her bus to nowhere and everywhere.

If you're feeling like you've been waiting forever at the bus stop of life for a lift into your future, and you're beginning to wonder if your route has been canceled, watch *Ghost World* and remember that meaning, redemption, and yes, even love will eventually pull up to the curb and open the door for you, so long as you don't lose faith and leave the bus stop before the Greyhound of your destiny arrives.

■ *The French Lieutenant's Woman* (1981)
Stars: Meryl Streep, Jeremy Irons
Director: Karel Reisz
Writer: Harold Pinter, based on the novel by John Fowles

Okay, so she's the scarlet woman of Lyme, whom the townsfolk in their kinder moments refer to as "poor Tragedy," and she's forced to sell herself into indentured servitude to the most sour-faced matron ever to haunt the drawing room of a nineteenth-century British film adaptation (and that's saying a lot). But does that mean that a girl can't rise to the occasion and become a self-actualized heroine for the new millennium and discover her artistic center? Not in this big-budget period piece starring Meryl Streep as Sarah Woodruff, a caped, hooded, and distinctly gothic metaphor for abandonment issues and the Victorian victimization of women. And yes, she has a very convincing English accent.

Sarah stalks the ramparts on the wrong side of town, waiting for a ship that will never come in, and reminding us all that while sticks and stones may not break our bones, invitations to the hotel rooms of wounded but still randy—not to mention married— French officers can definitely hurt us, no matter how handsome they look in their epaulets. Rather than remain a victim of the small town's enactment of their collective psychosexual dysfunction, however, Sarah enlists the support of a handsome, albeit somewhat bookish, aristocrat, Charles (Jeremy Irons), and finds her way to freedom from the needs, desires, and prejudices of men and relationships.

This is a great movie to watch when you're feeling abandoned on the jetty of your own unrealized expectations of love, and there are no white sails on the horizon. *The French Lieutenant's Woman* will encourage you to believe that there is a happily ever after waiting for you, as soon as you find the strength to row your own boat to shore.

Meryl's Morsels

I was just going to have some iced tea and split the atom.

★ Meryl Streep as Francesca Johnson in
The Bridges of Madison County

I am so glad that I got sober now so I can be hyperconscious for this series of humiliations.

★ Meryl Streep as Suzanne Vale in *Postcards from the Edge*

And in that moment, everything I knew to be true about myself up until then was gone. I was acting like another woman, yet I was more myself than ever before.

★ Meryl Streep as Francesca Johnson in *The Bridges of Madison County*

▪ *Legally Blonde* (2001)
 Stars: *Reese Witherspoon, Luke Wilson, Selma Blair, Matthew Davis*
 Director: *Robert Luketic*
 Writers: *Karen McCullah Lutz, Kirsten Smith, based on the novel by Amanda Brown*

In this *Clueless-meets-The-Paper-Chase* flick, a not-so-dumb blonde comes of age, discovers her inner passion, and develops the courage to follow it . . . and then events conspire to bring her everything she deserves.

To her total shock, Elle Wood (Reese Witherspoon), a California University fashion major/sorority president/Alpha Barbie, gets dumped by her old-money, East Coaster boyfriend Warner Huntington III (Matthew Davis) because, as he puts it, she's a Marilyn and he needs a Jackie. Elle immediately begins working her way through boxes of bonbons while watching weepy love stories. But after one wretched week of despair, during which she not only doesn't deep condition her hair but actually lets her cuticles go, Elle picks herself up and formulates a plan to get him back. Yes, she'll ace her LSAT, get admitted to Harvard Law School (where Warner is headed), move to Cambridge, and win that man back.

Elle is thrilled to find that things work out even better than planned, and she eventually ends up with new friends, a much better lover than Warner could ever hope to be, a prime position in a Boston firm, and an array of Prada pumps.

So if you're feeling aimless and insignificant, and utterly hopeless about life and love, pop in *Legally Blonde*, break out the bonbons, attend to those cuticles, and get ready for a major pep talk.

Reese's Pieces

And last week I saw Cameron Diaz at Fred Segal, and I talked her out of buying this truly heinous angora sweater. Whoever said orange was the new pink was seriously disturbed.

★ Reese Witherspoon as Elle Woods in *Legally Blonde*

The rules of hair care are simple and finite.

★ Reese Witherspoon as Elle Woods in *Legally Blonde*

Reel to Real

Reese Witherspoon has been a Girl Scout, cheerleader, and debutante. When her date stood her up for her high school prom, she went anyway—with her father. And she is the descendant of one of the signers of the Declaration of Independence.

■ *My Brilliant Career* (1979)
Stars: Judy Davis, Sam Neill, Wendy Hughes, Robert Grubb, Aileen Britton
Director: Gillian Armstrong
Writer: Eleanor Whitcombe, based on the novel by Miles Franklin

Sybylla Melvyn (Judy Davis) is fond of playing spirited piano pieces, walking fully dressed through the pouring rain, climbing trees, and gaily singing pub songs, which is all behavior that, in turn-of-the-century Possum Gully, Australia, mark her as a very bad girl in need of being shipped off to the relatives for correction. In the hopes that a Jenny Jones makeover will result in her getting hitched to some unsuspecting local man, Sybylla's Aunt Helen (Wendy Hughes) and grandmother (Aileen Britton) do the day-spa thing, soaking Sybylla in lemon water and brushing her unruly red hair a hundred strokes each night.

This plan sort of works: the freshly scrubbed Sybylla does attract two potential suitors, Frank (Robert Grubb) and Harry (Sam Neill). But under the surface she is still the same incorrigible youth, unwilling to give up her dreams of a brilliant career that makes the most of her musical and literary gifts. Harry, the wealthier of the two suitors, holds out for a change of heart and dearly wishes he could fulfill Sybylla's needs. Sybylla does love him, but the social mores of the time and place force her to make a hard choice between career and marriage, and she's too strong a spirit to put her own needs behind those of anyone else.

Watch this movie when you're going through an I-hate-being-single patch and remind yourself that being unencumbered allows us to turn our attention toward fulfilling our own promise. And at least these days, marriage doesn't mean having to kill all hope of a brilliant career.

You Go, Girlfriend

Why does it always have to come down to
marriage? I don't want to be "part" of anyone.
★ Judy Davis as Sybylla Melvyn in *My Brilliant Career*

Maybe I'm ambitious, selfish . . . but I can't lose myself in
somebody else's life when I haven't lived my own yet.
★ Judy Davis as Sybylla Melvyn in *My Brilliant Career*

■ *I'm the One That I Want* (2000)
Stars: *Margaret Cho*
Director: *Lionel Coleman*
Writer: *Margaret Cho*

In this filmed version of comedienne Margaret Cho's live performance at the Warfield Theater in San Francisco, we get an up-close-and-personal view of Margaret's journey toward self-love, which begins, like many such journeys, with self-loathing.

When Margaret gets her first big break with a TV sitcom based on her life, the network immediately sets about molding Margaret into a television version of herself, the end result of which bears no resemblance whatsoever to the original. After initial screenings, network execs demand that Margaret lose thirty pounds in two weeks because "her face is too big," they rewrite the story of her life, and even hire an Asian consultant to teach this Asian American how to be Asian American. Then, in a final ironic twist, they cancel the show and replace Margaret with Drew Carey, who is definitely not a size eight. Margaret descends into a haze of disappointment, self-contempt, and vodka, but then rises from the ashes, reclaiming her original voice, her original sense of humor, and her original shape.

Margaret Cho's unflinching, hilarious, and sometimes raunchy brand of confessional stand-up reminds us all that the most important element in any happily ever after is to learn how to speak with our own voice, inhabit our own body regardless of its dimensions,

and become the one that we want by loving ourselves for who we truly are without the need for outside consultants.

Mae's Marshmallows

When I'm good, I'm very good. But when I'm bad, I'm better.

★ Mae West as Tira in *I'm No Angel*

When a girl goes bad, men go right after her.

★ Mae West as Flower Belle Lee in *My Little Chickadee*

Any time you got nothin' to do and lots of time to do it, come up and see me.

★ Mae West as Flower Belle Lee in *My Little Chickadee*

▪ *Living Out Loud* (1998)
Stars: Holly Hunter, Danny DeVito, Queen Latifah
Director and Writer: Richard LaGravenese

Judith Nelson (Holly Hunter) is angry, sexually frustrated, manic, compassionate, smart, single, and trying to sort it all out. When the movie opens, Judith has just come to realize that her husband of sixteen years is a lying, cheating dog, and worse, she's kind of known it all along, which means she's just wasted a decade and a half being dishonest with herself, all for naught. This uncomfortable revelation leads her to spend several nights soaking up martinis and torch songs in a nightclub called Jaspers. Her lips loosened by going several drinks over her limit, she heckles an amateur singer who delusionally believes she's singing in tune. Judith's brutal honesty charms the club's regular singer, Liz Bailey (Queen Latifah), who is in need of more honesty in her life too.

Over the course of several months, Judith also befriends Pat (Danny DeVito), a lonely and sad elevator operator in the midst of a midlife crisis, and finds the courage and grace (well, except for that awful night when she's just in too much pain to be polite) to nicely but firmly rebuff his efforts to start up a romance she's not ready for. Judith, you see, is sort of on hiatus from men. She wants to rediscover who she is and what she wants to do with her life, her career, and her sexuality. Yeah, sure, the dimpled and buffed masseur/gigolo she hires helps a bit, but it's that erotic Britney-esque dance in an after-hours club, followed by the fantasy of a slow dance with her tattooed, teenage self, that fully reawakens her and starts her on the road toward healing.

We wish our own journeys to selfhood were always so well costumed, scripted, and scored. Pop this one in when you need reassurance that when you get really, really honest with yourself, your lonely winter will end. We think it'll help you to emerge from the underworld of silent self-deception and go forth into the soft evening breezes of summer, feeling ripe with possibility, refreshed, and ready to live your life out loud.

Bette Bites

*Fanny Skeffington (Bette Davis): Do I know your
 father?*
*Johnny Mitchell (Johnny Mitchell): Oh, you must.
 He said he almost committed suicide over you.*
Fanny Skeffington: Well, I'll have to check my records.
> ★ from *Mr. Skeffington*

Moderation is a vastly overrated virtue.
> ★ Bette Davis as Miss Lilly Moffat in *The Corn Is Green*

I'd really like to kiss ya but I just washed my hair.
> ★ Bette Davis as Madge in *Cabin in the Cotton*

Burning Questions to Contemplate

I have rid England of her enemies. What do I do now?

★ Cate Blanchett as Queen Elizabeth I in *Elizabeth*

Has the fact that you're completely psycho managed to escape your attention?

★ Larisa Oleynik as Bianca Stratford in *10 Things I Hate About You*

Why do you wear the same clothes all the time? Why won't you give me your phone number? Are you married? Are you homeless? Are you a drummer?

★ Meg Ryan as Maggie Rice in *City of Angels*

I know you can be underwhelmed, and you can be overwhelmed, but can you ever just be, like, whelmed?

★ Gabrielle Union as Chastity in *10 Things I Hate About You*

Why must I be surrounded by frickin' idiots?

★ Mike Myers as Dr. Evil in *Austin Powers: International Man of Mystery*

Okay, maybe I overanalyze things. You know why I do that?

★ Alan Alda as Jack Burroughs in *The Four Seasons*

Do you prefer "fashion victim" or "ensembly challenged"?

★ Alicia Silverstone as Cher Horowitz in *Clueless*

When you decided to leave at six o'clock, did you know it came so early in the morning? ★ Lucille Ball as Susan Vega in *Forever, Darling*

If a man washes a dish and no one sees it, did it happen?

★ Breckin Meyer as Charlie McKay in *Kate & Leopold*

▪ *The Contender* (2000)
Stars: *Joan Allen, Jeff Bridges, Gary Oldman, Christian Slater, Sam Elliott*
Director and Writer: *Rod Lurie*

This political thriller puts a woman in the White House and gives us all an unflinching look at how good old-fashioned American politics, and good old-fashioned American sexism, can jeopardize any happy ending unless you persevere in a cause that you know is just, and maintain your integrity, no matter what the men in the room think about it.

When Sen. Laine Hanson (Joan Allen) is tapped to replace a Democratic vice president who has died in office, the Republicans unleash a no-holds-barred investigation into her sexual past and come up with some very embarrassing photographs, which they wave like a pair of panties before Congress and the American public. Like many scarlet women before her, however, Laine wears her scandal with dignity in the service of the greater good, and shows the world what little girls are really made of.

Are you engaged in a struggle to advance your version of truth, justice, and the American way, facing detractors who are lining up and blocking the gates to the promised land? Let *The Contender* remind you that the only power lies in staying true to your principles, that any happy ending involves achieving your goals with your "honor" intact, and that if you have political aspirations of any kind, you really ought to consider steering clear of toga parties.

▪ *Night Nurse* (1931)
Stars: *Barbara Stanwyck, Joan Blondell, Clark Gable, Ben Lyon, Ralf Harolde*
Director: *William A. Wellman*
Writers: *Oliver H. P. Garrett, with extra dialogue by Charles Kenyon,*
 based on the novel by Dora Macy

Despite her lack of education and credentials, Lora Hart (Barbara Stanwyck) snags a job as a night nurse by using the system and manipulating a sexist administrator into hiring her for her good looks. Now, in real life, we wouldn't want a gal who thinks her blood type is "4H" administering care to us when we're semiconscious, no matter how great her gams or her gumption. But in this movie we can't help rooting for Lora, who is drawn to

the medical profession for all the right reasons. She has no interest in marrying a doctor or getting horizontal with the fresh-mouthed interns; no, Lora is all heart, and really cares about her patients. What's more, she's a good egg who sticks up for her friend (Joan Blondell) when the prison matriarch—uh, head nurse—is ready to expel her. Best of all, Lora is willing to follow her instincts, risk being blackballed, and blow the whistle on a bigwig doc (Ralf Harolde) and a menacing chauffeur (Clark Gable) who she believes are plotting to starve two rich kids to death to get their hands on the children's money. Somehow we just know Lora's going to be rewarded for her bravery and integrity, and wind up with a career she loves and a guy who is worthy of her.

It's true that there are some dated plot elements here that bothered us, like Lora's too-quick decision to help out a bootlegger at the risk of her job, and the tidy ending doesn't seem in sync with her independent streak. But if you've been spending too much time lately playing Florence Nightingale and getting stuck with the night shift, watch this movie and remember that the world has a way of rewarding those who have the courage to follow their dreams.

■ *Songcatcher* (1999)
Stars: Janet McTeer, Aidan Quinn, Jane Adams
Director and Writer: Maggie Greenwald

This story of a turn-of-the-century "spinster" who discovers exquisite music that has gone virtually unheard will make you realize that energy spent nurturing a discordant relationship might be much better used toward achieving your own dreams. And, if you march to your own drummer, don't be surprised if a nice guy falls into step alongside you.

When her colleague and secret beau refuses to back her for a promotion, musicologist and professor Dr. Lily Penleric (Janet McTeer) realizes her relationship has hit a sour note. Furious, she immediately sets out for a much-needed vacation to retune and create some inner harmony. Despite inferior modes of transportation and far too many layers of restrictive clothing (how *did* women survive corsets and floor-length dresses in the summertime?), Lily makes her way to her sister Elna's (Jane Adams) schoolhouse and home in the backwoods of Appalachia. Here, barefoot children with plaintive, clear voices that come

straight from the heart sing long-forgotten songs of pure beauty. Lily is enchanted by her magical discovery and quickly begins hauling her primitive recording equipment up and down mountains to shack after shack so that she can capture the folk songs of the people, despite the disdain of Tom Bledsoe (Aidan Quinn), a cynical local who recognizes capitalist exploitation when he sees it. But as the summer progresses, Lily begins to shed her rigid Victorian attitudes about love, work, ownership, and melodic structure, along with a few muslin and cotton layers. Tom's political objections to her begin to evaporate along with Lily's Victorian preconceptions, and soon Lily learns that love comes to those with the courage to rewrite their own personal melody.

Bev's Culinarytherapy: The O Solo Mio Supper

Cooking a good meal for the people we care about is a labor of love. But even the most inspired chefs among us usually settle for Cheerios and milk when it comes to cooking for ourselves, because we just don't want to go to the trouble. Quit treating yourself like chopped liver and put a few lovin' spoonfuls in your own emotional soup bowl for a change with this O Solo Mio supper, guaranteed to feed the void without giving you dishpan hands.

The O Solo Mio Supper

Pay a visit to your local specialty food store and buy a large variety of really exotic, hopefully imported, and definitely fattening delicacies. Some of these items might include a couple of triple-cream cheeses, truffle mousse pâté, some rare and unrecognizable fruit that was grown in the shade of some mystical oasis on the other side of the international dateline, and, of course, designer ice cream. Then tastefully arrange your treats on a favorite platter, pull on some fuzzy slippers, pour yourself something with bubbles, pop in a Make Your Own Music Movie, and celebrate your solitude.

Period Pearls

I live among people the world tells me are kind, pious, Christian people. And they seem to me crueler than the cruelest heathens do, stupider than the stupidest animals. I cannot believe that the truth is so. That life is without understanding or compassion.

★ Meryl Streep as Sarah Woodruff in
The French Lieutenant's Woman

One does not like to generalize about so many people all at once, Mr. Knightley, but you may be sure that men know nothing about their hearts, whether they be six-and-twenty, or six-and-eighty.

★ Gwyneth Paltrow as Emma Woodhouse in *Emma*

Selfishness must always be forgiven, you know, because there is no hope for a cure. ★ Embeth Davidtz as Mary Crawford in *Mansfield Park*

■ *Hedwig and the Angry Inch* (2001)
 Stars: John Cameron Mitchell, Michael Pitt, Miriam Shor,
 Stephen Trask, Maurice Dean Wint
 Director: John Cameron Mitchell
 Writer: John Cameron Mitchell, based on the play by
 Stephen Trask and John Cameron Mitchell

Okay, we know. An East German drag queen who trades his manhood for freedom, only to discover that he was his own jailer all along, seems like an odd metaphor for find-

ing your inner voice and creating your own happily ever after. But *Hedwig and the Angry Inch* ultimately illustrates for us all that even if we subject ourselves to scalpels, plagiarizing pop stars, and really bad wigs, our true selves will ultimately shine through even the thickest pancake foundation—that is, if we find the courage to stand on our own two feet, accept ourselves as we are, and claim our talent.

Hansel (John Cameron Mitchell), a young boy growing up in East Berlin before the wall came tumbling down, makes a devil's bargain with Luther (Maurice Dean Wint), an American GI who promises marriage and a ticket out of totalitarianism . . . on one condition. Hansel has to undergo a sex-change operation. Unfortunately, sex-change surgeons in East Berlin are not up to snuff, and neither is Luther. And so Hansel—now Hedwig— winds up alone in a tawdry double-wide in a middle-American wasteland, without a friend or a gender, earning her keep as a baby-sitter for the child of another military candy man who doesn't measure up.

And, of course, as is usually the case, living alone in a tawdry double-wide in a middle-American wasteland with only a wig for company adds up to only one thing: rock and roll. So Hedwig begins to sing angry but compelling ballads about her own inner angst, and puts them, much like a wig, on the head of an innocuous son of the wasteland because she believes she's in love. Unfortunately, Tommy Gnosis (Michael Pitt) doesn't have half of Hedwig's talent or rock-and-roll rage. And, as is usually the case when we invest others with the best parts of ourselves because we're too afraid of the solitude of self-sufficiency, Hedwig's other half takes the good stuff and runs.

Hedwig then embarks on an odyssey in search of the half of herself that she has given away. Ultimately, however, Hedwig finds her holy grail inside herself, and we realize that Tommy Gnosis is not a lover preassigned by destiny but a metaphor for Hedwig's neglected inner child.

Watch this movie when you're feeling like you've been sliced and diced by life, and are longing to reconnect with your missing pieces. Hedwig reminds us all that we are complete in and of ourselves, and that the next time we go looking for our other half, we need look no farther than our own backyard. Because if it isn't there, we never lost it in the first place.

Nancy's Momentous Minutiae: Shake a Tail Feather

Disgusted by the quality of the fake feathers on a hat she was supposed to wear in a film, Marlene Dietrich ripped the entire thing to shreds, forcing the costume department to make a better one.

Once, Marlene Dietrich was set to wear a swan gown to a costume party and was horrified to discover that the swan had blue eyes when her own were green. She ordered the embroidered eyes to be ripped out and resewn and then, five hours later, she arrived fashionably late at the party.

Greta Garbo used to enjoy swimming around in a friend's pool, naked except for a big floppy hat.

You Go, Girlfriend

If I see a door comin' my way, I'm knockin' it down. And if I can't knock down the door, I'm sliding through the window.

★ Rosie Perez

No one can be exactly like me. Even I have trouble doing it.

★ Tallulah Bankhead

It might sound selfish, but all I want for the time being is what I'm finding inside me.

★ Julie Walters as Susan "Rita" White in *Educating Rita*

▪ *Educating Rita* (1983)
Stars: Michael Caine, Julie Walters
Director: Lewis Gilbert
Writer: Willy Russell, based on his play

Having become thoroughly bored with endlessly dyeing, teasing, and spraying the hair of her working-class neighbors who think that a half hour in a beauty parlor can transform them into Princess Diana, hairdresser Rita White (Julie Walters) marches into the hallowed halls of academia and signs up for a first-class education. Her "veddy" British tutor, Frank (Michael Caine), is in awe of Rita's refreshing honesty, integrity, and thirst for knowledge, and finds her enthusiasm as bracing as a belt from that bottle of Black and White that he hides behind a copy of *The Lost Weekend* on his bookshelf. However, as is the case with so many men that women like Rita meet on the road of their own personal growth, Frank is deeply uncomfortable when she starts to leave him in the dust. He gets downright snotty with her, not to mention jealous, possessive, and catty about her taste in poetry.

Yes, Rita takes a few bad detours—for a while, she becomes a little too pretentious about her knowledge of William Blake, starts caring far too much about classical allusion in contemporary literature, and confuses good taste in home furnishings and fabrics with creative intellectual thought. Eventually, however, she integrates the old self with the new and recognizes that at least now if she reads Somerset Maugham instead of Harold Robbins, it's because she chooses to, not because she is trying to be something she's not. And if she disappoints her paternalistic, alcoholic, cynical mentor, well, maybe he ought to spend less time playing Pygmalion and more time refashioning his own life.

Watch this one when you're feeling fettered by those who are supposed to be the wind beneath your wings. We think it'll give you the courage to fly solo, and stop worrying about what everyone back on the ground thinks.

■ *Nurse Betty* (2000)
 Stars: *Renée Zellweger, Morgan Freeman,*
 Chris Rock, Aaron Eckhart, Crispin Glover
 Director: *Neil LaBute*
 Writers: *John C. Richards, James Flamberg*

Even post-traumatic stress disorder has an upside in this movie about a Kansas City waitress/put-upon wife who transforms herself into a soap star and jet-setter through the power of delusional thinking.

Betty Sizemore (Renée Zellweger) is a meek but lovable ditz, who seems content to put up with just about anything in her real life, including an unfaithful husband who sells used cars, so long as she can be carried away every day into her soap opera hospital world, where doctors are heroes, nurses are saints, and married used-car salesmen at least have the good grace to keep it in their pants.

When Betty's no-account husband, Del (Aaron Eckhart), is scalped and murdered by a pair of philosophical and Homeric-influenced hit men (Morgan Freeman and Chris Rock), Betty's powers of denial are finally stretched beyond the breaking point. She finally busts through years of denial, unleashing a new and improved self-image built entirely upon the faith that she discovers in herself.

 Stupid Guy Quotes

New York's ruined her—she has a mind of her own.
 ★ Robert Montgomery as Steve in *Strangers May Kiss*

She doesn't want to make up her own mind—no
girl does. She wants you to make it up for her.
 ★ Charles Drake as Mick Anderson in *All That Heaven Allows*

If you're ready to hang up your apron, suspend your disbelief, and script a whole new happy ending for the story of your life, discover along with Nurse Betty that the first step toward happily ever after is to believe in ourselves. The second step is a solo spree through the cafes of Rome.

Happily Never After

It Should Happen to You (1954)
Stars: Judy Holliday, Michael O'Shea
Director: George Cukor
Writer: Garson Kanin

You've gotta love a gal who, after being fired from her modeling job, decides the best way to boost her career is to plaster her name on a billboard on a busy corner in New York City, then deftly negotiates her way into multiple signage that has everyone in the Big Apple talking about who this Gladys Glover (Judy Holliday) could be. Gladys shrugs off the criticism from a potential boyfriend, Pete (Michael O'Shea), then keeps her options open by dating more than one man, all the while breezily handling her new career as the model all-American girl. "I can't seem to get you down to earth," whines Pete, to which she can only reply, "What's so wonderful about earth?"

But then Gladys has to go and get engaged to her least loyal supporter, all in the name of a happy ending. As for this last-minute settling for the nearest man available and the abandoning of dreams, we can only say: it shouldn't happen to her—or anyone.

▪ *Ruby in Paradise* (1993)
 Stars: Ashley Judd, Todd Field, Bentley Mitchum,
 Allison Dean, Dorothy Lyman
 Director and Writer: Victor Nunez

Teenager Ruby Lee Gissing (Ashley Judd) jumps into her car and gets the hell out of Manning, Tennessee, and away from her controlling boyfriend and an oppressive upbringing, but where to go from there? She had a nice time once at a resort in the Florida panhandle, so Ruby heads thataway and talks her way into a job as a clerk in a gift shop despite the formidable barrier of it being off-season, when demand for neon-colored T-shirts and kitschy Lucite trays is at an all-time low.

Still, the shop's owner, Mildred Chambers (Dorothy Lyman), is impressed by Ruby's hunger for a new life and curious to see what this young woman will make of herself. So Ruby quickly finds herself mastering the art of facing shelves, stocking endcaps, scanning UPC bars—and dealing with complex relationships with two different young men (Todd Field and Bentley Mitchum).

With no role models as guides, Ruby flounders at trying to figure out what's right and wrong for her. She spends lots of time writing introspectively in a notebook, bonding with college student Rochelle (Allison Dean)—who encourages her to think about higher education—and surveying the world around her for clues about how to construct a life built on herself instead of around the nearest guy who's willing to put his arms around her and call her his girlfriend. Is it any surprise that once the tourists come flocking to the beach again Ruby has found her center?

Watch this movie when you don't know what your next move is and remind yourself that if you want to go forward you've got to start by knowing which way you're facing.

Manly, Yes, but Ladies Like It Too: The Jack Factor

What is it about the character of the lone wolf who shuns commitment, preferring instead to travel his own stark inner landscape unencumbered by love, family, companionship, or even reliable plumbing, that makes the hearts of men and women go pitter-pat? And when it's Jack Nicholson behind the banana bars of a Harley, a guy who bathes only intermittently and hangs out in truck stops flirting with individuals of questionable character, men want to be like him, and women, well . . . we just want to love and nurture him. But maybe women could learn to identify with the leader of the pack inside of all of us a little too. So if you're feeling hemmed in by the status quo of your daily life, watch one of these Jack Factor movies, and hit the open road Nicholson style. Because after all, what's good for the gander is good for the goose.

Five Easy Pieces (1970)
Stars: Jack Nicholson, Karen Black
Director: Bob Rafelson
Writers: Adrien Joyce aka Carole Eastman, Bob Rafelson

Jack plays Robert Dupea, a pianist of considerable promise who trades a career tickling the ivories for a job pumping gas because he's a metaphor for the rejection of leisure-class values. Bobby is called home to make peace with his disapproving father who suffered a stroke and is now a vegetable—which makes reconciliation a little difficult, and leads us to the inevitable conclusion with the classic Nicholson antihero heading off into the sunset, alone, morally ambiguous, more than a little directionless, but nonetheless his own man.

continued . . .

Easy Rider (1969)
Stars: Dennis Hopper, Peter Fonda,
 Jack Nicholson
Director: Dennis Hopper
Writers: Peter Fonda, Dennis Hopper,
 Terry Southern

Easy Rider is a seminal on-the-road film about two freewheeling, pot-smoking longhairs (Dennis Hopper and Peter Fonda) who set out on motorcycles across the Southwest in search of the flame of freedom long since extinguished by the conformity and corruption of contemporary society. Not surprisingly, the alternative Holy Grail that they discover is the boozy and rebellious scion of a wealthy southern family, George Hanson (Jack Nicholson, of course), who teaches them that freedom means never apologizing for being your own person and consuming a lot of bourbon.

One Flew Over the Cuckoo's Nest (1975)
Stars: Jack Nicholson, Louise Fletcher
Director: Miloš Forman
Writers: Bo Goldman, Laurence Hauben,
 Ken Kesey, based on the novel by Ken Kesey

One Flew Over the Cuckoo's Nest is one of those "life as a lunatic asylum" movies that introduces us to a world where only the crazy are sane. Nicholson's McMurphy is the reigning king on this island of misfit toys, and he's a charming, mischievous metaphor for the irrepressible male joie de vivre that is never completely extinguished by the evil Nurse Ratched, psychotropic drugs, electroshock therapy, or even being deprived of hot dogs and the World Series. Which just goes to show you, you can lead a man to a lobotomy, but you can't make him think.

■ *Tokyo Pop* (1988)
 Stars: Carrie Hamilton, Yutaka Tadokoro
 Director: Fran Rubel Kuzui
 Writers: Fran Rubel Kuzui, Lynn Grossman

One of the most exhilarating things about being barely out of one's teens is the sheer force of one's adventurousness. If it's been a long time since you did something completely crazy on a whim, this movie will get you back in touch with that daring inner twenty-somethinger who is willing to mix motorcycle jackets with pillbox hats and a postpunk aesthetic with good old American pop.

Singer Wendy Reed (Carrie Hamilton) is rapidly wearing out her stiletto boot leather in search of a rock-and-roll band worthy of her talents. Unfortunately, no one seems to appreciate spunky Jersey girls who want an audience that numbers at least in the double digits. And so, inspired by a postcard of Mount Fuji, Wendy heads off to Japan, though she has almost no money, no grasp of the language or culture, and no address for the only person she knows on the entire island. Even so, she manages in short order to find a place to stay, a job, a boyfriend (Yutaka Tadokoro), and a band that lets her sing lead, and in one of those twists of fate that can only happen in Japanese junk culture (portrayed here in all its color, vibrancy, and downright weirdness), she becomes a "rock" star overnight.

But as Wendy soon discovers, being true to the song in one's heart is always more important than rock-and-roll superstardom, and once again she finds the courage to do a 180. Finally, she has gained the wisdom and maturity to be able to belt out a self-penned auto-biographical rock/pop anthem perfectly suited for a bittersweet but ultimately uplifting montage about making hard choices. Wendy, girl, you rock.

We recommend this movie for when you're buried in self-doubt and excuses and thinking that if you could just find a boyfriend everything would be all right. We bet it will help you stay true to your priorities and sing your own song loud and strong.

Chapter 2

Rapunzel, Rapunzel, Let Down Your Hair: Finding Your Prince Movies

Let's face it, there just aren't that many guys around willing to scale a hundred-foot tower in a suit of armor to ask a princess out on a date with destiny. These days a girl actually has to stage her own liberation. The upside is that we don't have to be damsels in distress anymore, which means we don't have to ride off into the sunset with the first guy who shows up with a pair of crampons and a reliable rope, either. But climbing down out of our towers can make a lot of us modern-day Rapunzels just a little nervous. If your emotional tower is getting a little claustrophobic, but you're afraid of heights, watch one of these Finding Your Prince Movies about women who have taken the plunge. They'll give you some tips about how to land on your feet and give you the confidence to go and meet your Prince Charming halfway.

■ *Bridget Jones's Diary* (2001)
 Stars: Renée Zellweger, Colin Firth,
 Hugh Grant
 Director: Sharon Maguire
 Writer: Helen Fielding, based on her novel

This movie addresses many of the fundamental conflicts of the female experience, like inner thigh panic, being loveless around the holidays, and the fear of what can happen when you have to speak in public after one too many glasses of cheap Chardonnay when all you've had for dinner is bar snacks.

Bridget Jones (Renée Zellweger) embodies the smart woman who makes foolish choices in all of us. She goes looking for love in all the wrong places, most notably in the bottom of aforementioned glasses full of cheap Chardonnay, in the pages of countless self-improvement books, and oh yes, in the trousers of her emotionally un-available—but nevertheless devastatingly handsome—hound of a boss, Daniel Cleaver (Hugh Grant).

But Bridget perseveres because she has made a New Year's resolution to improve her-self, and part of that to-do list is falling in love, dammit, and that's what she intends to do. She even tries to cook at her own dinner party. But like the rest of her spiritual makeover regimen, it too turns out to be inedible and nutritionless until Bridget realizes that what she really needs is to gain enough confidence to take the plunge professionally and emotionally, and start following her own instincts instead of worrying about what her mother is thinking. As soon as Bridget can see the beauty in herself, she not only snags a better job, but is able to see the beauty in others (particularly the good man inside that appalling reindeer sweater) and recognize the Mr. Right that has been right under Rudolph's nose all along.

This is a great movie to watch when you've just about given up on being the perfect modern woman and snagging yourself the perfect man. Let Bridget remind you that there is no such thing as a perfect woman, or a perfect man, and that when we start from where we're at right now, and make the tough choices on our own behalf, love will always follow.

Famous Last Words

*She is tolerable, I suppose, but not handsome
enough to tempt me.*
★ Colin Firth as Mr. Darcy in *Pride and Prejudice*

*Mother, I do not need a blind date. Not with a verbally
incontinent spinster who drinks like a fish, smokes like a
chimney, and dresses like her mother.*
★ Colin Firth as Mark Darcy in *Bridget Jones's Diary*

■ *Rear Window* (1954)
Stars: James Stewart, Grace Kelly, Thelma Ritter, Raymond Burr
Director: Alfred Hitchcock
Writer: John Michael Hayes, based on the book by Cornell Woolrich

New York society princess/fashion model Lisa Fremont (Grace Kelly) turns the tables in this Hitchcock classic and literally scales the wall of a Greenwich Village tower in order to rescue her stranded prince from the prison of his own voyeuristic inclinations.

News photographer L. B. Jeffries (James Stewart) has broken his leg and is confined to a wheelchair in his Greenwich Village loft. Unable to work, and crawling the walls, he indulges his inner Peeping Tom, scrutinizing the comings and goings of his eclectic big-city neighbors, including a sun-worshipping sculptress, a lonely heart who sets a place nightly for her fantasy lover, and an extremely limber dancer whom he calls Miss Torso. One night, while peeking through the peephole of life, Jeff becomes convinced that he has witnessed a murder. It is then up to his girlfriend, Lisa, who parades in and out of the apartment sporting the most extravagant collection of Edith Head-ian chiffon and crinoline ever assembled in one walk-up, to do her designer best to get Jeffries to pay attention to his own life instead of everybody else's. In the end, Lisa wins her prince, but not with her designer

gowns or her Aristotelian geometric cheekbones. Rather, it is Lisa's willingness to participate in his inner life that wins Prince Jeff over in the end.

If you're all dressed up with no place to go, watch *Rear Window* and remember that when you see a guy who catches your eye, don't be afraid to go after him, because he may not be able to go after you. Moreover, the quickest way to a man's heart is not through crinoline and lace, but through an active interest in his private world. Watch this one on a date with your distracted dreamer, and make sure you draw the drapes!

Women We Wish We Could Go for a Beer With

Joan Cusack—Because no matter how bad the evening goes, you always get the idea that Joan has seen worse and come out of it in one piece. That can be a comfort when it's dollar-shot night at the Electric Bull out on that dark patch on Route 5, and the lights go out. And it's always nice to have somebody around who isn't afraid of cowboys, pastels, or Barbra Streisand.

Sally Field—Because we really, really like her.

Reese Witherspoon—Because, just in case we run into trouble with the fashion police, it's nice to have somebody who understands that orange is not the new pink, and can prove it in court.

Illeana Douglas—Because she fits any occasion and it's nice, just in case we come across any unexpected glacial expanses, to have someone who can figure-skate to the next gas station.

Eileen Brennan—Just in case somebody gets out of line, it's good to have a drill sergeant around who can make them drop and give her twenty.

Dolly Parton—Because somebody who knows how to hog-tie the boss can be useful.

Frances McDormand—Because it's nice to have somebody around who obeys all the traffic laws and can be the designated driver, and who always knows where to find live bait.

Emma Thompson—Because having somebody around who can speak proper English and can quote Jane Austen at the drop of a hat is usually good for a free cosmo or two at the writers' watering holes we hang out at.

Happily Never After

Having Wonderful Time (1938)
Stars: *Ginger Rogers, Douglas Fairbanks Jr.,*
Red Skelton, Eve Arden, Lucille Ball
Director: *Alfred Santell*
Writer: *Arthur Kober*

Ginger Rogers played a lot of bodacious gals who knew just what they were worth and just what they wanted out of life. Here she stars as Teddy, a Bronx secretary who saves her pennies from working in the typing pool at a faceless New York company and heads to Camp Kare-Free—not to find a husband, as other girls (Lucille Ball, Eve Arden) do, but in the hopes that fresh air, sunshine, and a break in routine will renew her spirit. In no time Teddy meets Chick (Douglas Fairbanks Jr.), a college-educated lawyer working as a waiter who is just as uninterested in romance as she is. She reveals to him her secret desire to continue her education and then . . .

And then the entire thread of her self-discovery is dropped in favor of her permanently hooking up with Chick, all the while protesting that she can be a good wife and live on his meager salary. And of course she gets all huffy when he makes a pass at her because as soon as she gets under that moonlit sky her mind turns not to romance but to marriage, and preserving her virtue for same. We wish poor Teddy could've spent less time playing backgammon and more time checking out listings of adult education classes and exploring her sensuality.

■ *Almost Famous* (2000)
Stars: *Billy Crudup, Frances McDormand, Kate Hudson, Patrick Fugit*
Director and Writer: *Cameron Crowe*

Whenever there's a movie about rock and roll, you know that at the heart of it there's going to be a male coming-of-age tale about a rock-star-struck boy who learns that there's more to life then sex, drugs, and rock and roll. And this film, based on the life of the

movie's writer and director, Cameron Crowe (who was a *Rolling Stone* magazine prodigy in the late sixties), is no exception. The only difference here is that there's also a teenage girl who learns that in the concert of life, even if you know where to find the boys, you will never get a backstage pass to happiness without self-respect, honesty, and the courage to love and be loved in return.

William Miller (Patrick Fugit), an aspiring young rock critic, gets an opportunity to do a cover piece on a band poised to break through to the big time. Although he's only fifteen and still in high school, his mom reluctantly lets him join the band on the road. In the course of the tour he loses his virginity, his innocence, and his heart to a rock groupie named Penny Lane (Kate Hudson). Penny believes that she is not a groupie but a muse who inspires rock stars to achieve greatness through the inspirational power of her belly shirt and her come hither smile. This new approach to groupiedom really catches on, and soon Penny Lane becomes the head of a new rock-and-roll religion for girls, the first commandment of which is to never, never fall in love. Penny's religion is turned upside down when she breaks her own rule and falls hard for Russell Hammond (Billy Crudup), an extremely charismatic and extremely married rock god who ultimately trades Penny for a case of beer during a game of poker . . . and it's not even imported beer. This leads to the inevitable rock-and-roll stomach-pumping scene, and the realization that the first place you have to look for love is inside yourself. The second place is Morocco.

▪ *Fools Rush In* (1997)
Stars: Matthew Perry, Salma Hayek, Jon Tenney, Carlos Gómez,
Siobhan Fallon, Suzanne Snyder
Director: Andy Tennant
Writers: Katherine Reback, based on a story by Joan Taylor and Katherine Reback

We all want to believe that when we least expect it, a chance meeting in a most unlikely place will lead to passion, romance, love—even marriage, a baby, and happily ever after. Hey, why shouldn't a one-night stand lead to a sunset-splashed cliff-top wedding overlooking the Nevada desert?

Isabel's (Salma Hayek) and Alex's (Matthew Perry) magical adventure begins when they're in line for the bathroom at a loud Mexican restaurant in Las Vegas and Isabel

strikes up a conversation with Alex. Despite her assertive first move, Isabel vanishes with the sunrise, only to show up again at Alex's three months later, with the news that the condom failed. Once he has recovered from the shock—and learned Isabel's last name—Alex readily offers to stand by Isabel in any way he can. Even more conveniently, he falls madly in love with her after spending just a few hours with her family (don't you just wish!).

Although Alex is a blue-shirt-khaki-pants-and-Docksiders-clad workaholic East Coaster who's supposed to be transferred back to New York City in a few months, and Isabel is an earthy local photographer of desert scenes, they are an utterly perfect match. Oh, there are clashes between in-laws and careers, and a couple of annoying yuppie types

Best Pickup Lines

Look, lady. A fellow can't turn around in this town without seeing signs saying, "Houston Welcomes You," "Anything Houston can do to make you happy," and, "There ain't no such thing as a stranger in Houston." You gonna make a sucker out of Houston?
★ Dan Dailey as "Dizzy" Dean in *The Pride of St. Louis*

You know, if you're just looking for something beautiful to put on your wall, you might want to think about a mirror.
★ Hugh Grant as Michael Felgate in *Mickey Blue Eyes*

Would you be shocked if I put on something more comfortable?
★ Jean Harlow as Helen in *Hell's Angels*

You know how to whistle, don't you, Steve? You just put your lips together . . . and blow.
★ Lauren Bacall as Marie Browning in *To Have and Have Not*

trying to break them up—Alex's eternal bachelor colleague Jeff (Jon Tenney) and a pushy prepster who is out to snag Alex for herself (Suzanne Snyder). And there's not one, not two, but *three* scary pregnancy moments to shake things up. But just as we can count on plenty of scenes of Matthew Perry openmouthed and in shock at his situation, we can count on the script resolving all these crises in a cheery and vague way (exactly what is the family-oriented young mom supposed to do once she's stuck with a newborn two thousand miles away from all her family and friends?). Quibble, quibble. Let's all just pretend everything will work out as perfectly as those Gray's Papaya hot dogs arrive in the desert, having been airmailed, complete with sauerkraut, from New York City.

We recommend this one for when you're feeling hopeless about the bar scene and want to believe that you too can defy the laws of probability and physics, and have your hot dog and eat it too.

▪ *The Matchmaker* (1997)
 Stars: Janeane Garofalo, David O'Hara, Milo O'Shea, Jay O. Sanders, Denis Leary
 Director: Mark Joffe
 Writers: Karen Janszen, Louis Nowra, Graham Linehan,
 based on a screenplay by Greg Dinner

Does it seem that your romantic self has taken a long vacation and left you without its cell phone number? Here's a movie that will put you back in touch and assure you that when you stay true to yourself and allow yourself to have a little fun now and again, romance will find your number.

A thoroughly disgusted political aide named Marcy Tizard (Janeane Garofalo, who specializes in thoroughly disgusted) is sent by her boss, John McGlory (Jay O. Sanders), to the cozy little Irish town of Ballinagra on a fool's errand. McGlory, it seems, wants to find some authentic Irish roots for himself so he can win the hearts of Boston voters. At first, Marcy and Ballinagra mix about as well as a Grey Goose martini and a mug of Guinness. After all, Ballinagra is in the midst of its annual matchmaking celebration, filled with lonely hearts of both genders and all ages who are eager to pair up, while Marcy's romantic feelings are reserved for her fax machine, cell phone, and Sunday *New York Times*. Soon, of course, the quirky Irish town wrapped in a sea of greenery,

populated by goofy yet charming local guys with plaintive tenor voices and open hearts, cures Marcy's cynicism and reawakens her sense of romance.

But just as Marcy's starting to warm up to Sean Kelly (David O'Hara), the local journalist who dreams of writing a novel, McGlory arrives with his campaign manager (Denis Leary) to make sure she's not having any fun. Next thing you know, Marcy is in spiked heels and dancing an exhilarating jig on the top of McGlory's car, and it becomes clear that no matter which side of the pond she ends up on, she will never again give her heart away to a thankless job or a passionless life.

When the possibility of romance feels as far away as County Cork, check out *The Matchmaker* and rediscover the carefree lass within who knows she'll find love and fulfillment as surely as the heather blooms on the heath.

▪ *Next Stop Wonderland* (1998)
Stars: Hope Davis, Alan Gelfant, Philip Seymour Hoffman, Holland Taylor
Director: Brad Anderson
Writers: Brad Anderson, Lyn Vaus

Hey, there are times in our life when we're just not up for romance. Erin Castleton (Hope Davis), for example, probably needs a little me-time after being dumped by her tube-socks-and-Birkenstocks-shod boyfriend (Philip Seymour Hoffman), who leaves her with a video of himself lecturing her on the "8 Reasons Our Relationship Is Doomed"—but takes the VCR with him. Forget dating again—Erin would just as soon revert to nicotine addiction and drown herself in sad but beautiful Brazilian love songs.

Erin's time for reflective solitude is not to be, however, because her busybody mom (Holland Taylor) has decided she knows best and surprises Erin with the news that she's placed a personal ad on her behalf. At first Erin protests that she's not interested. But on a whim, Erin checks her voice-mail box and learns she has sixty-four potential suitors. Hmm . . . maybe she ought to reconsider her early retirement from the dating scene after all?

What follows is a montage of Erin's dates from hell, each wackier than the last. Naturally, Erin's savvy enough to dismiss this parade of despicable toads with a languid exhalation of cigarette smoke. But as we watch Erin wrestle with whether or not to open the

door to romance again, we have to wonder if she will ever hook up with Alan (Alan Gelfant), the handsome, introspective stranger who seems just right for her and whose story parallels her own struggle for redefinition.

If ever there were a perfect movie for when a gal's feeling maybe it's time to end her hiatus from men, this is it. Watch it and you'll feel assured that Mr. Right is just a few ponds away, and you'll discover him when you find the courage to venture beyond your own lily pad.

Emotional Makeover Movies

These movies feature awkward cygnets who ultimately soar like beautiful swans through the lift and thrust of their own buoyant personalities. When you're feeling stuck in the ugly duckling phase, and are ready to grow some fine feathers, watch one of these Emotional Makeover Movies, and take wing.

Clueless (1995)
Stars: Alicia Silverstone, Dan Hedaya, Paul Rudd, Brittany Murphy, Stacey Dash
Director and Writer: Amy Heckerling

In this Hollywood update of Jane Austen's *Emma*, Cher (Alicia Silverstone), who is the height of Hollywood High School chic, takes naive New Yorker Tai (Brittany Murphy) under her wing and attempts to transform her into a brunette and slightly less willowy version of herself. In the process, Tai learns the ABC's of Beverly Hills teenage etiquette, like how to mingle at parties or locate a good plastic surgeon, and to always take out your nose ring when you have a cold. As soon as Tai starts rolling with the homies and busts out of her flannel shell, the tables turn and Tai winds up teaching Cher that when it comes to love and life, a good heart and a good mind are more important than a great outfit.

continued . . .

Never Been Kissed (1999)
Stars: Drew Barrymore, David Arquette, Michael Vartan,
 Molly Shannon, Leelee Sobieski
Director: Raja Gosnell
Writers: Abby Kohn, Marc Silverstein

Josie Geller (Drew Barrymore), a high school geek turned big city copy desk geek, reluctantly returns to school and poses as a student in order to do a story on the state of teen spirit in Chicago. At first her undercover experience feels like a recurring nightmare of her real high school years when she was dubbed "Grossie Josie," ostracized from high school society, and even pelted with produce at the prom. Given a second chance to make a splash in school, however, Josie undergoes an emotional makeover when she discovers that the only difference between geeks and homecoming queens is the application of a little maturity and self-confidence.

Superstar (1999)
Stars: Molly Shannon, Will Ferrell, Elaine Hendrix, Glynis Johns
Director: Bruce McCulloch
Writers: Molly Shannon, Steve Koren

Molly Shannon stars as the perennially wormy adolescent Mary Katherine Gallagher, who has the distinction of being the only Catholic schoolgirl on the big screen who doesn't look kittenish in a minikilt. Despite a crippling case of social acne that alienates her entirely from high school society, Mary Katherine dreams that one day Sky (Will Ferrell), the most popular boy in school, will kiss her meaningfully and realize that it is Mary Katherine, and not the more beautiful and far more socially adept Evian (Elaine Hendrix), who is the love of his life.

And so Mary Katherine gives herself a makeover, and with a little help from her friends, as well as a few thousand sequins, some really great disco choreography, and an *SNL* seal of approval, Mary Katherine becomes a SUPERSTAH!

Worst Pickup Lines

To me, Fanny, you are a temple wherein I may worship. ★ Claude Rains as Job in *Mr. Skeffington*

In the words of David Cassidy—in fact, uh, while he was still with the Partridge Family, uh—I think I love you.
★ Hugh Grant as Charles in *Four Weddings and a Funeral*

We are not strangers! I have known you at least two lifetimes—that I know of. ★ André de Silva as José Zuniga in *Next Stop Wonderland*

I learned French for you!
★ Joseph Gordon Levitt as Cameron James in *10 Things I Hate About You*

My therapist says I'm a good catch.
★ Potential suitor of Katie (Marla Schaffel) in *I Love You, Don't Touch Me*

My company is the largest importer of medium weight farm equipment in Japan.
★ Potential suitor of Wendy Reed (Carrie Hamilton) in *Tokyo Pop*

I could dance with you till the cows come home. On second thought, I'd rather dance with the cows when you came home.
★ Groucho Marx as Rufus T. Firefly in *Duck Soup*

I'm taking you home in a bulletproof limousine.
★ Clark Gable as Ace Wilfong in *A Free Soul*

Don't you think angora has a tactile sensuality lacking in all other clothing? ★ Johnny Depp as the cross-dressing Ed Wood in *Ed Wood*

continued . . .

Worst Pickup Lines

I'm the, uh, VP of operations at the Krylex Corporation in Waltham. Krylex manufactures small rubber parts for a variety of commercial and industrial products—products ranging from the small rubber helmets on wall-mounted spring doorstops to the waterproof gaskets on street newspaper vending machines.

★ Potential suitor of Erin (Hope Davis) in *Next Stop Wonderland*

Betty, you've no idea what a fascinating little devil a chicken can be.

★ Fred MacMurray as Bob MacDonald in *The Egg and I*

Words to Live By

I choose vodka. And Chaka Khan.

★ Renée Zellweger as Bridget Jones in *Bridget Jones's Diary*

Well, I always just thought if you see somebody without a smile, give 'em yours!

★ Dolly Parton as Miss Mona in *The Best Little Whorehouse in Texas*

I refuse to go out with a man whose ass is smaller than mine.

★ Elizabeth Perkins as Joan in *About Last Night*

Never date a guy who knows more about your vagina than you do.

★ Robin Bartlet as Ann in *City of Angels*

Forever Female (1953)
 Stars: Ginger Rogers, William Holden,
 Paul Douglas, James Gleason, Pat Crowley
 Director: Irving Rapper
 Writers: Julius J. Epstein, Philip G. Epstein, suggested by
 J. M. Barrie's play Rosalind

In this gem from a bygone era, not one but two divas pursue their careers with so much determination and confidence that they make Madonna look shy, and are rewarded with fame, fortune, fawning fans, and lovers who are utterly devoted to them. And the best thing is, though they are professional and personal rivals and this is a fifties flick written by men, there isn't a single catfight or catty remark between them!

It's been years since Broadway actress Beatrice Page (Ginger Rogers) could carry off ingenue roles, but her ex-husband, Harry (Paul Douglas), a wealthy promoter, showers her with favors, attention, and plays that are rewritten to allow her to pretend to be twenty-nine and holding. The ever-confident Beatrice braves the blunt criticism of a brash young playwright, Stanley Krown (William Holden), who shows up at Sardi's one night, and she even encourages Harry to check out Stanley's play. Before you know it Stanley starts paying attention to his hunger pangs, sets aside his integrity, and starts rewriting the ingenue role for a gal of, oh, let's say—twenty-nine. Enter Sally Carver (Pat Crowley), an energetic and often downright obnoxious nineteen-year-old actress, who will stop at nothing to replace Beatrice in the play and launch her career by starring as the ingenue, which she'd like to see rewritten for a gal of, oh, let's say—nineteen.

As Stanley tries to figure out what to do about his play and his dual romances with Beatrice and Sally, and Harry tries to win back the heart of the only woman he's ever loved, Beatrice and Sally find they have to dig deep and face the truth about themselves in order to earn the right to have top billing on stage and in their own lives.

Watch this movie when you're feeling less than desirable and remind yourself that a healthy dose of entitlement, combined with perseverance and pluck, will land you starring roles as well as your pick of leading men.

Stupid Guy Quotes

Look, Miss Fremont, that feminine intuition stuff
sells magazines, but in real life it's still a fairy tale.
★ Wendell Corey as Lieutenant Doyle in *Rear Window*

Truth doesn't mean the same to a woman as it does to a man. To
them, it's what they want to believe, regardless of the facts.
★ Rex Harrison as Lord Broadbent in *The Reluctant Debutante*

If I die, tell **Rolling Stone** *that my last words were "I'm on drugs!"*
★ Billy Crudup as Russell Hammond in *Almost Famous*

■ *Edie and Pen* (1997)
　Stars: Stockard Channing, Jennifer Tilly,
　　Scott Glenn, Stuart Wilson
　Director: Matthew Irmas
　Writer: Victoria Tennant

In Reno to obtain quickie divorces, Edie (Jennifer Tilly) and Pen (Stockard Channing)
meet and become friends despite their distinctly different attitudes toward their current
marital status. Edie is positively giddy with her newfound freedom, ready to toss her ring
in the nearest lake and tipple a few margaritas before flying off to Acapulco to marry
again. Pen, on the other hand, just wants to get stinking drunk on vodka and cry into her
martini glass.

They're an unlikely pair, but in a bar the day after their divorces become final, Edie offers Pen pretzels, another round, and the hope of reclaiming joy. She even tags along with Pen to look out for her after Pen throws caution to the desert winds and takes a ride with three cowboys in their Winnebago. Soon Pen is trading sob stories with one of the men, a morose fellow named Harry (Scott Glenn), whose self-pity and anger at the opposite sex is a perfect match for hers. The bubbly and lovably ditzy Edie persuades Pen to borrow a flashy miniskirt, go dancing, and reclaim her sexuality. As Pen's heart opens to possibilities, Edie's eyes open too, and both set off for new relationships that promise to be far more fulfilling than the last ones were.

This is the perfect movie to watch when you are ready to shed your mourning clothes and put on your dancing shoes. You may not know who your next partner will be, but *Edie and Pen* will convince you that even in the desert, love finds a way to blossom.

Happily Never After

Moulin Rouge! (2001)
Stars: Nicole Kidman, Ewan McGregor,
John Leguizamo, Jim Broadbent
Director: Baz Luhrmann
Writers: Baz Luhrmann, Craig Pearce

Christian (Ewan McGregor), an aspiring poet and playwright living in fin de siècle Paris, longs to become a literary standard bearer heralding a new generation of people who have loosened the bonds of social convention and intellectual restraint. Thus, Christian courts a bohemian lifestyle, which basically involves hanging out with Toulouse-Lautrec and immersing himself in the extremely well-lit and mesmerizingly crimson underbelly of the notorious Moulin Rouge.

continued . . .

But of course, like most bohemians, then and now, Christian is actually a babe in a morally paradoxical and psychosexual wood. And so, of course, the first thing he does is break all the rules and fall in love. And what's worse, he falls in love with the leading lady, the ethereal Satine (Nicole Kidman), whose job it is, when she isn't swinging fairylike from the flies, to keep the rich customers happy so that the show can go on.

Between having to handle an enraged producer who is possessive of her favors and dying of consumption, there's not a lot of room in Satine's life for puppy love. But fall in love she does, and flies away with Christian on the wings of pure pretty-in-pink devotion into a scarlet sunset of perpetual bliss, only to come plunging back to earth, a broken angel who must send her lover away in order to spare him future pain.

Now, we admit that on the surface this can look like a beautiful gesture, particularly when you dress it up in bedazzled magenta crinoline and fishnet stockings, light it with nine thousand champagne-tinted period bulbs, suspend it above a captivatingly costumed cast of period extras, and slap a beaded crown on its head. But in the daylight of modern psychology, Satine's emotional martyrdom is the masochistic act of a classic codependent. Not only is she taking responsibility for somebody else's feelings, but she's making decisions for Christian that he really ought to be making for himself.

This is the kind of Homeric/Judeo-Christian literary tradition that has left us with a legacy of heroines throwing themselves in front of trains, getting tied to railroad tracks, or, like Satine, plunging earthward from her tragic archetypal pedestal into the arms of a stranger, because she's so busy worrying about everybody else's problems that she's not taking responsibility for her own health maintenance, or the laws of gravity.

Frankly, we wish that Hollywood would spend a few more dollars lighting and costuming heroines who know how to take care of themselves, and making emotional health look as rosy as dysfunction.

Snappy Answers to Stupid Questions

Frank (Victor Argo): So, uh, what's an attractive girl like you doing in a bar so early? Looking for fun maybe?

Erin (Hope Davis): What's that on your nose? The purple blemish, on the end of your nose? It looks like a basal cell nevus, or maybe a melanoma? You know, you may want to get that checked out. For a man your age, a malignant melanoma can be fatal if not properly removed.

★ from *Next Stop Wonderland*

Stephen Ashe (Lionel Barrymore): Are you suggesting that I'm not a good dancer?

Jan Ashe (Norma Shearer): No, but we can't both dance on my feet, you know.

★ from *A Free Soul*

■ *Serendipity* (2001)
Stars: John Cusack, Kate Beckinsale,
 Eugene Levy, Molly Shannon, Jeremy Piven
Director: Peter Chelsom
Writer: Marc Klein

Serendipity is a great consolation for anyone tired of waiting for love to show up already, reassuring us that if we pay attention to what is happening in our world and are willing to follow the signs, Mr. Right will appear—albeit on fate's timetable, not ours.

Jonathan (John Cusack) and Sara (Kate Beckinsale) meet serendipitously at Bloomingdale's while Christmas shopping—because, of course, the first rule of a romantic comedy is to have at least one scene of New York City at Christmas, and this flick's got as

many of them as Fifth Avenue has shoppers on December 24. The two admit they are already in relationships. But could there be some grand reason for their chance meeting? To find out, Sara comes up with a kooky scheme that will allow fate to decide whether they are destined for each other.

Luckily, Jonathan and Sara have the help of Hollywood screenwriters who can come up with an endless number of coincidences, lucky accidents, and signs to put them on a quest to reunite on the eve of his wedding a few years later. A sales receipt she stuffed into her glove rather than her wallet on that fateful night? He'll find it. A jacket she forgets somewhere in the vastness of Central Park? He'll find that too. Hey, she even discovers a chewed piece of gum he stuck on the back of a bench. Frankly, we think that improper disposal of chewing gum is an indication that maybe a man isn't husband material, but that's not how things work in this movie. Yep, all signs point to one thing—the lovers reuniting at a destined, romantic place. Even the weather cooperates: it snows on cue.

When you're feeling that the odds are against you finding love, watch *Serendipity* and watch all of New York City conspire to bring lovers together. There—the world doesn't seem so indifferent to your desire for romance after all, does it?

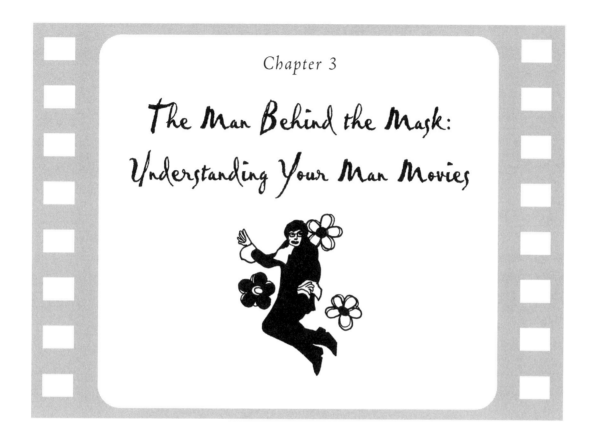

Chapter 3

The Man Behind the Mask: Understanding Your Man Movies

Let's face it, guys are, well . . . different from us. When you first fall in love, all you can see are the points of intersection, which seem cosmic and divinely ordained. Who could have guessed that there would be another person in the world who likes the sun in the morning and the moon at night, who prefers gazpacho cold and coffee hot, understands that you can lead a horse to water but you can't make him drink, that a stitch in time really does save nine, the world is unequivocally round, and that John Lennon was without a doubt the most talented Beatle? And then the hormones wear off, and you begin to realize that even though he looks like a duck and quacks like a duck, he's really not a duck at all, but a bona fide, regulation, card-carrying M-A-N who you can count on to do the most inexplicable things.

If you're beginning to realize that your knight in shining armor is just a guy in a metal suit, watch one of these Understanding Your Man Movies featuring films that reveal the real him, and unlock the secrets of the opposite sex. *Vive la différence!*

Stupid Guy Quotes

Why make trillions when we could make . . . billions?

★ Mike Myers as Dr. Evil in
Austin Powers: The Spy Who Shagged Me

Believe me, looks are everything.

★ Jack Nicholson as Jonathan Fuerst in *Carnal Knowledge*

■ *Austin Powers: The Spy Who Shagged Me* (1999)
Stars: *Mike Myers, Heather Graham, Michael York, Robert Wagner,*
Rob Lowe, Mindy Sterling, Verne Troyer, Elizabeth Hurley
Director: *Jay Roach*
Writer: *Mike Myers*

Austin Powers has become a central myth in the male collective unconscious because all men want to believe that underneath it all, funny-looking guys with bad teeth, bad suits, bad hair, and a complete lack of sexual desirability are really debonair globe-trotting secret agents who can combat evil on a cosmic scale—and win the heart of some chick who looks like Heather Graham and whose last name is Shagwell for a damn good reason.

The world of Austin Powers is a male utopia untroubled by physics, real politics, genetics, economics, the laws of cause and effect, or the civilized government of a woman's touch. In fact, it's pure guydom. Here, women have machine-gun "jubblies" and can be fast-forwarded, paused, or muted via remote control . . . And they all have these really weird up-flip dos and overly tweezed eyebrows like those bizarre ensign chicks on *Star Trek.* In Shagville, villains are just fractured father figures who are unable to admit their vulnerabilities, rebellious sons are never really replaced by miniature and more compliant

Daddy clones, and no man ever really loses his mojo. And of course, there is a Burt Bacharach ballad playing perpetually in the background, and Elvis Costello is *gorgeous*.

For guys, this is the real deal, the brass ring, and the sail home to a final harbor. For women, this movie offers the reassurance that guydom is ultimately a benign and friendly kingdom where men aren't measured by the size of their mojo but by their capacity for love. So the next time you're at a critical impasse with your international man of mystery, hop on the good foot and do the bad thing with Austin "double-oh behave" Powers, and thwart the forces of evil with laughter, love, and understanding. Then party like it's 1969.

▪ *A Knight's Tale* (2001)
 Stars: Heath Ledger, Mark Addy, Rufus Sewell,
 Paul Bettany, Shannyn Sossamon, Laura Fraser
 Director and Writer: Brian Helgeland

He's got it all: the manly, muscular forearms, the winning smile, the exquisite bone structure, the blond hair extensions, the slightly angled phallic jousting stick that promises that he will, yes he will, rock you. William (Heath Ledger), squire to a knight, has all the makings of a rock-and-roll superstar, thrilling the medieval European jousting crowds as they do the wave to a seventies testosterone-driven soundtrack featuring Queen and Bachman Turner Overdrive.

Now, this anachronistic hero may look like a peasant when he's in dirty clothes and battered secondhand armor, and yes, he has a woeful back story about his hard-luck life as the son of a thatcher, but it quickly becomes clear that he also has a nobleman's heart and the ambition to headline at stadiums worldwide. Still, can he do so and maintain his humility, charm, loyalty, and honor, not to mention dignity, while wearing tights and doing a modified funky chicken to a club mix of Bowie's "Golden Years," which has somehow magically transported itself into the feudal age? Well, wop wop wop—you can bet he'll do it without sacrificing his masculine appeal or his international viability as a leading man. Yeah, you try it, Leonardo—it ain't easy.

Watch this movie when you're in the mood for a preposterously silly bit of courtly love. It will have you believing that underneath all that shabby armor your man wears lies a true

knight who knows exactly how much to sacrifice for a woman without losing his powerful sense of self and hence his attractiveness. But if your boyfriend is over the age of seventeen, we suggest you give him the night off. Who needs adolescent cynicism when there's a Lancelot like Heath Ledger in the room?

You Go, Boyfriend

A man CAN change his stars, and I won't spend the rest of my life as nothing.

★ Heath Ledger as William Thatcher
in *A Knight's Tale*

■ *Primary Colors* (1998)
Stars: John Travolta, Kathy Bates, Emma Thompson,
 Adrian Lester, Billy Bob Thornton
Director: Mike Nichols
Writer: Elaine May, based on the novel by Joe Klein

He seems like he's the ideal man. He's got that kind, all-knowing smile, the reassuring shoulder, understanding eyes, and he wears his heart on his sleeve. He always knows exactly what to say in a difficult situation, he's elevated handshaking to an art form, and his tie always, but always, matches the occasion. And yet, there's that little voice in your head that's telling you that anybody who is working that hard to be perfect has got to be hiding something.

If the candidate in your life is too good to be true, and you're wondering if you should elect him president or launch a special subcommittee investigation into his personal past, *Primary Colors* will give you some valuable pointers on how to tell the spit from the polish and save yourself a fortune in emotional taxpayer dollars trying to expose the human being behind the golden boy.

John Travolta stars as Gov. Jack Stanton, a Clinton-esque political rainmaker from the Deep South, who can charm pure Tupelo honey from the bees, but whose own sweet tooth often gets the better of him. His forays into the South's fertile deltas result in a swamp of sexual indiscretions, including an affair with his Hillary-esque wife Susan's (Emma Thompson) hairstylist—who has the bad taste to name herself Cashmere. And there have been rumors spreading about his fathering a child with the teenage daughter of one of his staunchest African American supporters.

It is up to Stanton's high-minded, squeaky-clean campaign manager, Henry Burton (Adrian Lester), and his feisty but principled investigator, Libby (Kathy Bates)—who's a kind of human Dustbuster, and a lesbian with attitude—to decide whether Stanton is full of the right stuff or just plain full of it.

And in the end, it is up to all of us to decide if we want to put a person or a well-scripted sound bite into our personal Oval Office. This movie reminds us all that good partners, like good presidents, are just people like the rest of us. And when we go looking for perfection in an imperfect world, what we will inevitably find is not perfection at all, but a politician.

Stupid Girl Quotes

The only shot we have here is to be perfect.
★ Emma Thompson as Susan Stanton in *Primary Colors*

He smokes some grass. He uses some psychedelics.
He uses peyote, but he is down on hard drugs.
★ Illeana Douglas as Denise Waverly
in *Grace of My Heart*

In a good shoe, I wear a size six, but a seven feels so good, I buy a size eight.
★ Dolly Parton as Truvy Jones in *Steel Magnolias*

Manly, Yes, but Ladies Like It Too: The Tin Men

The Tin Men of the silver screen are heroes who can switch off all inconvenient emotion that impedes a man's ability to do what a man's got to do as easily as clapping on and clapping off. Whether he's a man on a mission, or a cyborg with an axe to grind, these automated enforcers let us pretend, if only for a few moments, that there are guys out there who aren't silver plate but solid shining armor, and who execute their mission with a singularity of purpose, without whining even once about doing their chores. So the next time you're in the mood to spend a few hours with a heavy-metal hero who knows how to get the job done, here are a few Tin Men classics guaranteed to make your day.

First Blood (1982)
Stars: Sylvester Stallone, Richard Crenna, Brian Dennehy
Director: Ted Kotcheff
Writers: Michael Kozoll, William Sackheim, Sylvester Stallone,
* based on the novel by David Morrell*

This is the first in a series of action-adventure films featuring John Rambo (Sylvester Stallone), an iconic and disenfranchised Vietnam vet who wanders into a small town to pay tribute to a fallen friend and is immediately targeted by local police, who round him up and shake him down. But as Sheriff Teasle (Brian Dennehy) and the rest of America are soon to discover, this is no marginalized Vietnam vet with a few screws loose. This is a highly trained, finely tuned, and well-oiled killing machine, capable of using a forest like a slingshot and conquering an entire police force, the National Guard, and movie audiences everywhere without moving a single facial muscle.

continued . . .

Dirty Harry *(1971)*
Stars: Clint Eastwood, Harry Guardino,
 Reni Santoni
Director: Don Siegel
Writers: Harry Julian Fink, Rita Fink, Dean Riesner

Dirty Harry Callahan (Clint Eastwood) is an iconoclastic and laconic plainclothes detective who doesn't so much crack cases as blow them to smithereens with one wave of his .44 Magnum and a gritty grimace that makes our jaws cramp just looking at him. Dirty Harry and his sidekick, Chico (Reni Santoni), roam the nighttime streets of San Francisco in search of scum that must go, shooting first and asking questions later, mostly because it's hard to have a dialogue when your teeth are perpetually clenched. Wherever Harry goes, he runs into some form of human filth fouling the streets for decent citizens. And like a human SOS pad, Harry zeroes in on the dirt and scrubs the city clean, and all without ever once unsquinting his eyes.

Shaft *(2000)*
Stars: Samuel L. Jackson, Busta Rhymes,
 Vanessa L. Williams
Director: John Singleton
Writers: Richard Price, John Singleton, Shane Salerno,
 based on a story by John Singleton and Shane Salerno,
 based on the novel by Ernest Tidyman

When Richard Roundtree first portrayed this blaxploitation antihero, the zeitgeist was a bit more morally ambiguous, so John Shaft, in his endless array of fine leather jackets and turtlenecks, was a bad motha-*shut-your-mouth* who looked stylishly cool even as he threw criminals out windows just for crowdin' his space. The original Shaft was a private dick who sometimes cooperated with

continued . . .

cops, and sometimes with gangsters, but whose loyalty was to himself, as his ladies soon learned. But then Samuel L. Jackson brought us a kinder, gentler Shaft for the new millennium—a Shaft who donned an even wider array of Armani leather jackets and who was a moral lighthouse in a sea of corruption, determined to right wrongs and help those who'd been "shafted." This new and improved Shaft expanded his emotional palette beyond anger, lust, and nonchalance to include compassionate wincing. Shaft, you've come a long way, baby.

Terminator 2: Judgment Day (1991)

Stars: Arnold Schwarzenegger, Linda Hamilton, Edward Furlong,
* Robert Patrick*
Director: James Cameron
Writers: James Cameron, William Wisher Jr.

The Terminator (Arnold Schwarzenegger) takes the Tin Man archetype one step further, and actually plays a machine, rather than a metaphor for the mechanized man of duty, who, like the Energizer Bunny, just keeps going and going and going. No matter what, we know the Terminator will not be stopped until his mission is executed without any emotion, moral conflict, or vocal inflection whatsoever.

Can I Speak to a Supervisor?

Listen! And understand! That terminator is out there. It can't be bargained with! It can't be reasoned with! It doesn't feel pity, or remorse, or fear. And it absolutely will not stop, ever, until you are dead!

★ Michael Biehn as Kyle Reese in *The Terminator*

■ ***The Second Woman*** *(1951)*
Stars: Robert Young, Betsy Drake,
 John Sutton, Florence Bates
Director: James V. Kern
Writers: Mort Briskin, Robert Smith

Despite the unsettling signs of architect Jeff Cohalan's (Robert Young) neuroses, our heroine, Ellen Foster (Betsy Drake), is in love with Jeff and determined to do the emotionally healthy thing and dig below the surface. For his part, the mysterious Cohalan holes up alone in a self-designed home that he built for his fiancée before her tragic death in a car crash on the eve of their wedding a year ago, and Ellen is the first person he lets in, literally and figuratively. He is attracted to her, but he does wish she'd stop asking so many discomfiting questions—like, what's with the arsenic in his topsoil? And, why did he try to asphyxiate himself in her aunt's garage minutes before he knew she'd go looking for him? A local doc warns Ellen about Jeff's dizzy spells and recurring periods of depression, and Ellen witnesses for herself his patches of absent-mindedness. But despite his flimsy excuses and his urging her to forget about the fact that everything he loves—from his former fiancée to his horse, dog, and favorite prize rosebush—ends up dead or destroyed by an unseen force, Ellen stands her ground. Yes, she insists on digging up the dirt, exposing his dark memories to the light of day, and ultimately figures out what's poisoning Jeff's world and threatening her future with him.

This movie is a great one to watch when your own man appears to have something wrong with his root system and is telling you not to worry because it's probably just leaf rot. It'll encourage you to look at what lies beneath the surface so that you can be sure to reap a harvest of truth—because the assurance of a good crop begins underground.

Baseball Movies That Are over the Fence

Even guys who remember exactly how a play unfolded in the third inning of the fourth game of the 1947 World Series are happy to have facts thrown to the wind when it comes to legend-making movies about the great ballplayers that serve as metaphors for the male experience. When you watch these baseball movies that are over the fence, you'll learn less about the All-American game than you will about the dreams and ideals of the All-American male. And hey, can we just say we're waiting for the *New England Journal of Medicine* article about curing invalid boys by knocking homers out of the park for them?

The Babe Ruth Story (1948)
Stars: *William Bendix, Claire Trevor*
Director: *Roy Del Ruth*
Writers: *George Callahan, Bob Considine,*
 based on the book by Babe Ruth and Bob Considine

The original Babe Ruth biopic, this flick flattens the charismatic, icono-clastic, larger-than-life Babe (William Bendix) and sugarcoats his excesses. But it did solidify for men the Babe's reputation as a bad boy with a heart of gold, whose dazzling performances made up for his breaking the rules, proving that when you've got the goods, your employer will have to answer to you.

The Babe (1992)
Stars: *John Goodman, Kelly McGillis*
Director: *Arthur Hiller*
Writer: *John Fusco*

This movie presents the Babe (John Goodman) as a sweet-natured oaf with major mommy issues, which lead him to womanize, engage in unhealthy drink-

continued . . .

ing behaviors, overconsume red meat, and tearfully confess his deep feelings of abandonment. But it also paints a portrait of a man who defiantly proved his critics wrong again and again, coming back from every slump. This is a great movie to watch with your man when he's feeling like he's about to be shipped to the minors and needs a little encouragement to find his second wind.

The Pride of the Yankees (1942)
Stars: Gary Cooper, Teresa Wright, Babe Ruth
Director: Sam Wood
Writers: Herman J. Mankiewicz, Casey Robinson, Jo Swerling,
* based on a story by Paul Gallico*

Lou Gehrig (Gary Cooper) was a nice guy who was faithful to his wife, never partied, called his mom regularly, and had a career-long record of punctuality and perfect attendance. You'd think modern men would groan at his squeaky clean image, but Gehrig hit like an iron man, which just goes to show that nice guys can finish first. Unfortunately, Lou "The Ironman" Gehrig contracted a rare disease (ALS) that ended his career and his life far too early, but his courage and dignity in the face of death are as laudable as his baseball record.

The Pride of St. Louis (1952)
Stars: Dan Dailey, Joanne Dru, Richard Crenna
Director: Harmon Jones
Writer: Herman J. Mankiewicz, based on a story by Guy Trosper

Ozark-born Jerome "Dizzy" Dean (Dan Dailey) pitches a durn good fast-ball and yet does zany stuff like skip a game to go fishin', or call time out to discuss with the catcher whether or not to buy a shotgun for duck huntin'. Ultimately, however, time takes its toll and ol' Diz has to admit he's gotten too old for the game, but he reinvents himself without losing his boyish appeal, proving that a fella doesn't ever really have to give up his boyhood.

continued . . .

The Natural (1984)
Stars: *Robert Redford, Glenn Close,*
 Kim Basinger, Robert Duvall, Barbara Hershey
Director: *Barry Levinson*
Writers: *Roger Towne, Phil Dusenberry, based on the novel*
 by Bernard Malamud

Star rookie Roy Hobbes (Robert Redford) loses his pitching arm and his nerve because of the actions of a jealous woman (Barbara Hershey), but through the magic of baseball, he is suddenly breaking balls, smashing all manner of barriers, and setting off streams of fireworks with that long, hard, powerful bat. Watch this one with your man when he's been suffering from performance anxiety and let him be inspired by the grand mythology of virility regained.

Field of Dreams (1989)
Stars: *Kevin Costner, Amy Madigan, Ray Liotta, Timothy Busfield,*
 James Earl Jones, Burt Lancaster
Director: *Phil Alden Robinson*
Writer: *Phil Alden Robinson,*
 based on the book Shoeless Joe *by W. P. Kinsella*

Ray (Kevin Costner) is a middle-aged farmer who recognizes that he lost his childhood innocence when he stopped bonding with his dad over baseball, so he builds a baseball diamond in his cornfield where he can recapture lost dreams and opportunities, and reconnect with his pop. Meanwhile, his ever-supportive wife stands by her man as he blows all their money on his Field of Dreams. This one's a great reminder that it's never too late to make peace with your past.

■ *The Elephant Man* (1980)
Stars: Anthony Hopkins, John Hurt, Anne Bancroft, John Gielgud
Director: David Lynch
Writers: Eric Bergren, Christopher De Vore, David Lynch, based on books
by Ashley Montagu and Sir Frederick Treves

Based on a true story, this movie about a cosmetically challenged English gentleman, whose beautiful soul is covered up by a face that is the nineteenth-century equivalent of Jason without the ski mask, reinforces the old adage that in the sideshow of life and love, you can't judge a freak by his cover.

John Merrick (John Hurt), aka the Elephant Man, is a nineteenth-century English-man who is afflicted with Proteus syndrome, a disease so disfiguring that it causes adult men to gape in horror, women to faint, dogs to growl, and children to resort to *Lord of the Flies* behavior and chase him through blind alleyways with sharp sticks. Okay, we know, the Victorian British had a weird sensibility about the savagery of children, but you get the point.

John Merrick is rescued from the degradation of life as a feature act in a traveling freak show by Dr. Frederick Treves (Anthony Hopkins), a kind and enlightened physician who sees the beautiful soul behind the disfiguring disease that has robbed the Elephant Man of his dignity, his humanity, and any hope of a successful dating life.

Because he receives the care and support of the hospital nurses who are soothed by John's gentle and polite manner—and cease needing smelling salts to change his linens—and the loving guidance of the doctor and eventually even the queen of England herself, John's noble nature shines through and he becomes the toast of London society. He also wins the heart of Mrs. Kendal (Anne Bancroft), a celebrated leading lady of the London stage, who helps the Elephant Man confront his negative body image and embrace his inner Romeo.

This is a great movie to watch when you need to remember that while truth is beauty, beauty is not always truth, and the true measure of a man or a woman's desirability is not what's reflected in the mirror but what's reflected in one's heart.

Reel to Real

In actuality, Madge Kendal, the toast of the London stage who sees the Romeo inside the Elephant Man in the movie, was hardly best buddies with him. Although John Merrick did build a miniature model church for her completely out of paper, Mrs. Kendal sent her husband to pick up the present, and she never met the Elephant Man at all.

Primal Scream Therapy

I am not an animal! I am a human being!
★ John Hurt as John Merrick in *The Elephant Man*

Damn you! I'm not an actor, I'm a movie star!
★ Peter O'Toole as Alan Swann in *My Favorite Year*

I'm mad as hell, and I'm not going to take it anymore!
★ Peter Finch as Howard Beal in *Network*

Can I Get That Printed on a Coffee Mug?

I just met a wonderful new man. He's fictional, but you can't have everything.
★ Mia Farrow as Cecilia in *The Purple Rose of Cairo*

■ *Dream Wife* (1953)
 Stars: Deborah Kerr, Cary Grant, Walter Pidgeon,
 Betta St. John
 Director: Sidney Sheldon
 Writers: Sidney Sheldon, Herbert Baker,
 Alfred Lewis Levitt

If her fiancé, Clemson "Clem" Reade (Cary Grant), finds that Priscilla "Effie" Effington (Deborah Kerr) is a little distracted these days, it's only because she is a high-powered official at the U.S. State Department who is busy brokering an international oil treaty upon which peace in the Middle East depends. Clem whines about Effie letting the dinner roast get cold while she works late and insists that "if a woman can run a home and still find time to have a career, that's fine, but first things first." But for all his chauvinistic protests, somehow we know that the twinkly eyed Cary Grant will eventually see the error of his ways, be a good boy, and heel, all without losing his manly charm.

In order to provoke his distracted fiancée into paying a little more attention to him, Clem gets the idea to marry Tarji (Betta St. John), the daughter of the sultan of Bukistan. Tarji is "the product of five thousand years of training Bukistani girls in the art of pleasing a man," her father brags. This being a general-release 1950s film, that translates to fetching slippers, walking ten paces behind, and performing "erotic" foreign dances that are more postwar Greenwich Village than ancient Persian. Still, irritated as she is at her ex-beau's flaunting his new docile mate, the preternaturally poised Effie chooses not to set off an international incident. Instead, she readily accepts her boss's assignment to follow her now-ex-fiancé and his bride-to-be around and teach them about proper protocol and psychologically healthy marriage dynamics. Effie's teachings result in a reshuffling that leaves everybody happier, wiser, and exactly where they ought to be.

Watch this one when you're feeling on the brink of an international incident of your own. We think you'll be reassured that a peace agreement is always possible when the man you love has a good heart.

■ *My Favorite Year* (1982)
Stars: Peter O'Toole, Mark Linn-Baker, Jessica Harper,
 Joseph Bologna
Director: Richard Benjamin
Writers: Dennis Palumbo, Norman Steinberg

When Alan Swann (Peter O'Toole), a beloved swashbuckling, damsel-delivering hero of the silver screen, decides to make a comeback, he must first overcome his fear of live audiences and intimacy conflicts, as well as an epic appetite for single-malt Scotch, in order to return the luster to the legend. Flat broke, dead drunk, and at odds with his family and the IRS, Alan Swann agrees to a guest slot on the *King Kaiser Variety Hour* to pay off the government and wipe his slate clean. Unfortunately, he shows up for his fresh start a day late, more than a dollar short, and just a few stops shy of the end of the line.

When King Kaiser (Joseph Bologna), the show's star, threatens to fire Swann, it's up to Benjy Stone (Mark Linn-Baker), a young writer struggling to embrace his inner hero, to save his childhood idol Swann from his own baser instincts.

This movie both shatters and fulfills all of our expectations of male heroism and reminds us all that beneath the swagger and the swashbuckle, all heroes are just regular guys, and all just regular guys are really heroes. If your Sir Galahad has been a little bit less than noble, watch *My Favorite Year* together, and remind yourselves that a heart of gold, a good sense of humor, and a reliable chauffeur are worth ten suits of shining armor.

■ *Airheads* (1994)
Stars: Brendan Fraser, Steve Buscemi, Adam Sandler,
 Joe Mantegna, Michael McKean, Amy Locane
Director: Michael Lehmann
Writer: Rich Wilkes

When he's a long, lean, heavy-metal machine with hair to there and one of those studded Axl Rose belts draped over his hips just so, it can be hard to practice tough love

and force him to get a job. And normally we'd applaud live-in, gainfully employed girlfriend Kayla (Amy Locane) for bringing her boyfriend's gravy train to a screeching halt. But in this ode to the underdog who sticks to his principles, is true to his word, and goes forth boldly to embrace the American Dream, metalhead Chazz (Brendan Fraser) really, honestly does plan to wine and dine his girl just as soon as the fame and fortune that are his birthright catch up with him. But if she could spring for a burrito for him and cover his half of the rent just this once . . .

Tossed onto the street by Kayla as well as every record company executive in L.A., Chazz powwows with his bandmates and comes up with a simple plan to get some airplay for their demo tape, convinced that's all he needs to snag a major label contract and, by extension, instantaneous wealth and worldwide recognition of his formidable talents. Unfortunately, just like Chazz, his drummer, Pip (Adam Sandler), and his bassist, Rex (Steve Buscemi), are a few tacos short of a combination plate. Before you can say "Lemmy is God!" the three airheads are holed up at the local rock-and-roll radio station, watching over a handful of hostages and issuing a list of wacko demands designed to stall the SWAT teams until Larry, Moe, and Curly can figure out what the hell to do next.

For all their do-or-die devotion to their dream, when fame and fortune finally come sniffing around, Chazz and the boys are man enough to refuse to sell out. Chazz proves that he is loyal to his girl, has an unshakable faith in the spirit of rock and roll, and knows that the real measure of a man lies in his ability to stand firm in the face of temptation and remain true to his heart.

Watch this movie when your boyfriend hasn't been holding up his end of late and you're feeling a bit prickly about it. It'll give you a good laugh, and who knows? It just might help you see that your guy's seemingly illogical behavior might be a manifestation of his loyalty to his principles rather than just another boneheaded stunt.

Masculine Laments

*Women! I feel like I've been placed in the delete
bin of life next to Mahogany Rush.*

★ Mike Myers as Wayne Campbell in *Wayne's World 2*

*I always just hoped that, that I'd meet some nice
friendly girl, like the look of her, hope the look of
me didn't make her physically sick, then pop the question, and,
um, settle down and be happy. It worked for my parents. Well,
apart from the divorce and all that.*

★ James Fleet as Tom in *Four Weddings and a Funeral*

■ *Mr. Lucky* (1943)
Stars: Cary Grant, Laraine Day, Gladys Cooper, Charles Bickford
Director: H. C. Potter
*Writers: Milton Holmes, Adrian Scott, based on a
story by Milton Holmes*

Joe "The Greek" Epinopolous (Cary Grant) is a little too quick to come up with easy money schemes that are surefire win-win scenarios, so wartime fund-raiser Dorothy Bryant (Laraine Day) refuses to trust his motives at first. And somehow, with that clipped accent and command of Cockney rhyming slang, he just doesn't look like an Epinopolous, even if that is what it says on his ID. But despite some initial skepticism, Dorothy quickly finds herself charmed by good ol' Joe and full of excuses for him. Really—how can she think poorly of a man who is secure enough in his manhood to knit in public, and proudly purl for the war effort?

Because Dorothy believes in him, Joe begins to see himself through Dorothy's eyes and starts discovering that he's not quite as mercenary as he thought he was. Suddenly he can conceive of a cause besides saving his own skin and keeping himself in fine suits, fedoras, and profit-generating gambling boats. Those unnerving Uncle-Sam-Wants-You posters are starting to get to him, and Dorothy's refusal to see Joe as the grubby-faced, hungry, and desperate street kid he feels like deep down inside makes him start thinking about a new self-definition. But does Joe have the courage to turn legit and serve his woman, his country, and his conscience?

Now, we all want to believe that the love of a good woman combined with a little spiritual uplift can soothe the troubled soul of a ne'er-do-well and transform him into heroic leading man material. And it's true, having faith in a man can bring him further than he ever thought he could go. But in real life, reforming bad boys isn't so easy— especially when they're con men with false IDs and the Feds on their tail. In fact, bad boys rarely change no matter how much faith you place in them, so it's probably a better idea to hedge your bets and instead of trying to change him, invest a few hours in nurturing yourself.

▪ *Carnal Knowledge* (1971)
Stars: Jack Nicholson, Ann-Margret, Candice Bergen, Art Garfunkel
Director: Mike Nichols
Writer: Jules Feiffer

Two college chums square off in a battle over opposite approaches to love, higher education, and the opposite sex in this ode to male rivalry and the power of puberty to dominate the lives of men whether they are eighteen or eighty.

Jonathan (Jack Nicholson) is a big man on campus, and for good reason. He's rakish, he's funny, and he's very sexy. He's got the most adorable feckless schoolboy grin you ever did see, one of those unmanageable forelocks that falls in his eyes just so, and way down deep inside, he really, really can't stand women. What red-blooded American codependent coed could ask for anything more?

Sandy (Art Garfunkel), on the other hand, is the opposite of Jonathan in every way and as a consequence is very unpopular with the ladies. He's unpolished, unfunny, has no sexual confidence, his life thus far seems to have been one long and continuous bad hair day, and way down deep inside, he really, really likes women. Or does he?

This movie begins as a cautionary tale about how women should never jilt a nice but funny-looking guy in favor of a bad but rakishly handsome one. It winds up teaching us, however, that the only difference between a nice boy and a bad boy is the quality of his hair, which can be quickly compensated for with a license to practice medicine and a fancy Italian sports car. So the only carnal knowledge worth having is to leave the nice boys and the bad boys behind, and find yourself a full-grown man.

Boy Talk

Lou Gehrig (Gary Cooper): What does it mean when a girl says you remind her of a Newfoundland puppy?

Sam Blake (Walter Brennan): Well, if it was an Airedale, that would be bad. Or a police dog—that'd be fatal. But a Newfoundland puppy? I'd see her again if I was you.

★ from *The Pride of the Yankees*

▪ *Wayne's World 2* (1993)
 Stars: Mike Myers, Dana Carvey, Tia Carrere, Christopher Walken,
 James Hong, Larry Sellers, Michael A. Nickles
 Director: Stephen Surjik
 Writers: Mike Myers, Bonnie Turner, Terry Turner, based on characters created by Mike Myers

Most of us would tend to dismiss the relationship potential of basement metalheads who drive AMC Pacers that they refer to as "The Mirthmobile," and who busy themselves

with grandiose plans for mega rock concerts to be held on the outskirts of Aurora, Illinois. But *Wayne's World 2* reminds us that underneath that grungy baseball cap we might discover a man of inestimable loyalty and vision who is willing to engage in gravity-defying Bruce Lee–like showdowns with anyone who threatens our happiness.

Wayne Campbell (Mike Myers) isn't a total slouch. He has, after all, managed to purvey his budget cable show—filmed at the Acme Doll factory in Aurora with a crew of two along with his sidekick, Garth (Dana Carvey)—into a local cult phenomenon. His girlfriend Cassandra's (Tia Carrere) rock-and-roll career, of which he is endlessly supportive, is taking off, and the two of them go together like Fender Strats and Marshall stacks. But complications ensue when a skeevy record producer (Christopher Walken) blows into town, and Cassandra's patriarchal papa (James Hong) arrives from Hong Kong, and a naked Indian (Larry Sellers) starts invading Wayne's dreams, leading him across desert dunes to Jim Morrison (Michael A. Nickles), who insists that Wayne launch a mega rock concert featuring the most awesome array of bands since Ozfest. Can Wayne remain true to his vision, resist giving in to jealousy, and win over Cassandra's dad? Or will he lose faith, and find himself in an Aurora state of mind?

This is the perfect movie to watch when you're feeling skeptical about the opposite sex. *Wayne's World 2* teaches us that even a guy with a mullet, a goofball sense of humor, and a flame decal on his Pacer can be the emotional equivalent of Pierce Brosnan in a tux.

Chapter 4

Light My Fire: Sex and Sensuality Movies

The birds do it and the bees do it, so why does doing what comes naturally sometimes seem so difficult for us? Well, let's face it, we've got a few issues to overcome when it comes to sex that the birds and the bees don't have to deal with. Some of us are so worried about whether he'll notice the size of our thighs that we have trouble losing ourselves in passion. Some of us are just beginning to explore sexuality and want to share a sexy movie with our new partner. And some of us could really use some creative ideas about how to breathe new life into a long-term relationship.

So if you've been feeling lately that you'd like to increase your pleasure potential, or you want to experiment with a few variations on a main theme, these Sex and Sensuality Movies are guaranteed to get those sparks flying between you and your couch mate, whatever phase of the mating game you find yourself in. They will remind you that eroticism is in the eye of the beholder, and that the most important erogenous zone is that little voice inside your head that tells you that you're sexy just the way you are.

Striking the Match

Are you ready to strike the match and ignite the first sparks of passion in your love life, but insecure because you operate under the principle that only classically beautiful people can take their clothes off in front of other people (unless there's a total eclipse of the sun)? Have you been feeling that sensuality is the exclusive domain of the under-thirties, or working under the mistaken belief that sexuality does not exist in the forest unless there's a naked man beside you? If so, watch one of these Striking the Match Movies about women who burn up the screen with the sensual power of self-acceptance. They'll help you to realize that beauty is in the eye of the beholder, that there is indeed a lid for every pot, and that the most powerful aphrodisiac in the world is a positive self-image.

▪ *Hairspray* (1988)
 Stars: Ricki Lake, Sonny Bono, Ruth Brown,
 Debbie Harry, Divine
 Director and Writer: John Waters

Tracy Turnblad (Ricki Lake) has the biggest bouff in Baltimore, and a waistline to match, but that doesn't stop her from becoming a teen dancing queen, landing the heart of the cutest boy in school, becoming a spokesperson in favor of integration and other socially responsible philosophies, debuting as a lingerie model, and ultimately snagging the title of Miss Auto Show 1963. How's that for a résumé? Not bad for a chunky teen from the burbs who casts her unflinching inner light upon our cultural notions of what is and is not sexy. In a *Hairspray* world, big hair and big women are sexy. So are big men in tight dresses. Turnoffs include segregation and the wet look. This movie illustrates, as only John Waters can, that if we can free ourselves from our cultural definitions of what is beautiful, then we can find beauty in some of the most unexpected places.

If you need to breathe some new height into your bubble do, do the mashed potato with Tracy Turnblad, the indomitable fat girl who makes all of her dreams as well as her social utopian visions and sexual fantasies come true through the sensual force of her personality.

Get Out of My Hair Space

Tracy (Ricki Lake): I'm an integrationist.
 We shall overcome someday.
Beatnik Chick (Pia Zadora): Not with that hair,
 you won't.

★ from *Hairspray*

Make a wish, and see yourself on stage, inside out. A tangle of gar-
lands in your hair. Of course you are pleasantly surprised.

★ Ewan McGregor as Curt Wild in *Velvet Goldmine*

Miss Truvy, I promise that my personal tragedy will not interfere
with my ability to do good hair.

★ Daryl Hannah as Annelle DeSoto in *Steel Magnolias*

I think tomorrow is a say-something-hat day.

★ Patrick Swayze as Vida Boheme in
To Wong Foo, Thanks for Everything! Julie Newmar

■ **The Thomas Crown Affair** (1999)
Stars: René Russo, Pierce Brosnan, Denis Leary
Director: John McTiernan
Writers: Leslie Dixon, Kurt Wimmer, based on a story by Alan Trustman

It's not often that Hollywood lets an over-forty actress be frankly sexual and smart
to boot, but in this movie about a hunter and her prey, René Russo is allowed to be

brilliant, sexy, confident, successful—and even vulnerable. Well, okay, her weak moments *are* fleeting. Mostly she spends the movie kicking Pierce Brosnan's butt (psychologically speaking, that is) until he has to admit he's been outmaneuvered—and has fallen madly in love with her.

Insurance investigator Catherine Banning (René Russo) is a consummate professional, ever in control, but when she's called upon to investigate an art theft she quickly begins an erotic game of cat and mouse with Thomas Crown (Pierce Brosnan), a man who sinks a yacht for the fun of it, or steals his favorite Monet painting just so he can spruce up his bachelor den. Moreover, he bears an uncanny resemblance to James Bond, dances divinely, and was clearly born in a tux.

Catherine has a delicious time tantalizing Crown. She even crashes fancy parties and dances in front of him with erotic abandon until he can't resist her for another second. Yes, the delectable Crown is intoxicated by Catherine, and who can blame him? She appreciates his alpha male appeal, not to mention his taste in fine art, she's supersmart and totally confident, and isn't intimidated for a moment by his money or his power. All right, so the blond twentysomething at his side is a bit disconcerting to Catherine, but we somehow feel certain that Thomas Crown knows the difference between a trophy wife and a warrior woman, and that the latter is a far superior companion.

Now it's true, not all of us who are hovering around forty years of age have quite the bod or the bone structure of René Russo. But even so, what makes her a role model for sensuality isn't her visage or physique so much as her wit and self-confidence. So pop this one in when you've seen one too many Britney Spears videos and need a reminder that while bubbleheaded pubescent waifs can have sex appeal, true sensuality is the province of full-grown and substantive women.

👁️👁️ *So Nice They Made It Twice:* Much as we enjoyed Faye Dunaway's calculatingly cool performance in the 1968 original, the newer version—and René Russo—is infinitely more steamy.

> ⚠️ *Warning Label: Appreciators of fine art will be disheartened by the hey-it's-only-overpriced-wall-decoration attitude here.*

Bods We Don't Buy

Sandra Bullock in *Miss Congeniality*

Yeah, so she can wrestle a man to the ground, but we can't imagine that a gal who lives on hero sandwiches and doughnuts, and is past that first post-teen metabolism shift, would fill out a bathing suit or minidress like the buffed and underweight Ms. Bullock.

Michelle Pfeiffer in *The Story of Us*

Aside from the occasional power walk, this suburban soccer mom spends her days sitting at a computer or driving her two preteens around, drinks a lot of red wine, and yet she's got absolutely no body fat and a bony figure so delicate it looks like she could float away in a sea of overflowing soapsuds from the washing machine. Everyone knows that L.A. is super body conscious, but please—does this woman *never* touch barbecue, chips, or ice cream?

Holly Hunter in *Living Out Loud*

Doctors' wives on Manhattan's Upper East Side can tend toward the birdlike when it comes to their figures, because they nibble on salads and tone their muscles at outrageously expensive gyms, but those extraordinarily husky biceps seem to be borrowed from Linda Hamilton in *Terminator II*. Last time we checked, building up bulging biceps wasn't exactly a hot trend among the ladies in the French poodle belt.

Bods We DO Buy

✳ The gorgeous swimsuit models in *Neptune's Daughter* (1949), who have visible cellulite *and* thighs that touch. And what's more, their boss, female bathing suit designer and entrepreneur Eve Barrett (Esther Williams), cheerily advertises that the suits she sells go up to size twenty.

✳ The ever plucky, Mars-Bar-and-beer-loving Bridget Jones in *Bridget Jones's Diary.* We admire actress Renée Zellweger for putting on twenty-five pounds for the role, but we've got to say, with as much fuss as the press made about her weight gain, we were expecting a little more bloat for our buck.

✳ Liz Bailey, played by Queen Latifah, looking like the Wittendorf goddess meets Rita Hayworth, in *Living Out Loud.*

▪ ***Where Angels Fear to Tread*** (1991)
Stars: Helen Mirren, Helena Bonham Carter,
* Rupert Graves, Judy Davis, Giovanni Guidelli*
Director: Charles Sturridge
Writers: Tim Sullivan, Derek Granger, Charles Sturridge,
* based on the novel by E. M. Forster*

This movie is yet another in a long line of Merchant Ivory period pieces about uptight Victorian British women who go to Italy, discarding centuries of culture-wide sexual

dysfunction to plumb the depths of their sensuality with a really handsome Italian guy. Said Italian guy usually has lips like the finest Amarone, eyes as dark as the salubrious soil of Tuscany, arms like Michelangelo's David, and absolutely no marketable skills whatsoever. Forbidden passion and social isolation results.

And so it is with this lavish morality play, featuring Lilia Herriton (Helen Mirren), a frustrated widow starved for the richness of life and love by the sallow morals and soggy sandwiches of her dead husband's family. She embarks on a trip to Italy, ostensibly to put the roses back in her cheeks, but mostly because nobody knows quite what to do with a widow who's starved for the richness of life and love and who has a deep-seated antipathy for watercress sandwiches. She is chaperoned on her journey by Caroline (Helena Bonham Carter), a stilted but sensitive matron who looks like she hasn't seen the sun in the better part of three decades and has been protein deprived to boot.

Almost immediately Lilia meets and falls in love with, you guessed it, a really handsome Italian guy who has lips, eyes, arms, etc., and who is also twenty years her junior (Giovanni Guidelli). And he's a dentist, which is a slight departure, although given the probable state of turn-of-the-century Italian dentistry, maybe not really.

As one might imagine, soon there are not only roses but profuse peonies blossoming in Lilia's cheeks. She marries her "lovely boy" and moves to some drafty but terribly picturesque villa in the countryside, resolving to spend the rest of her life drinking in those heady lips by the caskful.

Sounds like paradise, right? Wrong. Because Lilia forgot rule number one in the *Cinematherapy Field Guide to Guys for Victorian English Widows Abroad*, which clearly states that there's more to marriage than Italian sex, and that even forbidden passion gets boring if you can't make new friends and invite them over for tea parties.

This is a great movie to watch when you're weighing the pros and cons of your own celestial infatuation. Let Lilia remind you that it's perfectly fine to date your wildest Michelangelo fantasy and embark on a trip to paradise for two. But before you marry your pre-Raphaelite angel, you had better look past his exquisitely chiseled swells and hollows, and see if you two share more than a fondness for Aristotelian geometry and a high-altitude-induced euphoria. Because good matches aren't made in heaven, but with your feet firmly planted in the earth.

▪ *A Hard Day's Night* (1964)
 Stars: John Lennon, Paul McCartney, George Harrison,
 Ringo Starr, Wilfrid Brambell, Victor Spinetti
 Director: Richard Lester
 Writer: Alun Owen

There's nothing like crowds of screaming, bacchanalian prepubescents to remind us all that wild abandon and a willingness to trample over all manner of barriers is a surefire route to ecstasy—and that unconsummated schoolgirl crushes are, let's face it, a really fun form of safe sex.

So how did the Beatles manage to flip our wigs and our switches with the mere shake of a mop top or a harmonic high note? Well, as *A Hard Day's Night* proves, there's something incredibly sexy about men who aren't afraid to wear their hair long and their trousers tight. Yeah, yeah, yeah, we know, their magic was more than that—even decades later we can't help sighing over their lovable cheekiness, their disdain for stuffy rules of conduct, their unwillingness to suffer fools, and, of course, their revolutionary music that speaks to the heart, the mind, and the nether regions all at the same time.

Richard Lester's movie so perfectly captures the Fab Four's energy, style, and wit that *A Hard Day's Night* seems more like a documentary than a fictional depiction of a day in the life of four harried lads who just want to have fun. Chased all over Britain by screaming girls, the Beatles—just as they did in real life—dive into limos and hide out in hotel rooms. For all their creative getaways, we're all in on the secret that—at least on-screen—they love being pursued and would probably really enjoy being caught. Still, the twentysomething "lads" from Liverpool always remain a few steps ahead of the much younger girls, a fact that, when combined with their boyishness, gentleness, and unthreatening sexuality (after all, they just want to hold our hands), makes them safe targets for unbridled girlish passions. Yes, we gals can take comfort in knowing we'll never catch them and have to do the scary work of figuring out what to do next. We can just have fun lusting from afar.

Okay, so we're all adults now, and we're supposed to be beyond swooning over unattainable pop culture icons. But hey, whenever we're obsessed by erotic fantasies about an

unavailable man, it's fun to watch this totally "gear" film and remind ourselves that there's nothing foolish about occasionally indulging in sex from a totally emotionally safe distance. So hide yourself behind locked doors, set aside your inhibitions, and orgasmically scream your favorite mop top's name whenever he appears on-screen. Whooooooooo!

Reel to Real

Model/actress Patti Boyd, hired to play one of the swooning Beatles fans in *A Hard Day's Night*, later married George Harrison.

Fanning the Flames

Just like soft light, soul music, and a rich and resonant Amarone Valpolicella bottled in the salubrious hills of Tuscany, a steamy and sensual movie can help put you in the mood for love. So if you're ready to fan those first flickers of passion into a roaring blaze, then crack open the wine and let it breathe, snuggle up on the couch together, watch one of the Fanning the Flames Movies featuring couples who really turn the heat on, and burn, baby, burn.

■ *Immortality* (1998) (*also titled* The Wisdom of Crocodiles)
 Stars: *Jude Law, Elina Löwensohn, Timothy Spall*
 Director: *Po-Chih Leong*
 Writer: *Paul Hoffman*

Okay, so anything with Jude Law in it is going to be hot on a certain level, but this new twist on the vampire theme manages to be thematically resonant, visually stunning, lyrical, philosophically relevant, morally responsible, and totally steamy all at the same time.

Steven Grlscz (Jude Law) is a vampire with modern malaise and is as short on real human emotion as he is on vowels in his last name. He stalks the outback of urban alienation hunting for women with crippling self-esteem issues to feed his insatiable appetite for the love and devotion in their blood. Beautiful, tortured, enigmatic, and sexually ambiguous, Steven is an emotional vampire, a creature of the night that a girl just can't resist, and one by one these disappointed and emotionally wounded women fall prey to his lethal instant intimacy. But then Steven meets Anna Levels (Elina Löwensohn), who is also beautiful, tortured, enigmatic, and sexually ambiguous, and this time it is Steven himself who must decide whether to sacrifice himself for love or continue to feed on the woman he has found to finally love him.

Okay, so Steven Grlscz is like a walking metaphor for a narcissistic personality disorder, and his victims are the embodiment of weapons-grade codependence, but for God's sake look at the guy. He's the most adorable human parasite we have ever seen on a screen, and who cares if you can't pronounce that last name. Steven Grlscz has joined Louis and LeStat in our top ten vampires we'd be willing to become undead for.

Come on . . . admit it. Bloodsuckers though they may be, vampires are sexy. There's just something about an aristocratic guy in a cape opening our jugular and gorging himself that makes our hearts go all aflutter. So if you're in the mood to be devoured whole, watch *Immortality* and indulge in the forbidden pleasures of the night without having to get a transfusion, and let Steven's crocodile tears remind you that much like good living, good loving begins with letting go.

Reasonable Demands

Oh, Clem, make an earthquake for me.
 ★ Deborah Kerr as Priscilla Effington in *Dream Wife*

Bev's Culinarytherapy: Nude Food

As everybody since King Solomon knows, there's a very thin line between food and sex, so when you're in the mood for a feast of the senses, loosen those apron strings and whip up something sticky, then eat it with that someone special, clad only in your birthday suits.

Sticky Buns

Please—they come in ready-made rolls in every grocery store, so grab a tube, bake your buns until they're golden brown, and smear the icing all over yourselves. And be sure to eat two. They're small.

▪ ***The End of the Affair*** (1999)
Stars: Ralph Fiennes, Julianne Moore, Stephen Rea
Director: Neil Jordan
Writer: Neil Jordan, based on the novel by Graham Greene

Ralph Fiennes can smolder better than just about any actor we know, and in this movie about a man still angry and wounded after his lover cut him off years previously, he's explosively sexy. Maurice Bendrix (Ralph Fiennes) finagles his way into a PI job investigating the extramarital activities of a British wife (Julianne Moore) who, unbeknownst to her husband (Stephen Rea), has indeed been unfaithful to him—with Maurice. While the Germans were dropping bombs all around them, Sarah (Moore) and Maurice engaged in all sorts of naughty, impetuous behavior, like sliding garters off her legs and "christening" the staircase, and making rash promises that ultimately led to their breakup.

This entire movie seems to take place in the fading golden glow of the afternoon and portrays forbidden passion as exquisitely painful and emotionally addictive, and as hauntingly beautiful as Ralph Fiennes's gray-blue eyes. Face it, reckless abandon is hot. But if you'd prefer not to suffer the emotional equivalent of an Axis forces' bombing afterward? Cuddle up with your honey, watch this movie together, and enjoy the heat in your own living room.

👀 *So Nice They Made It Twice:* The 1955 version with Deborah Kerr and Van Johnson can't quite live up to the eroticism of Neil Jordan's direction or Ralph Fiennes's brooding.

Stupid Guy Quotes

Ah, button the lip and give me the body.
★ Lee Bowman as Buzzy in *Having Wonderful Time*

Your sister's very beautiful . . . but you're more beautiful. Mind you, I've seen plenty of beautiful women all over the world. The most beautiful ones are the Turkish women. They've got their faces covered so you can use your imagination.
★ Errol Flynn as Frank Medlin in *The Sisters*

First we'll have an orgy. Then we'll go see Tony Bennett.
★ Elliott Gould as Ted Henderson in *Bob & Carol & Ted & Alice*

■ *High Art* (1998)
Stars: Ally Sheedy, Radha Mitchell, Gabriel Mann,
Patricia Clarkson
Director and Writer: Lisa Cholodenko

Ally Sheedy stars as Lucy Berliner, a talented photographer with an illustrious past, a formidable heroin habit, and a girlfriend, Greta Albert (Patricia Clarkson), who is like a character out of one of your wildest Lina Wertmuller fantasies. The combination of the above has taken Lucy far away from her art, and from the public acclaim she enjoyed in the eighties before the bill for her sex, drugs, and disco came due. Then one day, out of the blue, Lucy's life changes when Syd (Radha Mitchell), her beautiful, blond, straight, and bored downstairs neighbor—who also happens to be an up-and-

coming editor for an arty photography magazine—wanders into Lucy's apartment to investigate a leak.

A leak indeed. If this sounds like the setup for an art house lesbian soft porn flick, that's because it is. Fed up with her boring boyfriend, her boring assistant editorship, and her boring life, Syd is immediately attracted to Lucy's heroin chic, and resolves to put Lucy back in touch with her creativity and her public, and catapult her own career in the process. Many darkly compelling and narcotic-induced, euphoria-laden love scenes ensue, which are almost hot enough to make you forget that what you're witnessing is less about love between two women as it is about Lucy's infatuation with death. But if you're in the mood for a walk on the wild side, indulge vicariously with *High Art*, and experience the euphoria without having to go through withdrawal.

▪ *Sea of Love* (1989)
 Stars: Al Pacino, Ellen Barkin, John Goodman
 Director: Harold Becker
 Writer: Richard Price

Feeling the need to turn up the heat in your living room? See if this one doesn't raise the temperature a few degrees.

Al Pacino plays Frank, a divorced homicide detective in the throes of a major midlife crisis who goes against his better judgment and starts dating a murder suspect, Helen (Ellen Barkin). Frank falls hard for this single mom in stilettos despite the fact that she may well be a black widow with a penchant for shooting her lovers execution style after she's been satisfied. How can he help it, when she keeps flashing that crooked smile at him? And then, when she rubs up against him in steamy scene after scene, we find ourselves moaning and groaning too, and we start musing about whether Al ought to make fewer gritty boy movies and do a little more bumping and grinding on-screen.

Admittedly, the character motivations in this thriller get awfully fuzzy, and we guessed right off what was up with all the postcoital brutality, so the femme fatale angle didn't make the sex feel quite as dangerous as it ought. Yet somehow we were too caught up

in wondering how it feels to run one's fingers through that delightful thicket of hair on Al's head to care.

And hey, can we just vent a little about booty parity? We get to see Barkin's top half, but just how delightful Mr. Pacino's derriere looks without his pants on remains a mystery. No fair!

⚠ Warning Label: *Movies that begin with someone being brutally murdered while lying naked on the bed usually turn us off immediately, but this movie has such sexy scenes of passion that we suggest you just cover your eyes until the detectives show up at the crime scene a minute or two into the film.*

World-Class Rants

It's inevitable. It's the wear and tear of the job. The diapers, the tantrums, the homework, the state capitals, the kingdom, phylum, genus, species, your mother, his mother, and suddenly all you're aware of is that there are too many wet towels on the floor, he's hogging the remote, and he's scratching his butt with a fork. And finally you come face-to-face with the immutable truth that it is virtually impossible to French-kiss a person who takes the new roll of toilet paper and leaves it on top of the empty cardboard roll. Does he not SEE it? Does he NOT SEE IT?!!! Marriage is the Jack Kevorkian of romance.

★ Rita Wilson as Rachel in *The Story of Us*

▪ *The Postman Always Rings Twice* (1981)
 Stars: Jack Nicholson, Jessica Lange,
 John Colicos, Anjelica Huston
 Director: Bob Rafelson
 Writer: David Mamet,
 based on the novel by James M. Cain

This atmospheric neonoir film contains some of Hollywood's edgiest screen sex. And legend holds that Jack and Jessica weren't just acting. Whether or not this is true, we're here to tell you, watching the sex scene on the bread table really expanded our ideas about what you can knead on a marble slab. And we've never looked at a flour sifter the same way since.

Jack Nicholson stars as Frank (of course, his name would be Frank), a classic down-on-his-luck drifter with a pocket full of lint and a heart of gold, who appears like a five o'clock shadow at a roadside gas station. Nick (John Colicos), the aging station owner, has a much younger wife, Cora (Jessica Lange), who is beautiful, terminally insouciant, and obviously brimming with repressed sexual energy. Irresistibly drawn to each other, and in the throes of an epic sexual compatibility, Frank and Cora conspire to murder Nick, take over the gas station, and live happily ever after redefining work surfaces, eluding prosecution, and becoming a cautionary tale about the terrible karmic consequences of allowing our passions to overrule our better judgment.

This movie is cinematic sin served à la mode. And it's just as delicious as it is dangerous. So if you're in the mood to get your hands dirty, watch *The Postman Always Rings Twice* with your soulful drifter, and make some dough rise. Just make sure you don't scald the yeast.

👀 *So Nice They Made It Twice:* The 1946 Lana Turner/John Garfield version is classic noir suspense, but there's more passion in their fighting than their kissing. Still, if you're studying to be a stylish femme fatale, the original is required viewing.

Best Bodice-Ripping Lines

*Paris! Sleeping while the moon keeps watch. Oh,
what fools people are to waste the moonlight
in sleep . . . And there's Montmartre, where
artists live and dream. There it is, at your feet,
where all the world should be.*

★ Cary Grant as Andre Charville in *Suzy*

*I've never loved anybody this way. Never looked at a woman
and thought, if civilization fails, if the world ends, I'll still
understand what God meant.*

★ Jack Nicholson as Will Randall in *Wolf*

*I would rather have had one breath of her hair, one kiss from her
mouth, one touch of her hand, than eternity without it. One.*

★ Nicolas Cage as Seth in *City of Angels*

*I have, let's see, only eight hours to learn by heart how your
eyelashes are tangled, the way your hair smells of jasmine, and
how just one corner of your mouth smiles as if it had a secret.*

★ Cary Grant as Andre Charville in *Suzy*

*Surely you and I are beyond speaking when words are clearly not
enough.* ★ Jonny Lee Miller as Edmund Bertram in *Mansfield Park*

I came across time for you, Sarah. I love you and I always have.

★ Michael Biehn as Kyle Reese in *The Terminator*

continued . . .

Best Bodice-Ripping Lines

You have allowed me to hope as I never scarcely allowed myself hoping before, dearest, loveliest Elizabeth.

★ Colin Firth as Mr. Darcy in *Pride and Prejudice*

■ **One Night Stand** (1995)
Stars: Ally Sheedy, A Martinez
Director: Talia Shire
Writer: Martin Casella

This female-directed movie is stylish, sensual, and ultrasteamy, so while it's unfortunate that the movie turns into a standard-fare thriller toward the end, hey, by then the two of you will probably be too busy exploring your erotic potential to care.

Mickey (Ally Sheedy) is in mourning for her mother, deep into the winter of her personal discontent, when she meets a sexy guy (A Martinez) on her girls' night out. Overdue for reconnection with the life force and her inner Aphrodite, she's more than ready for a one-night stand; in fact, she doesn't even want to know her lover's name. Of course, many burning candles, whispered confessions, creative uses of wine, and Spanish guitar flourishes later, she starts thinking that maybe she'd like this guy to stick around a bit longer. After all, he's intense, mysterious, smoldering about something, sensitive to the cries of babies in distress, and intoxicated with her womanly essence. And the thing he does with the wine is definitely worth repeating.

Suddenly, it is springtime for Mickey—the flowers are in bloom, and she's donning kicky little skirts and looking forward to another night of "the blood of the grape," but then it all gets so complicated. Lucky for Mickey, by this point she actually knows her lover's name, so there's hope that this liaison can withstand an annoying series of plot twists about a murder and fully blossom into a rich romance.

Ready to take it slow and easy? Pop in *One Night Stand*, open some "blood of the grape," and see what transpires with your own man of mystery.

Manly, Yes, but Ladies Like It Too:
Only His Hairdresser Knows for Sure

Every once in a while, Hollywood throws caution to the wind and bends the gender rules for its screen heroes, allowing them to look damn good in a little black dress and a pair of pumps and still be *muy macho*. It's too bad there's a double standard where our screen heroines are concerned. But if you're in the mood to kick off your pumps and bend the rules, watch one of these movies featuring stiletto-heeled heroes who remind us all that it's not the clothes that make the man, and what's good for the goose is good for the gander, and vice versa.

The Rocky Horror Picture Show (1975)
Stars: Tim Curry, Susan Sarandon, Barry Bostwick,
 Richard O'Brien, Patricia Quinn, Nell Campbell, Meat Loaf
Director: Jim Sharman
Writers: Richard O'Brien, Jim Sharman, based on the play by
 Richard O'Brien

Nothing puts the USDA stamp of approval on gender bending like *The Rocky Horror Picture Show*'s corseted and fishnetted sweet transvestite from transsexual Transylvania. Dr. Frank-N-Furter (Tim Curry) waylays Brad (Barry Bostwick) and Janet (Susan Sarandon), two bonnet- and bow-tie-wearing stranded motorists, and puts them in touch with their inner disco queens.

Frank-N-Furter and his merry band of Studio 54-inspired disciples encourage Brads and Janets everywhere to throw off their bonnets and bow ties, and take a big jump to the left, by demonstrating that wearing a merry widow and red lipstick doesn't make you any less of a man.

continued . . .

Performance (1970)
Stars: *Mick Jagger, James Fox, Anita Pallenberg, Michèle Breton*
Directors: *Nicholas Roeg, Donald Cammell*
Writer: *Donald Cammell*

Nobody bent gender rules quite like Mick Jagger. In fact, nobody bent *any-thing* quite like Mick Jagger, who shows us in this curious cinematic blend of macho neonoir and sixties psychedelia that you can wear a silk caftan, rouge your lips, sleep with both men and women, live in a house where gender rules are completely ignored, and still be a stud.

When Chas Devlin (James Fox), a hit man on the run, rents the base-ment in a Soho flat, he inadvertently enters into a strange cat-and-mouse game with his landlord, Turner (Mick Jagger). By the time Turner and his live-in girlfriends, Pherber (Anita Pallenberg) and Lucy (Michèle Breton), are done with Devlin, this typical tough guy from the wrong side of town is wear-ing a wig and heels and a bad shade of orange lipstick. But he can still roam the mean streets with the best of them, even when all the rules of sexual alternate-side parking have been suspended.

Velvet Goldmine (1998)
Stars: *Ewan McGregor, Christian Bale, Jonathan Rhys-Meyers,*
 Toni Collette
Director: *Todd Haynes*
Writers: *Todd Haynes, James Lyons*

Bowie-esque pop star Brian Slade (Jonathan Rhys-Meyers) stages his own fake murder during a concert. Ten years later, journalist and former fan Arthur Stewart (Christian Bale) goes in search of his fallen icon, to prove that his favorite glam rock star is still alive. In the end, Arthur manages to resurrect Slade, and his own forgotten fabulousness, and remind us all in the process that inside every starch-collared and blue-suited macho man is a little bit of glamour.

Words to Live By

Tracy, we all have responsibilities in life. You may think owning the Hardy-Har joke shop is all drudgery: unwrapping dribble glasses, checking doggy doo. But I wuv it.

★ Jerry Stiller as Wilbur Turnblad in *Hairspray*

Women defend themselves by attacking. It's just that they attack by sudden and strange surrenders.

★ Jonathan Rhys-Meyers as Brian Slade in *Velvet Goldmine*

Don't dream it, be it.

★ Tim Curry as Frank-N-Furter in *The Rocky Horror Picture Show*

Rekindling the Embers

If you're struggling to rekindle the embers of passion into a roaring blaze in your long-term relationship, but sex has become about as routine and predictable as balancing your checkbook—or if you're just reentering the world of sexuality after an extended leave of absence from love—watch one of these Rekindling the Embers Movies. They'll help you see where you and your partner may have gone astray on the road to passion, and figure out how you can get back onto the freeway of sensual love.

▪ *Boys' Night Out* (1962)
 Stars: Kim Novak, James Garner, Tony Randall,
 Howard Duff, Howard Morris
 Director: Michael Gordon
 Writers: Ira Wallach, adaptation by Marion Hargrove, based on a
 play by Arne Sultan and Marvin Worth

In this flick, four puerile fellows *think* they want an "easy" blond gal with a great figure—no strings attached, just a discreet monthly payment for their share of a bachelor pad in the city that their wives back in suburban Connecticut will never find out about. But as sociology grad student Cathy (Kim Novak) proves, male sexuality is a lot more complicated—and amusing—than it appears.

The trouble starts when three married junior execs (Tony Randall, Howard Duff, and Howard Morris) and their divorced pal Fred (James Garner) decide to split the costs of a New York City love nest and a swinging blonde, and they elect Fred to procure both. Reluctantly, he achieves his goal, unaware that the sexy blonde he's hired (Novak) is actually a grad student studying the sexual habits of middle-class suburban males. She knows exactly what these fellas truly desire: not Marilyn Monroe and a leather trapeze, but a good, hearty meal, an attentive ear, and a chance to prove their competence at fixing stuff around the house.

Eventually, all the wives, husbands, moms, students, and graduate advisers sort out what's been going on, and when everything simmers down, faith in monogamy is restored for all, as you'd expect from a comedy of the post-Eisenhower era. What's most interesting, though, is that the divorced man is portrayed as the emotionally mature one of the group, ready to propose marriage to a woman who is unapologetic about her promiscuous past. And we love that once she says "I do," Kim Novak retains her sensuality, cultivating a black leather jacket look. Obviously, there's one couple in the bunch who won't spend all their evenings playing bridge.

Now it's true, there's a little bit of man bashing going on here—we think that in real life there are plenty of guys who can think of more creative ways to spend their boys' nights out than drinking beer and fantasizing about hot babes. But we have to applaud a movie that

shows that sexuality doesn't have to wither away when you become husband and wife, and that women with a sexual past are desirable. Watch this movie when you're thinking irritably that guys just wanna get laid, and see if it doesn't inspire you to dig a little more deeply into what he wants in a romance—and in a lover.

> ⚠ Warning Label: *The script's blame-the-victim jokes about the former occupant of the bachelor apartment leave a disturbing aftertaste in these more enlightened times.*

Nancy's Momentous Minutiae: Silver Screen Goddesses

Jean Harlow eschewed lingerie, iced her nipples to make them stand out, and dyed her pubic hair blonde so it wouldn't show through when she wore her trademark clingy white gowns.

Howard Hughes designed a special seamless brassiere for full-figured gal Jane Russell to wear in the movie *The Outlaw*, but Russell secretly tossed out the uncomfortable contraption and just wore Kleenex over the seams of her own bra to obtain that smooth, cross-your-heart look.

Marilyn Monroe's classic skirt-over-the-subway-grate scene in *The Seven Year Itch* was semiaccidental: the fellow in charge of the wind machine created a blast instead of a breeze, and director Billy Wilder so enjoyed the result that he kept the footage in the film.

Sex goddess Mae West was forty-one when she made her first movie in 1933.

Like Crackers in Bed

9 ½ Weeks (1986)
Stars: Kim Basinger, Mickey Rourke
Director: Adrian Lyne
Writers: Sarah Kernochan, Zalman King,
 Patricia Louisianna Knop, based on the novel by Elizabeth McNeill

Sure, it all *sounds* sexy: lovemaking in front of the fridge with lots of dripping honey, or making out on a sample bed in Macy's. But then the camera lingers again and again on Kim Basinger's flawless face, impossibly long legs, and concave—yes, *concave*—tummy. Somehow, it's hard for us to identify with a woman who is always perfectly toned and coiffed, particularly when her psychological motivations and thought processes are completely incomprehensible. Meanwhile, Mickey Rourke always seems to have his clothes on—which, it's true, is probably a good thing—and he's always wearing an annoying smirk that no amount of kinky sex, violent quarreling, or change in locale or circumstance can wipe off his face. Nine and a half weeks? We'd dump this jerk in 9 ½ seconds.

▪ *The Blood Oranges* (1997)
Stars: Charles Dance, Colin Lane, Sheryl Lee, Laila Robins
Director: Philip Haas
Writers: Belinda Haas, Philip Haas, based on the novel by John Hawkes

We all feel pressure to stretch our imaginations and our comfort zones in order to keep the flames of passion burning in a long-term relationship. And this is when people get ideas about opening up the relationship to include new costumes, new positions, new situations, and sometimes, new people. But as *The Blood Oranges* clearly illustrates, more is not necessarily merrier, particularly when it comes to troubled monogamous relationships that start out triangulating, and wind up squaring off into a sexual game of musical partners that

leaves us all grateful for the simple equations of monogamy that don't involve multiplying dysfunction to the highest power.

Spouses Cyril (Charles Dance) and Fiona (Sheryl Lee) move to an unspecified but highly Italianized landscape to pursue their sexual fantasies. There they ensnare another married couple into their golden web of desire. All partake greedily in the "love lunch" until emotional botulism spoils the picnic and leaves everyone feeling a little queasy.

The Blood Oranges sets out to suggest that conventional monogamy is always codependent and therefore the enemy of love. The geometric tangle of feelings that emerges in this movie, however, actually implies that unless we're emotional trigonometrists with an advanced degree in group sex, it's probably a better idea to stick with simple equations. Watch this one when you're feeling trapped by your romantic routines and it'll make you feel a whole lot better about being boring and conventional. After this cinematic love lunch, tea for two never looked so good.

Shut Up and Kiss Me, You Fool

Jerry Warriner (Cary Grant): You're wrong about things being different because they're not the same. Things are different except in a different way. You're still the same, only I've been a fool . . . but I'm not now.

Lucy Warriner (Irene Dunne): Oh.

Jerry Warriner: So long as I'm different don't you think that . . . well, maybe things could be the same again . . . only a little different, huh?

★ from *The Awful Truth*

I realize that when I met you at the turkey curry buffet, I was unforgivably rude, and wearing a reindeer jumper.

★ Colin Firth as Mark Darcy in *Bridget Jones's Diary*

▪ *The Bliss of Mrs. Blossom* (1968)

Stars: Shirley MacLaine, Richard Attenborough,
James Booth
Director: Joseph McGrath
Writers: Alec Coppel, Denis Norden,
based on the play by Alec Coppel, from a story by Josef Shaftel

Tempted to ignore your sexual frustration? Here's a movie that proves that those powerful feelings won't go away so much as mutate into an uncontrollable desire to decorate one's home with garish pop art and single-handedly achieve world peace through the domination of the global underwear market.

In this farce from the *Magical Mystery Tour* era, everything is loud, colorful, and whimsical, from the art nouveau-meets-Peter Max home decor to Mrs. Harriet Blossom's (Shirley MacLaine) absurd decision to cure her suburban housewife ennui by stashing a working-class lover (James Booth) in her rather roomy attic. Her hubby, Robert (Richard Attenborough), is far too busy in his role as "Orpheus of the undie world," trying to design the ultimate brassiere, to notice that Harriet has become remarkably chipper of late. Nor does it register with him that she has replaced her wardrobe of high-collared, stiff-skirted maxi dresses with low-cut psychedelic chiffon minis.

Harriet delights in her newfound sexuality, and her career as a painter and her fantasy life flourish as her Carnaby Street wardrobe expands. Meanwhile, her befuddled husband feels guilty about neglecting her sexually and otherwise, signs off on the bills, and buys her a beagle so that she'll have a "man around the house," unaware that she's already got one, thanks. Anyway, the man in the attic starts itching to break out of his confines and begins showing up at Harriet and Robert's parties, much to Harriet's consternation. Eventually the truth comes out, but will Harriet be able to integrate her sexual and domestic lives? Can a suburban homemaker find passion with just one man, when all sense of forbidden love and danger is removed?

Thinking that you can go on indefinitely without losing yourself to passion? Check out this movie, which is a fun reminder that containment isn't so easy, so you probably ought to stop sublimating your urges and shopping till you drop and start rekindling the embers instead.

Like Crackers in Bed

Eyes Wide Shut (1999)
Stars: Tom Cruise, Nicole Kidman
Director: Stanley Kubrick
Writers: Stanley Kubrick, Frederic Raphael,
 based on the novel by Arthur Schnitzler

This is the most sexless movie ever made about sex, and despite the fact that the weird Gregorian chant thing that underscored the sex scenes enjoyed a brief moment in the spotlight throughout the coffee bars and discotheques of lower Manhattan, we don't think we're alone in saying that this was the cinematic equivalent of a cold shower or a slipped disk.

Tom Cruise and Nicole Kidman star as Bill and Alice Harford, a picture-perfect and apparently blissful Upper East Side Manhattan couple. He's a doctor, she's an art dealer, their kid looks like she belongs in an Ivory soap commercial, and everything they wear matches the decor wherever they go. One night, after one too many top-shelf highballs, Alice confesses a slight indiscretion she enjoyed with a sailor, which, despite the fact that it turns out to have just been an unconsummated fantasy, sends Dr. Bill into such a tailspin that he winds up at the heart of a secret society that promotes group sex with a de Sade–inspired period motif. Now, one would think that Tom Cruise in an S&M-inspired mask and cape would result in some kind of sensual mercury swell, but somehow the whole thing remains a pretty fluidless jaunt into the chafed world of male avoidance behavior.

■ *The Awful Truth* (1937)

Stars: Cary Grant, Irene Dunne, Alexander D'Arcy,
 Ralph Bellamy
Director: Leo McCarey
Writer: Viña Delmar, based on a play by Arthur Richman

It's often been said that the sexiest part of the body is the mind, and this is the movie that proves it. Without a single soft-focus/full-color/breast-baring/orgasm-faking modern love scene, and with only one on-screen kiss between the lovers (and that in the last reel), *The Awful Truth* features a married couple that sets off a shower of sexual sparks with every one-liner, droll observation, and sassy comeback.

Cary Grant plays squash-playing, eggnog-drinking, upscale married gent Jerry Warriner, and he gets along famously with his wife, Lucy (Irene Dunne), until one day when their mutual white lies come to light in front of a group of friends, and they start to experience that seven-year itch and a serious case of distrust. He can't quite buy her story about getting stuck out in the boonies overnight with her slick voice teacher, Armand (Alexander D'Arcy), and she discovers that the oranges he brought back from his Florida business trip are stamped with the seal of the California orange growers. Before you can say, "The road to Reno is paved with suspicions," divorce papers are being processed, and Jerry is filing a motion for court-appointed doggy visits to their pooch, Mr. Smith.

Lucy quickly finds herself a new beau, a hopelessly hick Texas mama's boy (Ralph Bellamy), who serves as perfect fodder for Jerry's witty put-downs. Rather than get mad she gets even, publicly embarrassing Jerry in front of his snooty new girlfriend, the heiress—an act that makes Jerry flirt with Lucy even more. The more outrageous their jabs and practical jokes, the more obvious it is that the two of them will eventually forget about divorcing, make peace, and find a hotel room already—like, say, in a cozy log cabin out in the countryside.

Are the home fires mere embers of late? Invest in a nice bottle of bubbly and a really warm, soft blanket and cuddle up to a movie that will make you feel frisky while reminding you that brains, wit, and clever banter can make any man a Cary Grant and any woman a love goddess.

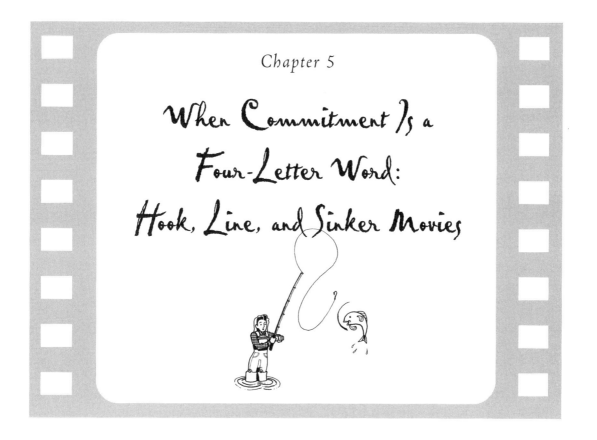

Chapter 5

When Commitment Is a Four-Letter Word: Hook, Line, and Sinker Movies

So you finally found a guy you can really care about and who seems to really care about you. He's sensitive, kind, compassionate, cute, smart, funny, sexy, and even gainfully employed. You both love candlelight dinners, long walks in the moonlight, and Olivia Newton-John ballads. You both want a house in the country, kids, and work that is personally fulfilling. And you're spending almost every night together anyway, so it seems perfectly logical that you would start to discuss a future together. Only the subject never seems to come up. Neither of you has dared to use the "C" word, let alone the "M" word, and the next thing you know, one of you is heading for the hills, and your Xanadu for two has turned into Butcher's Holler—scored by a Loretta Lynn ballad about the one who got away.

If one of you has been waiting to hear those magic words but the other is terminally tongue-tied, watch one of these Hook, Line, and Sinker Movies about couples who've taken the plunge and discovered domestic bliss—or learned the hard way about the high cost of holding back.

▪ *Shrek* (2001)
 Stars: the voices of Mike Myers, Eddie Murphy,
 Cameron Diaz, John Lithgow
 Directors: Andrew Adamson, Vicky Jenson
 Writers: Ted Elliott, Terry Rossio, Joe Stillman, Roger S. H. Schulman,
 based on the book by William Steig

This animated allegory about love and marriage demonstrates that even Disney-produced fairy princes and princesses aren't immune to self-esteem issues that can prevent them from forming committed relationships and living happily ever after.

Shrek (Mike Myers) is an ogre with an attitude who frightens away every friend or foe who happens by his lonely hut, because he presumes that they will judge his book by its unsightly cover. Convinced that the world will never see him as anything but an ugly green monster, Shrek retreats into a world of defensive posturing and isolating behaviors. Then he meets a wiseass donkey on the edge (Eddie Murphy), who goads Shrek into a reluctant friendship. Together they go on a mission to rescue the Princess Fiona (Cameron Diaz) and free the kingdom from a genocidal short guy with a blood lust for ridding the world of fairy-tale creatures. In the end, it is Shrek himself who winds up being liberated by his princess with a secret. She rekindles the courage to be vulnerable in Shrek's intimacy-conflicted heart.

This is a great movie to watch when your ogre goes green at the mention of happily ever after, retreats into his emotional swamp, and slams the door on your Disney-inspired destiny. *Shrek* will reassure you both that the ability to love begins with an ability to love yourself, that true love means never having to ask, "Do I look fat?," and that even in a land where fairy tales have been outlawed, miracles can happen if you aren't afraid to commit yourself to what you believe in and be open to the possibility that magic really can happen, even to an ogre.

▪ *About Last Night* (1986)
Stars: *Demi Moore, Rob Lowe, James Belushi, Elizabeth Perkins*
Director: *Edward Zwick*
Writers: *Tim Kazurinsky, Denise DeClue, based on the play*
 Sexual Perversity in Chicago *by David Mamet*

Back in the eighties, the motto of the urban American singles scene was have your fun and move on quickly before things get complicated. Sexual attitudes—and consequences—have changed a lot since then, but new lovers still struggle with those age-old questions: Where are we headed? Who's gonna cook dinner? Who should say "I love you" first, and does it count if you're both naked when it happens? And, of course, how does a gal fit his Naugahyde beanbag chair into her decorating scheme? (Note for to-do list: find out when bulk garbage day is.)

After a night of passion with a stranger she met in a bar, upwardly mobile twenty-something Debbi (Demi Moore) is pulling her underwear back on and trying to remember her new lover Dan's last name. For his part, Dan (Rob Lowe) is struggling valiantly to figure out proper one-night-stand protocol. Faster than a softball team can empty a kegger, the two of them discover their feelings for each other run deep, but they haven't a clue about how to proceed in these postmodern times. Their best friends—snarky Joan (Elizabeth Perkins) and vulgar Bernie (James Belushi)—just want Debbi and Dan to keep playing the game and move on to the next opponent, like they do.

As for Debbi, when it comes to how to handle living with the man you love, the only game plan that comes to mind is how Mom used to do things. Of course, this doesn't work out very well. And Dan isn't ready to slip into Ward Cleaver's easy chair, but then again he doesn't feel like cruising for the next conquest either. In the end, Dan and Debbi both discover that we all need to take a breather from our expectations about what *should* be if we are to have any hope of figuring out what any given relationship actually *is*.

When you're wondering whether to bunt, wait for a better pitch, or take a full swing, *About Last Night* will remind you that you can study all the rule books and strategy guides you like, but in the end only you can decide how to play it.

Bev's Culinarytherapy: A Meal to Seal the Deal

When you're trying to reach your special someone's commitment button through his upper GI system, there's no shortcut from a guy's stomach to his heart like a little comfort food just like Mom used to make. So the next time you're looking to throw something into the pot that's sure to seal the deal, try this recipe for Mom's Meat Loaf and Mashed Potatoes, because just like Mom always said, nothing says lovin' like a meat loaf in the oven.

Mom's Meat Loaf and Mashed Potatoes

Meat Loaf:

> 1 pound ground beef
> 1 pound ground veal
> 1 large yellow onion, chopped
> 2 eggs, beaten
> ¼ cup olive oil
> 1 cup bread crumbs
> ¼ cup milk
> 1 or 2 cans tomato sauce

Throw all of the above into a bowl and mush it up good, only not too good, because if you use too heavy a hand, you'll wind up with a brick in the oven instead of dinner. Form the meat mixture into a loaf, pour the tomato sauce over the top, and

continued . . .

bake at 350° for about 40 minutes, or until the meat is cooked completely through, which means no pink and no E. coli. Let the meat loaf sit for a few minutes before slicing, because meat loaves are like life: if you try to rush things, your carefully formed loaf will fall completely apart.

Mashed Potatoes

> 3 or 4 white potatoes
> ¼ to ½ cup milk or half-and-half (go ahead, use the half-and-half—you're going for broke, remember?)
> 2 to 3 tablespoons margarine or butter (see note above re going for broke)
> salt and pepper

Peel the potatoes and boil until soft. Drain and add half-and-half, butter, and salt and pepper to taste. Then whip those potatoes until they're light and fluffy, and don't stand for any lumps. This process has the added benefit of letting you release some of that pent-up tension you've been feeling ever since you-know-who started all this nonsense about avoiding commitment, so you'll be nice and relaxed by the time your commitment-phobe arrives. And remember, good potato whipping is a lot like good fly-fishing: it's all in the wrist.

▪ *The Mummy* (1999)

Stars: Brendan Fraser, Rachel Weisz, John Hannah,
 Arnold Vosloo
Director: Stephen Sommers
Writers: Stephen Sommers, Lloyd Fonvielle

There's nothing like a movie that punishes a guy for playing the field by subjecting him to mummification, entombment, and a plague of swarming locusts to send your commitment-phobic pharaoh running like an Egyptian into the safe embrace of long-term relationship tranquility.

This vintage-style big-screen adventure is a cautionary tale for your man about the cost of indulging forbidden appetites when he should really just stay at home with his significant other and watch a movie or something and not go tramping off to some unpronounceable forbidden city on the other side of the globe, sticking his nose in where it doesn't belong. And also he should never, under any circumstances, pursue a passionate but ultimately lethal obsession with the love object of an exalted ruler of an ancient dynasty who has the power to green-light live burials.

Rick O'Connell (Brendan Fraser), a dashing but reluctant hero, is off in the ruins of aforesaid unpronounceable forbidden city, sticking his nose in where it doesn't belong, in search of hidden treasure. Unfortunately the jewel he unearths is the moldering mummy of Imhotep (Arnold Vosloo), an ancient Egyptian and extremely well-sculpted priest who was sentenced to live mummification and entombment three millennia earlier because, you guessed it, he pursued a passionate but ultimately lethal obsession with the love object of an exalted ruler of an ancient dynasty who had the power to green-light live burials.

Rick is accompanied on his foolhardy mission by a beautiful but brainy damsel in distress, Evelyn (Rachel Weisz), and a bumbling, often inebriated, but lovable and rakish sidekick, Jonathan (John Hannah). Together they defeat the evil forces of ancient infidelity, and strike a blow for modern monogamy everywhere, as well as put a major dent in the subterranean scarab population of ancient Hamunaptra.

This is a great movie to watch when your big-screen adventurer has developed an irresistible urge to go spelunking into the forbidden recesses of infidelity. Get under the winding sheets together, watch *The Mummy*, and remind him that the next time he goes looking for his heart's desire, he need not dig any deeper than the barbecue pit in his own backyard.

Stupid Guy Quotes

These girls go out with you and they get nervous, man. They feel dumpy. They don't want to compete. They want a guy like, like me—you know, a guy that's gonna make THEM look good. Best thing gonna happen to you, Danny, is an industrial accident.

★ James Belushi as Bernie to Rob Lowe as Dan in *About Last Night*

I'm a temp but that's not, like, a permanent thing.

★ Potential suitor of Erin (Hope Davis) in *Next Stop Wonderland*

Yeah, I called her up, she gave me a bunch of crap about me not listening to her, or something, I don't know, I wasn't really paying attention.

★ Jeff Daniels as Harry Dunne in *Dumb and Dumber*

Shhh! You had me at "Get lost!"

★ Jason Alexander as Mauricio Wilson in *Shallow Hal*

■ *Mansfield Park* (1999)
 Stars: *Embeth Davidtz, Jonny Lee Miller, James Purefoy*
 Director and Writer: *Patricia Rozema,*
 based on the Jane Austen novel and Austen's letters and journals

When you're struggling with the complexities of commitment, it's always good to take in a Jane Austen movie. That's because in Jane's day, marriage wasn't just a big decision for women, it was THE decision that determined whether a woman would end up with a loving man who appreciates poetry, and a palatial home with sheep grazing on the lawn, or a lout, an airless hovel by the docks, and a lifetime of misery. *Mansfield Park*, a particularly heart-wrenching story about a woman whose marital offers aren't what she'd like them to be, will remind you that, difficult as your decisions are, hey, at least you've got some decent options.

Fanny Price (Embeth Davidtz), a poor Irish girl, is farmed out to relatives, with the understanding that she is to pay for this charity by helping with the housework, cultivating an apologetic posture, wearing lots of plain black dresses, and agreeing to whatever economically suitable marriage her uncle Thomas Bertram (James Purefoy) can arrange. However, Fanny is congenitally clever, spirited, and blessed with a sense of independence that makes her far less malleable than those around her would like her to be. If she can't marry her wonderful, kind, noble cousin Edmund (Jonny Lee Miller), who has always deeply admired Fanny and her writing talents, then she is determined not to marry at all. And somehow, the world is just going to have to accommodate her wishes.

Of course, as in all Jane Austen stories, Fanny's powerful sense of self is rewarded by destiny, while the shameless lotharios and scheming hussies end up banished from the social circuit. After viewing this one, you'll feel more optimistic about fate's maneuverings in your own relationship.

Reel to Real

Although Jane Austen had a few suitors in her day—including a mysterious would-be lover who died suddenly, and a man whose proposal she accepted, then rejected the next day—she never married. However, she was very close to her family, and if her novels are any indication, she was perfectly content to be a "spinster."

Happily Never After

The Mexican (2001)
Stars: Brad Pitt, Julia Roberts, James Gandolfini
Director: Gore Verbinski
Writer: J. H. Wyman

Hot-tempered, high-spirited, and teeth-achingly adorable Samantha (Julia Roberts, who else?) gives her ne'er-do-well-but-sublimely-beautiful-in-the-classic-Greek-sense boyfriend, Jerry (Brad Pitt, who else?), an ultimatum. Either he stops spending all of his time fooling around with his mob friends and makes a commitment to their relationship, or she'll hit the highway. Unfortunately, Jerry has also received an ultimatum from his mob boss, who has asked him to recover an antique pistol called "the Mexican" from an obscure and apparently lawless town south of the border, or he will be swimming with the fishes. Forced to choose between his life and his love, Jerry takes off for Mexico, fully intending to quickly dispatch his responsibilities to the mob, gain his freedom from *la famiglia*, turn over a new leaf, and marry Samantha.

Samantha, however, winds up kidnapped by a gay enforcer (James Gandolfini) who is more sensitive to her needs and feelings than Jerry ever

continued . . .

was, not to mention more fun on a road trip, and Samantha really begins to question her relationship choices. What ensues is a feature-length chase scene, traversing back and forth across the borders of credibility, with Samantha learning at the feet of a gay man what it means to be a woman, and with Jerry losing and finding and losing the Mexican pistol, and speaking bad pidgin Spanish.

In the end, Samantha and Jerry finally do intersect geographically. They shoot their gay intermediary in the back, stuff him in a trunk, and happily set about planning their wedding. Now, we understand that Samantha and Jerry have a lot in common, as they're both adorable box office stars and conscienceless killers. But they never address any of their interpersonal issues before making a commitment. In this movie, true love means never getting to the point where enough is enough, which might work in real life, so long as you can be assured that you and your intended, like Samantha and Jerry, never inhabit the same screen for longer than three minutes.

You Go, Girlfriend

The most incomprehensible thing in the world to a man is a woman who rejects his offer of marriage.
★ Gwyneth Paltrow as Emma Woodhouse in *Emma*

▪ *All That Heaven Allows* (1955)
 Stars: *Jane Wyman, Rock Hudson, Conrad Nagel*
 Director: *Douglas Sirk*
 Writer: *Peg Fenwick, based on a story*
 by Harry Lee and Edna L. Lee

After the loss of a relationship, it can be difficult to commit to a new one. Your own confidence can be shaky enough without having everyone around you telling you that you aren't equipped to make the right match this time around. But as this movie reassures us, after a winter of loneliness, spring will bring new buds on the branches along with that beefy young tree pruner with the Vitalis-ized ducktail, so tell them all to buzz off because you can make your own decisions just fine.

Jane Wyman plays Connecticut widow Cary Scott, whose comfortably middle-class, bridge-playing neighbors think she should marry the local drip, Harvey (Conrad Nagel), or spend the rest of her life in a perpetual state of melancholy, wearing simple gray twinsets and sighing over a solo cup of tea. Cary, however, comes to realize she can find companionship in the arms of Ron Kirby (Rock Hudson), a tanned, studly, and decidedly younger man. After Ron surprises her with poetic talk about the Chinese golden rain tree, and gives her a Wedgwood teapot he has carefully reconstructed from broken shards she discovered one day, Cary decides that it's time to take her romantic life out of the shed and into the light of the sun. This act of independence deeply upsets her children, who, although college age now, think they have the right to keep Mother cryogenically preserved as a grieving widow. And it really twists the panties of those jealous neighbor ladies who ought to spend less time sublimating their own sexuality into the fanatical planning of club meetings and more time reconnecting with their own sense of romance.

This is a great movie to watch when you've just announced to your family and friends that you're serious about a certain man, and they've decided you need a lecture on what's best for you. Pour yourself a nice cup of tea, feel free to shout at the screen every time Cary nods dumbly as her obnoxious kids and friends cross her boundaries, and then vow to stop letting other people tell you how to run your love life.

Best Proposals

*If you choose me, after all my blundering and
 blindness, it would be a happiness which no
 description could reach.*
 ★ Jonny Lee Miller as Edmund Bertram in *Mansfield Park*

Marry me. Marry me, my wonderful, darling friend.
 ★ Jeremy Northam as Mr. Knightley in *Emma*

*I have come with no expectations, only to profess—now that
 I am at liberty to do so—that my heart is and always will be
 yours.*
 ★ Hugh Grant as Edward Ferrars in *Sense and Sensibility*

*I rode through the rain! I'd—I'd ride through worse than that if
 I could just hear your voice telling me that I might, at least,
 have some chance to win you.*
 ★ Jeremy Northam as Mr. Knightley in *Emma*

Best Proposal Not Penned by Jane Austen

*I want you to faint. This is what you were meant for. None of the
 fools you've ever known have kissed you like this, have they?
 Your Charles or your Frank or your stupid Ashley. . . . Say
 you're going to marry me. Say yes. Say yes.*
 ★ Clark Gable as Rhett Butler in *Gone With the Wind*

continued . . .

Best Sadie Hawkins Proposal

I want you to be with me, I want you to marry me, I want you to love me the way that I love you.

★ Jennifer Aniston as Nina in
The Object of My Affection

■ *Miami Rhapsody* (1995)
Stars: Sarah Jessica Parker, Mia Farrow, Antonio Banderas, Kevin Pollak,
Paul Mazursky, Gil Bellows, Barbara Garrick, Naomi Campbell
Director and Writer: David Frankel

Why is it that just when Gwen (Sarah Jessica Parker) is ready to say "I do," everyone around her has to go and royally screw up their marriages and annihilate all her faith in the institution? There's her sister (Barbara Garrick), who probably hasn't even had time yet to send thank-you notes for the wedding gifts she received, who decides that her new purple crotchless teddy would be less appreciated by her husband than by her ex-boyfriend. There's Gwen's brother (Kevin Pollak), who resents that his wife pays more attention to their baby than to him. Rather than helping with the child care and encouraging her to re-discover her romantic self, he takes up with a fashion model (Naomi Campbell). And there's her mom (Mia Farrow), who is way too eager to discuss her affair with a Mexican nurse (Antonio Banderas). Even the blubbering woman in the restaurant ladies' room is having an affair . . . and it turns out the cad who seduced her was Gwen's dad (Paul Mazursky). No wonder the confused and disillusioned Gwen is given to *Sex-and-the-City*–style narrative voiceovers, Woody Allen–esque conversations in shopping malls, and an astonishingly long explanation of her current sexual status to her gynecologist, which

essentially is the entire movie (geez, two hours with a patient? Can we get on that health care plan?).

Gwen voices her apprehension aloud and soon starts making daring choices like picking out a table for the foyer without checking first with her fiancé, Matt (Gil Bellows). All this freaking out starts giving him cold feet, and then Sarah's got to decide what's really going to make her live "happily ever after."

This movie reassures us that if you're honest with yourself about what you really want, and what your personal morality is, you'll make the right decision. So if the idea of commitment is making you nervous, watch *Miami Rhapsody*, have a good laugh, take a deep look inside and an even deeper breath, and you might just discover that you're ready for that big plunge after all.

Words to Live By

Panic is a reasonable response.
★ Sarah Jessica Parker as Gwen Marcus in *Miami Rhapsody*

Happily Never After

Bell, Book and Candle (1958)
Stars: Kim Novak, James Stewart, Jack Lemmon,
* Ernie Kovacs, Hermione Gingold, Janice Rule*
Director: Richard Quine
Writer: Daniel Taradash,
* from the play by John Van Druten*

From the moment we enter Gillian Holroyd's (Kim Novak) shop full of primitive artwork, and feel her feline familiar, Pyewacket, brush against us, it's love at first sight. How can you not admire a woman who attended Wellesley, runs her own business, appreciates ancient goddess statuary, lives in black catsuits, casts spells, and walks around barefoot except for when she visits an underground bohemian club and dons fiery-red stilettos?

Now, Gillian's neighbor Shepherd Henderson (James Stewart) may be engaged to an uppity cold fish, Miss Kitteridge (Janice Rule), but of course he's going to be bewitched by Gillian's far superior charms. Unfortunately, he's supposed to be married in twenty-four hours, so Gillian gets a little antsy and does a love spell on him so he can't get away. When he discovers Gillian's little secret, Darren—er, Shep—gets all huffy. Because she has fallen in love, Gillian loses all her powers (how's that for a metaphor about male/female dynamics?). Even worse, she feels compelled to turn into good wife material to win over her man. That translates not into gentle compromise, equal division of labor, and a rejection of power plays, but anemic yellow A-line dresses with petticoats, a shop full of kitschy tourist junk like seashell sculptures, and a flattened personality. Hey, commitment should *add* to your powers, not drain them. And even Samantha got to have a *little* fun once she was ensconced in that suburban bungalow. We only wish Gillian had a mom, an uncle, and a Dr. Bombay to encourage her to keep her power and élan postmarriage, even if it does make other people uncomfortable.

■ *Dead Poets Society* (1989)
Stars: *Robin Williams, Robert Sean Leonard, Ethan Hawke, Josh Charles, Gale Hanson*
Director: *Peter Weir*
Writer: *Tom Schulman*

We admit that a male coming-of-age film about a beloved English teacher at a boys' school might seem like an odd choice for when you're struggling with commitment issues. But in fact *Dead Poets Society* is some of the most powerful cinematic medicine to cure the "he won't seize the day" blues.

John Keating (Robin Williams) is an unorthodox educator in an Ivy League prep school nestled in a verdant hollow in the locked jaw of New England. In addition to poetry, he teaches his students about the meaning of life. His motto is *carpe diem* (seize the day). And like a pied piper of iambic pentameter, he leads his boys out of Hamelin and into the caves towering above the village, where they are encouraged to drink the cup of life to the very dregs, be all that they can be, take life by the lapels, and shake it until it spits silver dollars. . . . You get the idea. This is a movie about finding the courage to make a commitment to the things that are important to us, and sticking by those commitments, come what may. And it's told in the do-or-die, *semper fi*, unto-the-death voice that guys really respond to for some reason. When your dead poet is hanging back from his destiny, watch this movie together and celebrate the body electric.

Great Moments in Passive Aggressiveness

I must throw a party for her. Otherwise everyone will feel at once how much I dislike her.
★ Gwyneth Paltrow as Emma Woodhouse in *Emma*

When Steve hates me enough he'll know that he can't live without me.
★ Alix Talton as Corinne Talbot in *Rock Around the Clock*

Everything Old Is New Again

Negotiations in your own relationship got you dazed and confused? Sometimes it's comforting to know that your problems are as classic as a Bette Davis movie or a bias-cut evening gown, and at least when it comes to real-life drama, you have script approval.

Ex-Lady (1933)
Stars: Bette Davis, Gene Raymond
Director: Robert Florey
Writer: David Boehm, based on a story by Edith Fitzgerald
* and Robert Riskin*

This is a very early talkie about a modern gal on the go who discovers that redefining marriage isn't as easy in practice as it is in theory. Bette Davis plays Helen Bauer, a young woman who has no interest in settling down prematurely because she fears that marriage will rob her of her sense of freedom and adventure. Her fiancé, Don (Gene Raymond), finally convinces her to say "I do," and when things inevitably turn a bit dull, they get creative and establish a wonderful ritual of dating each other.

Unfortunately, being new to the modern era, Helen and Don make a lot of totally absurd assumptions about how to keep the fires burning. Hey, there is such a thing as going stag to a nightclub, or saying no to a sexually aggressive and downright obnoxious co-worker, or staying in for the evening (although, if we had a closet full of bias-cut slinky dresses like Miss D, maybe we wouldn't see the latter as an option either). In the end Helen and Don decide they'll have to have a traditional marriage after all, but sadly, the credits roll before they get a chance to discuss just how that's going to solve Helen's thirst for personal adventure.

continued . . .

The Divorcée (1930)

Stars: *Norma Shearer, Chester Morris, Robert Montgomery*
Director: *Robert Z. Leonard*
Writers: *John Meehan, Nick Grindé, Zelda Sears,*
 based on the novel Ex-Wife *by Ursula Parrott*

Norma Shearer plays Jerry, a post-Victorian, bobbed-hair babe who is confident, comfortable with her sexuality, and certain that *her* marriage is going to be different. Yes, she and her fiancé, Ted (Chester Morris), are going to share passion, intimacy, laughter, and plain old fun.

Ted, however, proves to be mired in that old swamp of the double standard: he expects Jerry to quickly forgive and forget when, before the ink on their marriage license is dry, he reveals he has already had an affair. Poor Jerry! What is there to do but flee to Europe, dance each night away with yet another handsome stranger, and drown one's sorrow in champagne and moonlight?

Jerry has just begun to really explore her feelings about sex, love, and fidelity when some moralistic screenwriter swoops in and makes her nostalgic for old Ted and traditional marriage no matter what its flaws, and all hope that this will end with a girl-power message 1930-style is drowned in romanticized muck. But until that happens, you can enjoy her adventurousness.

Strangers May Kiss (1931)

Stars: *Norma Shearer, Neil Hamilton, Robert Montgomery*
Director: *George Fitzmaurice*
Writer: *John Meehan, based on the novel*
 Ex-Wife *by Ursula Parrott*

Norma Shearer plays Lisbeth, a post-Victorian, bobbed-hair babe who is confident, comfortable with her sexuality, and certain that *her* marriage is

continued . . .

going to be different. Sound familiar? Like Jerry in *The Divorcée*, Lisbeth discovers her man (Neil Hamilton) is cheating, flees to Europe, has several elegantly costumed and well-scored evenings on the town with handsome gentlemen, spurns a marriage proposal from a loyal admirer, and finally settles for a man who has already proven himself unworthy of her considerable charms. But again, even if the ending is hopelessly 1931, our heroine's sensibilities are delightfully contemporary, and her dilemmas seem as complicated now as they were then.

Thoroughly Modern Millies

When I'm forty I'll think of babies. In the meantime there are twenty years in which I want to be the baby and play with my toys and have a good time playing with them.

★ Bette Davis as Helen Bauer in *Ex-Lady*

I just don't want to get married, Duane. I don't want life to settle down around me like a can of sourdough.

★ Norma Shearer as Jan Ashe in *A Free Soul*

- *Cast Away* (2000)
 Stars: Tom Hanks, Helen Hunt
 Director: Robert Zemeckis
 Writer: William Broyles Jr.

This is a movie about what happens when you separate a guy from all of the accessories of guydom. You take away the car, the career, the house, the hypertension, the girlfriend, the film score, and most of the dialogue, you plunk him down on an uncharted desert isle, and just watch what happens. And, of course, what happens is exactly what you always told him would happen: he realizes that he's become so reliant on work that he's forgotten how to live, and that he really can survive without a Palm Pilot. He understands finally that his career is not what's truly important, so all that Type A behavior has been a complete waste of time, because the most important thing in his whole life is making and upholding his commitment to you.

Tom Hanks stars as Chuck Noland, an overachieving FedEx executive who lives by the clock until his ship runs aground on the shore of an uncharted desert isle and he's forced to spend years alone, scraping out a meager existence. He passes the time ducking monsoons, building a raft, gazing at his ever-patient and all-enduring girlfriend's picture, and talking to a volleyball about what an unbelievable idiot he was for not dropping everything and marrying that beautiful and substantive woman while he had the chance.

Watch this movie when you need reassurance that a guy can learn his lesson and make a commitment, even if it takes being marooned on a desert island without fiber optics for an extended period. And the next time your overnight-mail exec is rushing to beat a deadline, get him to put down those tracking numbers, climb under the covers, and watch this movie with his honey, before it's too late.

Chapter 6

It's Déjà Vu All Over Again: Repetition Compulsion Movies

It comes upon us slowly, creeping in when we aren't looking. At first it's just an off comment here and there . . . an eerily reminiscent expression you've never made before but that you swear you've seen somewhere—like on your mother's face . . . and the next thing you know, you're channeling your parents' relationship—or your first doomed love affair— and the present starts to look a whole lot like the past that you swore you would never repeat and yet here you are, once again, right smack dab in the middle of the same recurring nightmare. And the worst part is, he is too. That's when you know that you have both come face-to-face with one of the strongest gravitational pulls in the emotional universe: the dreaded repetition compulsion, which causes us all to repeat the same maddening psychological patterns that have made just about everybody miserable for just about as long as you can remember.

Not so easy to check that emotional baggage at the door of your own romantic relationship, is it? If you're tired of lugging around the unwanted accessories of your obsolete defense mechanisms, watch one of these Repetition Compulsion Movies featuring people who have faced their destructive patterns and prevailed, or learned the hard way about the cost of refusing to travel light.

■ *Groundhog Day* (1993)
Stars: Bill Murray, Andie MacDowell, Chris Elliott
Director: Harold Ramis
Writer: Danny Rubin

Groundhog Day is a feature-length metaphor for the way in which we all repeat the same mistakes given the same set of circumstances, and are doomed, allegorically speaking, to exist in the same emotional winter until the groundhog of our subconscious stops running back into its cave because we are afraid of our own shadow.

Phil Connors (Bill Murray), a self-centered and distinctly unpleasant TV weatherman, sets off reluctantly for Gobbler's Knob in Punxatawny, Pennsylvania, to cover the festivities surrounding Groundhog Day, the annual agrarian ritual starring Phil Connor's namesake, the groundhog Punxatawny Phil, who predicts the coming of spring. It's the fourth year in a row that Phil Connors has been forced to cover what he considers to be a mundane, pedestrian event that brings him yearly to a place where nothing ever changes, to file a report on nothing. Phil is the embodiment of the Groundhog Day scrooge, ruining everybody else's day because he is miserable and impervious to the goodness around him—because he is blind to the goodness in himself.

Small-town stasis takes on new meaning when Phil wakes up and realizes that in Punxatawny, time has not only figuratively but literally stopped in its tracks. Every day is now Groundhog Day, but Phil is the only one who realizes it. Every morning begins with the same annoying drive time DJ patter on his alarm clock, the same inclement February chill outside the same down-home B&B window. His battle-scarred, disapproving producer, Rita (Andie MacDowell), treats him with the same much-deserved disdain, the same down-and-outer begs for soup and comes up empty-handed, and no one seems to

mind or even notice. Except Phil, who is ready to climb out of his skin with the repetitive monotony of his Sisyphean existential dilemma.

Redemption comes when Phil begins to use the repetition compulsion to his own advantage, and corrects his own behavioral patterns by enriching himself and reaching out to others, unencumbered by the bitterness and self-involvement of his past.

This is a great movie to watch when you're feeling like spring is never going to come again. Let Phil and his namesake remind you that we can't expect our environment, or our relationships, to change until we are willing to face our past mistakes and destructive patterns, stop running away from our own shadows, and change ourselves.

■ *The Shipping News* (2001)

Stars: Kevin Spacey, Judi Dench, Cate Blanchett, Pete Postlethwaite, Julianne Moore, Scott Glenn, Alyssa Gainer, Kaitlyn Gainer, Lauren Gainer
Director: Lasse Hallström
Writer: Robert Nelson Jacobs,
based on the novel by E. Annie Proulx

You can run as far away as the icy cliffs of Newfoundland, but if you think your painful memories will scatter to the four directions, here's a movie that will hit you with a bracing gale of cold reality. It also suggests that if you want to hide from your difficult feelings, you might want to pick a corner of the world where every day's weather report doesn't promise a metaphorical re-creation of your internal hailstorm.

Ever since childhood, Quoyle (Kevin Spacey) has been convinced he's a colossal failure. Naturally, he attracts a coldhearted, manipulative woman, Petal (Cate Blanchett), who feeds off his self-loathing and uses it to fuel her beer-drenched adventures in dive bars. Meanwhile Quoyle is stuck back home bathing their baby daughter, Bunny. Eventually fate frees Quoyle of his current psychic torment—Petal bites the dust—and Quoyle impetuously moves from Poughkeepsie, New York, to a dilapidated house in Newfoundland. He takes with him Bunny (Alyssa, Kaitlyn, and Lauren Gainer), a mysterious aunt who has just shown up out of nowhere (Judi Dench), and two huge gold urns containing the ashes of his dead parents, which is pretty weighty evidence of his unwillingness to bury the past.

In Newfoundland, land of pirate legends, squid burgers, and dark secrets, Quoyle fits right in and even appears to thrive. But soon he realizes that if he's to find personal peace, and forge a new, healthy romance with a gal named Wavey (Julianne Moore), he's going to have to confront his ghosts. And given that his sweet auntie has just poured Pop's ashes down the pit toilet, one might guess that Quoyle's family of origin might hold a few secrets he should bring into the light as well.

Thinking a change of scene is all you need? Check out *The Shipping News* and remind yourself that wherever you go, there ya are, so you might as well start unpacking your baggage and examining the foundations of your fears right here at home.

Famous Last Words

That's my family, Kay. It's not me.
★ Al Pacino as Michael Corleone in *The Godfather*

▪ ***Blow Dry*** *(2001)*
 Stars: *Alan Rickman, Natasha Richardson, Rachel Griffiths,*
 Josh Hartnett, Rachael Leigh Cook
 Director: *Paddy Breathnach*
 Writer: *Simon Beaufoy*

This quirky follow-up by the writer of *The Full Monty* shows us that just as life can be like a small-town striptease competition, it can also be just like a small-town hairstyling contest, where the winner is the one who turns his baggage into blessings, and Dippety Doo's one for the home team.

Phil (Alan Rickman) is a gifted coiffeur who has traded in his golden shears and inspired comb-outs for the pedestrian strap and straight blade of the corner barber shop ever since his wife ran off with his female hair model. When his ex-wife, Shelley (Natasha Richardson), is diagnosed with terminal cancer, she convinces Phil to help her bring the

whole hair team together, including model Sandra (Rachel Griffiths), who is still Shelley's lover, and their son, Brian (Josh Hartnett), who needless to say has a few mom issues to overcome. What ensues is like an emotional deep conditioning that touches up the roots, gel-fixes the bonds of love, and redefines what a happy family can look like.

This is a great movie to watch when your story is starting to read like a perpetual bad hair day. Let Phil and Shelley's unusual love story remind you that life, love, award-winning hairdos, and happily ever afters require that you know how to tell the difference between essential and nonessential baggage in order to have an enjoyable trip. And an occasional scalp massage from a shampoo boy who looks like Josh Hartnett doesn't hurt things much either.

Nancy's Momentous Minutiae: Star Power

During the filming of *Blonde Venus*, Marlene Dietrich refused to obey the director and toss her hat on a bed because she considered this gesture to be "bad luck." He compromised by letting her toss it onto a couch instead.

Lionel Barrymore would only do a scene if he had the backup of blackboards, positioned secretly off camera or hidden on the set, that contained his lines. One day he even insisted that he needed a gaffer to hold up a child's slate that included all his lines for the scene: "Yes."

For a two-day trip to Omaha as a traveling ambassador for Pepsi-Cola, Joan Crawford brought along twenty-two dresses and fourteen hats, then proceeded to ring room service to get an iron and ironing board and pressed each dress by herself.

■ *Pop & Me* (1999)
Stars: Richard Roe, Chris Roe, Julian Lennon
Director: Chris Roe

Filmmaker Chris Roe wanted to make a documentary about his trip around the world with his father, Richard, and together they decided to explore father/son relationships in several different cultures. As this movie shows, Pop and son both learned that when it comes to expressing paternal or filial love, guys all over the world, of all ages and cultures, desperately want an external crutch, like a camera, to get them off their duffs and say "I love you" already. Of course, this is something we gals might've guessed well before they even got to the airport.

It's an enlightening trip for both father and son, who begin to talk about the personal and cultural baggage that men have about expressing their feelings, and about having and being fathers. But, by the end, it's also clear that Chris and Richard are going to have to buy a hell of a lot more film and several more plane tickets to get to the bottom of their own complex dynamic, the roots of which go back to Richard's troubled relationship with his own father.

Over the course of several months, Chris's slow burn over his father's controlling personality style and lack of respect for his son's expertise threatens to flare up into an inferno. Meanwhile, his pop, doing his best to remain upbeat, mugs happily at the camera and once again orders the same damn noodle dish he's been ordering all week because he's too cheap to spring for a decent meal and is obviously determined to force his son to conform to his own way of doing things. Once they hit New Zealand, Pop's about had it with Chris's petulance and is ready to start swinging. Finally, Chris challenges Pop with an outrageously adolescent, dangerous, and testosterone-driven stunt that makes one realize that when it comes to sorting out the problems between a father and his adult son, we women should just stay the hell out of the way and make sure that the life insurance policy hasn't lapsed.

This a great movie to watch when you're frustrated with your own man's unwillingness to straighten it out with his father already. It'll remind you that it takes more than a couple of conversations, or even a six-month trip of nonstop companionship, to work through his and his pop's decades-old resentments and misunderstandings. What's more, it may even

make you realize that your relationship with your own pop probably will never have a simple three-act, two-hour story arc complete with happy ending either, so maybe you ought to have a little patience with your man's fractured father relationship.

Reel to Real

During the editing of the documentary *Pop & Me*, Richard and Chris Roe ended up in a therapist's office, trying to break their creative stalemate.

■ *The Long Kiss Goodnight* (1996)
Stars: *Geena Davis, Samuel L. Jackson, Yvonne Zima, David Morse*
Director: *Renny Harlin*
Writer: *Shane Black*

This tongue-in-cheek thriller puts a new twist on some old saws, and teaches us that what you don't know really can hurt you, and that the past is never truly behind you (especially when the government is involved). And that chefs aren't the only ones who have top-notch slicing and dicing skills in their job descriptions.

Samantha Caine (Geena Davis) is the picture of ideal bucolic housewifery. She lives with her patient, loving, gainfully employed and pleasant-looking-without-being-threateningly-gorgeous husband in a cozy suburban bungalow in the heartland. She has an angelic eight-year-old daughter named Caitlin (Yvonne Zima), a station wagon, a two-car garage—and a total loss of recall, which has wiped out any memory of her life before waking up on a beach eight years ago, pregnant and wearing clothes that she didn't recognize.

When Samantha finds herself the unwitting target of a band of bazooka-bearing thugs in nondescript Today's Man suits, she engages a cut-rate PI sidekick named Mitch (Samuel L. Jackson) to help her recover the facts about her former life, and her clear and present danger. The Furies that Sam and Mitch discover in the Pandora's box of Sam's past include

an incredible dexterity with a chef's knife, surprisingly accurate aim, an equally surprising lack of fear or conscience, and some really handsome but sinister-looking guy named Daedalus (David Morse) who has scintillating, ice-blue eyes and a kinky genius for innovative water torture. Obviously, folks, we're not in Libertyville anymore. As the plot thickens, Sam must make friends with her inner contract killer before she can truly be free to enjoy her upper-middle-class nirvana in peace.

While at first this may sound like a wide-screen realization of everybody's worst fears about the dark and dangerous potential of their repressed rage, in actuality, this is a morality tale about the value of self-exploration, and the life-and-death consequences of living without any connection to the origin and meaning of our behavior patterns. If you've been having a little trouble recognizing the person in the mirror lately, and have developed a sudden and persistent urge to prepare vegetables julienne style, watch *The Long Kiss Goodnight* and remember that you don't have to be afraid of your special skills, because how you put them to use is up to you.

Stupid Guy Quotes

Everyone knows, when you make an assumption, you make an "ass" out of "u" and "mption."
★ Samuel L. Jackson as Mitch Hennessey
in *The Long Kiss Goodnight*

The Vietnam War was fought over a bet that Howard Hughes lost to Aristotle Onassis.
★ Mel Gibson as Jerry Fletcher in *Conspiracy Theory*

Your work is ingenious. It's quality work. And there are simply too many notes, that's all. Just cut a few and it will be perfect.
★ Jeffrey Jones as Emperor Joseph II to Tom Hulce as Mozart in *Amadeus*

Can I Have That Printed on a Coffee Mug?

Today is tomorrow.

★ Bill Murray as Phil Connors in *Groundhog Day*

If you don't have anything nice to say about anybody, come sit by me!

★ Olympia Dukakis as Clairee Belcher in *Steel Magnolias*

■ *Angel Eyes* (2001)
Stars: *Jennifer Lopez, Jim Caviezel, Sonia Braga*
Director: *Luis Mandoki*
Writer: *Gerald Di Pego*

He has no visible means of support and no last name, refuses to talk about his past, and constantly leaves doors open, raising plenty of questions about his unresolved feelings and his attachment style. It's enough to make a gal wonder if a fellow calls himself "Catch" because he's a fella to snap up quickly or because he's a man whose got the kind of troubled past that's going to cause major snags in the fabric of a relationship.

Catch (Jim Caviezel) is a wonderful lover and chivalrous to boot. Hey, how can you not fall for a guy who shows up in the nick of time to save you from certain death at the hands of the criminal element? But Sharon (Jennifer Lopez) wants more—c'mon, this is J-Lo we're talkin' about, and you know she doesn't settle. Mystery is one thing, but when every time you ask basic background questions, like who he is, what he does, and where he comes from, he stares off into the distance with a pained look on his face, of course a gal is going to turn detective. Figuring out why he has no furniture but a kitchen drawerful of toy action figures, or why "Catch" runs away agitated when people on the street come up to him and say, "Yo, Jim!," keeps Sharon so busy guessing that she neglects to deal with her own unresolved past. But after witnessing her brother mutate into a carbon copy of her abusive

father, and watching Catch finally, successfully confront his own demons, she at last finds the courage to face her own.

This movie is a great reminder that when we repress the bad memories we also repress the good ones and numb ourselves to the joy in the present, all of which bodes ill for the future. Check this one out the next time you press him to elaborate on his family of origin and you find yourselves suddenly talking about the weather.

■ *Damage* (1992)
Stars: Jeremy Irons, Juliette Binoche, Miranda Richardson, Rupert Graves
Director: Louis Malle
Writer: David Hare, based on the novel by Josephine Hart

At first glance, this movie seems to be all about the sex scenes, which are edgy, aggressive, taboo, and more often than not staged in public places. But underneath all that steamy, forbidden, mood-lit, back-alley boot knocking lies a message about the allure, and the destructive power, of the repetition compulsion.

Dr. Stephen Fleming (Jeremy Irons) is an upstanding member of Parliament who lives the sedate and well-ordered life of a mid-level British aristocrat and who appears about as passionate as yesterday's fish-and-chips paper, yet falls into the grip of a dangerous obsessional love with Anna Barton (Juliette Binoche). Anna is very French, very enigmatic, and very engaged to Stephen's son Martyn (Rupert Graves). What ensues is an emotional cat-and-mouse game through the steamy back alleys and blue-lit stairwells of Europe, with Anna playing out in miniature the grand mal seizure of her earlier life, while the unwitting Stephen aggressively pursues his own destruction with his eyes closed and his pants, more often than not, down around his ankles.

This is a great movie to watch when you're falling prey to your own or somebody else's voracious and unconscious appetites. *Damage* is a visceral reminder that when it comes to the repetition compulsion, you can run, but you can't hide, and that just because you close your eyes and refuse to see something doesn't mean that it doesn't see you.

Words to Live By

Damaged people are dangerous, because they know they can survive.

★ Juliette Binoche as Anna Barton in *Damage*

To be normal, to drink Coca-Cola and eat Kentucky Fried Chicken, is to be in a conspiracy against yourself.

★ Mel Gibson as Jerry Fletcher in *Conspiracy Theory*

■ *The Straight Story* (1999)
Stars: Richard Farnsworth, Sissy Spacek, Harry Dean Stanton
Director: David Lynch
Writers: John Roach, Mary Sweeney

If ever there were an inspirational movie about going all out to achieve closure, it's this one. Based on a true tale of a man who rode a lawn mower 350 miles across the Midwest to make peace with his brother, this movie reminds us that getting past our anger is one thing, but true forgiveness and making one's peace with the past is worth even extraordinary efforts.

Al Straight (Richard Farnsworth) is getting up there in years, he's still smoking Swisher Sweets despite his poor circulation, and he can sort of get around by himself if he has a couple of canes to keep him propped up. Now that he's facing the end of his days, Al's come to realize that whatever it is that's kept him from speaking to his brother, Lyle (Harry Dean Stanton), for ten years is just not all that important anymore. And anyway, saying "I'm sorry" is something he's got to do in person. The problem is, Al's only motorized vehicle is a dilapidated John Deere lawn mower, and he doesn't even have a driver's license because his eyes are so bad, so the trip to Zion, Wisconsin, is a rather risky undertaking to say the least. Still, it is summer, so Al, being a low-maintenance kind of guy, figures all he needs for

the trip is a rain tarp, an orange Slow Moving Vehicle triangle, and a sizable stash of braunschweiger sandwiches. But after it takes five weeks to travel sixty miles, and the sun begins to set earlier each day, Al has to wonder if he'll reach his brother, Lyle, before one of them becomes unavailable for a face-to-face discussion.

Nursing a grudge that's keeping you from moving forward in your relationships? Clearing the air can be difficult, but this movie will remind you that, hey, at least you don't have to putt putt across three states over the course of an entire summer just to start the dialogue.

■ *Smoke Signals* (1998)
Stars: *Adam Beach, Evan Adams,*
 Irene Bedard, Gary Farmer, Tantoo Cardinal
Director: *Chris Eyre*
Writer: *Sherman Alexie, based on his novel*
 The Lone Ranger and Tonto Fistfight in Heaven

Sometimes we realize we've been inexplicably intertwined with a person we've known for years and we wonder why we keep hanging around someone who's been like a pebble in our shoe all our life. But, as this movie shows, if you look a little closer, you might find that it's not him that's making you so irritable as much as the mirror he's holding up to you.

Thomas Builds-the-Fire (Evan Adams), the king of uncool on the Coeur d'Alene Indian Reservation in Idaho, who is always dressed in cheap three-piece suits and wearing huge plastic glasses and a goofy grin, is a constant reminder to Victor Joseph (Adam Beach) of his father, Arnold Joseph (Gary Farmer). Old Arnold Joseph angrily drove off in his yellow pickup truck one day back in the seventies, never to be heard from again, and Victor has never gotten over it. Thomas asks all the uncomfortable questions, like, why'd your dad leave? Worse, he is always spinning long tales from his selective memory, painting Arnold Joseph as a warmhearted guy who'd buy a kid a plate of pancakes, or make a righteous stand as a warrior for the Native American cause—probably because if Arnold did any one good thing in his life, it was to save the infant Thomas from a fire that killed Thomas's parents.

Thomas's rosy view of Arnold enrages Victor, whose own memories of Pop are considerably darker. But when the call comes for Victor to go to Arizona and pick up his father's

possessions—because at last, the old man has died—he allows Thomas to tag along. Ostensibly Victor is attracted to Thomas's mason jar of cash, which will pay for the trip, but deep down, perhaps Victor senses that Thomas has his own father issues to resolve, so it's only right that they make the journey together. In the end, Thomas's wise words about forgiveness are as bittersweet as they come, and help Victor to at last access his complex web of feelings about his dad.

This is a great movie about achieving closure with someone who is unavailable for comment. We bet it'll inspire you to let go of some of the baggage you've been carrying all these years.

Thanks, Ma

He's not the Messiah. He's a very naughty boy! Now, piss off!
★ Terry Gilliam as Brian's mother in *The Life of Brian*

▪ *Amadeus* (1984)
Stars: Tom Hulce, F. Murray Abraham, Elizabeth Berridge, Jeffrey Jones
Director: Miloš Forman
Writer: Peter Shaffer, based on his play

This is a big-screen adaptation of the life of Wolfgang Amadeus Mozart as seen through the eyes of his nemesis, the terminally mediocre court composer Salieri, who is jealous of Mozart's talent. But it is the pivotal and often overlooked character of Constanze (Elizabeth Berridge), Mozart's petulant child bride, who teaches us that sometimes the in-laws who are hardest to deal with are the ones that live in our spouse's head.

Mozart (Tom Hulce) is a child prodigy with a stage father who put young Mozart into the limelight at the tender age of four, and kept him fixed in a paternal follow spot for the rest of his short life. And while Mozart is off making immortal masterpieces, or whatever

it is he does while he's away and doesn't even bother to call, poor Stanze is at home having to deal with a Teutonic father-in-law straight out of some epic myth featuring the gods of the underworld, and who doesn't like Stanze's power over his son, or her housekeeping habits.

Stanze and old man Mozart fight like Furies until the old man finally storms back to Austria and dies. But before Stanze can heave a sigh of relief, Mozart starts writing an opera with his father as the central figure, thus keeping the dreaded patriarch alive for all eternity.

This is a great movie to watch when your patriarch-in-law is threatening to become a leading player in your spouse's grand opera, and you're fearing a tragic ending. Let Wolfie and Stanze remind you that when it comes to the excess family baggage of someone you love, you can run, but you can't hide, so you may as well make peace with the patriarchs without and within.

Thanks, Pop

Captain Wentworth (Ciaran Hinds): My proposal of marriage to your daughter, Anne, has been accepted and I respectfully, sir, request permission to set a date.

Sir Walter Elliot (Corin Redgrave): Anne? You want to marry Anne? Whatever for?

★ from *Persuasion*

■ *Life as a House* (2001)

Stars: Kevin Kline, Kristin Scott Thomas,
 Hayden Christensen, Jena Malone,
 Mary Steenburgen
Director: Irwin Winkler
Writer: Mark Andrus

When George (Kevin Kline) is diagnosed with terminal cancer, he decides to use the last year of his life to tie up the loose ends that have been swinging in the breeze for the better part of four decades.

The first order of business for George is to heal his fractured relationship with his teenage son, Sam (Hayden Christensen), who has descended into a monosyllabic hormonal haze accompanied by the usual teenage tendencies toward pharmaceuticals and meaningless but incendiary confrontations with authority figures.

George takes custody of his reluctant and recalcitrant son for the summer, and together they look toward the second thing on George's spiritual to-do list. George is resolved to construct a dream beach house out of the seaside shack that he has been meaning to renovate since he was first married. And it is his poor follow-through skills that not only eroded his relationship with his son, but brought about his divorce from Robin (Kristin Scott Thomas), a woman he still loves but lost to another man who was able to give her a decent roof over her head.

At this point we understand that George's house is a metaphor for George's entire life. And it's a very shabby shack. As he knocks down the old structure, and puts up new and better support beams, and his son and ex-wife and even his hostile neighbors join in to help him, George realizes that sometimes everything must be demolished before a new and better structure can take its place.

Watch this one when your emotional house is falling down around your ears and remember that *love* and *family* are action words and that the active expression of love provides the only real shelter you need from any of life's storms.

Words to Live By

An eye for an eye only ends up making the whole world blind.

★ Ben Kingsley as Gandhi in *Gandhi*

■ *Frequency* (2000)
Stars: Dennis Quaid, Jim Caviezel, Elizabeth Mitchell,
 Andre Braugher, Noah Emmerich
Director: Gregory Hoblit
Writer: Toby Emmerich

Frequency is a chick flick for guys that feeds into that natural desire we all have to fix our past, prevent all emotional disasters, ensure the happiest of futures, and get a wounded guy to work through his lifetime of grief and loss in just a few conversations. And in this movie, you don't even have to change the laws of physics, Captain, to do it.

Thanks to an atmospheric glitch (to use the scientific term), cop John Sullivan (Jim Caviezel) is able to communicate via ham radio with his long-dead fireman father, Frank (Dennis Quaid). As John and Frank come to realize they are speaking thirty years across time, these two tough working-class heroes find the tears welling up. But things get really intense when they realize that with twenty-twenty hindsight, John can give Dad a piece of advice that will save him from being killed in a fire two days hence or thirty years previous, depending on one's perspective.

Unfortunately, by messing with that linear time thing, John and Frank have inadvertently set off another disaster: suddenly John realizes that it's Mom (Elizabeth Mitchell) who's been dead thirty years. Thus ensues a complex across-time chase that results not only in Frank resolving all his emotional traumas and re-creating his loving you-and-me-and-

baby-makes-three family, but in Mom and Dad erasing the big mistakes of their lives and living happily ever after.

When you're agonizing over past mistakes, indulge in this fantastical ride into the world of quantum physics where, with a little creativity and good communication, you can fix not only all your present problems, but their very roots as well.

Reel to Real

According to a theory in quantum physics, two particles that once were joined can be light-years apart, and yet if something happens to one, the other responds instantaneously. How this applies to ex-husbands and long-dead relatives is anyone's guess.

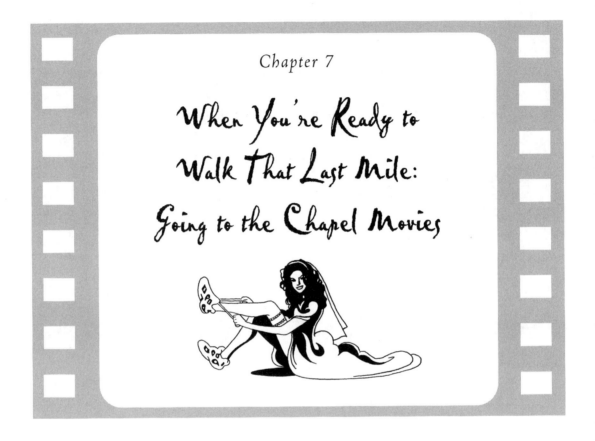

Chapter 7

When You're Ready to Walk That Last Mile: Going to the Chapel Movies

Finally, you're going to take the plunge, but as the date approaches, do you find you feel less like a bride-to-be than a lamb headed for the slaughter? Don't worry: weddings are an emotional time for everybody, and a bride's mood can vacillate wildly from bliss to terror and back again as she prepares to walk that last mile. If a wedding is looming on your emotional horizon, and you're developing a severe case of the wedding bell blues, or your mom has shifted into fifth gear and you're living in fear of a high-speed collision, don't freak out, chill out. Cuddle up in a soft pair of pj's, pull on a pair of fluffy slippers, consume large quantities of something that tastes great but has no nutritional value whatsoever, and indulge in these Going to the Chapel Movies guaranteed to make you feel better, no matter what your marital mood.

When You've Got a Case of Cold Feet

Are you doing the right thing? Is he really who you think he is, or is he just pretending to be civilized and considerate until the ink is dry—at which point he'll morph into some weird Dickens character and start making you do bizarre things like keep receipts and plan meals more than five minutes ahead of time? Are you really in a position to make a decision that's going to affect the rest of your life? What if the zipper breaks, the stocking runs, the flowers wilt, or the cake falls? What if this isn't really true love, but a vast global conspiracy to rob you of your saucy and irreverent independence, your maidenesque je ne sais quoi? Or what if you just simmer down now, take a load off, and watch one of these warm fuzzy movies, guaranteed to put the feeling back into those cold feet?

■ *Ever After* (1998)
 Stars: Drew Barrymore, Anjelica Huston, Dougray Scott
 Director: Andy Tennant
 Writers: Susannah Grant, Andy Tennant, Rick Parks,
 based on a story by Charles Perrault

There's nothing like a good old-fashioned fairy tale to make us feel all warm and cozy when we're feeling the frost of apprehension nipping at our noses. And there's nothing like an updated version of the Cinderella myth to remind us all that true love will find a way through any obstacle, and we should all have a little more faith in our fairy godmothers.

Danielle de Barbarac (Drew Barrymore) is a persecuted heroine for the new millennium, for it is not her beauty that distinguishes her from her evil stepsisters and stepmother, the Baroness Rodmilla (Anjelica Huston). Rather, it is her advanced social utopian philosophies, and her obvious opposition to the oppression inherent in a feudal system that render her a princess in pauper's clothing. Royal bad boy and reluctant monarch Prince Henry (Dougray Scott) is opposed to the oppression inherent in the divine right of kings, and so

despite the differences in their demographics, they manage to o'erleap the socioeconomic obstacles to their intimacy, and, yes, live happily ever after.

So if you're getting married in the morning, and you're worried about what tomorrow may bring, watch *Ever After* and believe in your happy ending.

■ *Every Girl Should Be Married* (1948)
Stars: *Betsy Drake, Cary Grant, Franchot Tone*
Director: *Don Hartman*
Writers: *Stephen Morehouse Avery, Don Hartman,*
 based on a story by Eleanor Harris

The postwar era has just begun, and shopgirl Anabel Sims (Betsy Drake) just wants to be a wife, stay at home, and cook pot roast for her mate. Okay, so her ambition to achieve her goal as Suzy Homemaker leads her to stalk a would-be husband in a manner that makes you wonder why he doesn't just apply for a restraining order. But, hey, she's got her cap set on Cary Grant, and, besides, this is the era when Rosie the Riveter was being tossed out of her job unceremoniously, so pursuing a career was a much more difficult venture than plucking a good provider from the pool of eligible bachelors. So can you blame her for being a little obsessive?

Yes, over just a short exchange at a magazine rack, Anabel determines that pediatrician Madison Brown (Cary Grant) is perfect husband material. She then sets in motion a complex plan to make him fall madly in love with her, drop to his knees, pop the question, and allow her to spend the rest of her life doting on him. Operation Mantrap requires her to spend long evenings researching the local society columns and making nosy phone calls to strangers in order to ascertain his food preferences, favorite reading materials, hobbies, and the color of his underwear.

Now, Madison is no fool, and he sees through all her ruses, yet despite his protests he eventually lets himself be led to the water and gulps from it as if it were the fountain of eternal happiness. Yep, he suddenly stops scolding Anabel for her brazen behavior and declares his undying love for her—just minutes before the minister she's confidently hired shows up at the door with *The Book of Common Prayer*.

So if you're worried that maybe you pushed him a little too hard, pop in this flick and

breathe a sigh of relief that any maneuverings on your part pale by comparison to those of this single-minded manhunter—and besides, though they'd rather die than admit it, guys like being chased, at least a little.

Reel to Real

Betsy Drake met Cary Grant in the summer of 1947 when they were both sailing on the *Queen Mary*. Cary, smitten by Betsy, pretended to make a phone call from a booth next to hers, and she "accidentally" fell into his arms when a huge wave caught the ship. Later, they began dating, Grant got her a film contract, and the two were married in December 1949.

Bev's Culinarytherapy: Handy Hints for Busy Brides Who Can't Boil Water

Well, you've gone and done it. You got married, and now you're expected to actually enter that rarely explored room adjacent to the dining room. You know, the one with the stove, and the refrigerator, and the sinkful of old take-out containers. And, even more alarming than this, you're expected to cook on that stove when it's made a perfectly good clothes-drying rack for all these years and you really don't see any reason to fix something that isn't broken.

If you're feeling overwhelmed by the effort it takes to feed the flames of your domestic bliss, put down that frying pan, put up your feet, and check out these handy hints for busy brides who can't boil water, guaranteed to take a load off and redistribute the labor.

continued . . .

Tip #1: *Think ahead.* Make sure that you've got a good backup supply of frozen dinners, because while whipping up that chicken l'elegance from scratch sounds like a good idea in the morning, you know full well that frozen chicken pot pie is going to be sounding a lot better by the time you get home from work. A good supply of take-out menus close at hand is also a good idea.

Tip #2: *Get out more often.* It's important for a bride to get plenty of fresh air and sunshine to maintain her sunny disposition. So when it's getting to be about dinnertime, take a walk to the nearest restaurant, and take your husband with you. You'll both be glad you did.

Tip #3: *Keep your sense of humor.* Next time he asks you why dinner isn't on the table, laugh really hard, and maybe even slap your knee a couple of times. He'll get the idea.

Tip #4: *Good posture prevents fatigue.* Then again, lying down works even better.

Tip #5: *While in the kitchen, dress comfortably.* In fact, don't dress at all. Believe me, he'll forget all about supper.

Tip #6: *Notice humorous and interesting anecdotes from your day to share at dinner.* For example, tell him that the bottom has fallen out of the market. Explain that with the NASDAQ plunging, not to mention the Dow, your vice presidency is on the line unless you can squeeze blood from a turnip. So if he thinks you're cooking dinner tonight he's delusional and ought to seek treatment instead of supper.

Tip #7: *Keep all cooking equipment within easy reach.* That way, he won't have to go hunting for it when it's time to make dinner.

■ *Runaway Bride* (1999)
 Stars: Julia Roberts, Richard Gere, Joan Cusack,
 Christopher Maloney
 Director: Garry Marshall
 Writers: Josann McGibbon, Sara Parriott

For some reason Maggie Carpenter (Julia Roberts) just can't seem to close the deal. She's been down and back up the aisle at least a dozen times, but she's never said "I do." Mainly because at the last minute she realizes that she totally doesn't. And so Maggie runs, or flies, or gallops off into the sunset at the last minute, all by herself.

Maybe the trouble is that Maggie just hasn't found the right man. Maybe it's that she hasn't found herself. Or maybe, as area reporter Ike Graham (Richard Gere) opines, it's that Maggie is a vicious man-eating tease who lures men to the altar only to dash their hopes in the eleventh hour.

Incensed at this grossly linear masculinist interpretation of her intimacy conflicts, Maggie writes a scathing letter to Ike's boss, and gets him fired. Thus it's up to Ike to come to town, just a few short days before Maggie's next nuptial attempt, to prove that he's been right about her all along. And of course, like all great eleventh-hour love/hate relationships, Maggie is at last able to say "I do" once a guy comes along who actually cares about finding out who she is.

This is a great movie to watch when you've got the "Oh my gosh is he really the right one for me?" jitters. Let Maggie reassure you that when the right man comes along, you'll know it, as long as you know yourself.

Always a Bridesmaid, Never a Bride

If you've stood up for everyone's wedding but your own, and are beginning to despair that you'll ever be able to turn in your pastel pumps for a pair of wedding slippers, these movies are a wonderful panacea for the why-her-and-not-me blues. They feature women who learn that the beauty of a wedding is no indicator of the beauty of a marriage, and being single might not be such a bad thing after all.

Muriel's Wedding (1994)
Stars: Toni Collette, Bill Hunter, Rachel Griffiths
Director and Writer: P. J. Hogan

This movie is about an ugly ducking (Toni Collette) from Porpoise Spit, Australia, who makes all of her ABBA-scored dancing-queen wedding dreams come true, only to discover that she'd much rather be on the road again with her best girlfriend (Rachel Griffiths) than tied down to a man she doesn't love, no matter how many times she sings "Fernando." This one's a great reminder that we really can make our dreams come true, so we better be careful what we wish for—and that a good soundtrack doesn't guarantee a happy marriage.

The Wedding Planner (2001)
Stars: Jennifer Lopez, Matthew McConaughey, Bridgette Wilson
Director: Adam Shankman
Writers: Pamela Falk, Michael Ellis

Mary (Jennifer Lopez) is a professional wedding planner, ever prepared with Krazy Glue, clothespins, and mouthwash for every conceivable disaster. What she isn't prepared for is the horrible discovery that that dimpled southern

continued . . .

gentleman pediatrician named Steven Edison (Matthew McConaughey), who just rescued her from a stiletto mishap and met her for a lovely not-really-a-date date, is the fiancé of her most important client, Francine Donolly (Bridgette Wilson). Once again poor Mary will be on the sidelines while someone else takes that happy walk . . . or is there a chance she will finally nab Dream Date Ken and get a chance to be Bridal Barbie herself?

Walking and Talking (1996)
Stars: Anne Heche, Catherine Keener, Todd Field,
 Liev Schreiber, Kevin Corrigan
Director and Writer: Nicole Holofcener

Amelia (Catherine Keener) has just learned that her cat has leukemia, and her only romantic prospect is some frizzy-haired, big-glasses video geek who thinks a hot date ought to start with a viewing of *Freak Show 7* or a visit to a sci-fi convention. But even he starts looking pretty good when Amelia discovers that her best buddy, Laura (Anne Heche), has just gotten engaged. Only after time and tearfully honest confrontations does she come to realize that being married is not necessarily the key to personal happiness and that a girlfriend's a girlfriend the rest of her life.

Out of Africa (1985)
Stars: Meryl Streep, Robert Redford
Director: Sydney Pollack
Writer: Kurt Luedtke, based on the novel by Isak Dinesen

After being snubbed by her lover, Karen Blixen (Meryl Streep), who is running out of options for marriage, decides to marry her lover's brother instead and spends her savings with the understanding that they're going to start a dairy farm in Africa. But then he disappears and she starts a coffee plantation. So the next time you're ready to make a desperate matrimonial move, watch *Out of Africa* and remember, single or married, if you want to start a farm in Africa, you're going to have to climb the Ngong Hills on your own steam.

When Your Mom Is in Wedding Overdrive

She's doing it to you, isn't she? Just like she always does. Things were going along just fine and then she has to start rocking the tippy wedding canoe, threatening to capsize the whole nuptial flotilla. First, she just had to have the sea-foam blue netting for the birdseed rosettes, even though you specifically told her it clashed with the holiday berry accents on the Godiva truffle table favors. And then, she goes ahead and orders the orange chiffonade frosting on the wedding cake even though she knows that orange chiffonade gives you hives and you specifically told her you preferred praline cream. If you're in the midst of a premarital mom-and-daughter duel to the death, maybe it's time to take a breath, declare a cease-fire, and watch one of these mother-of-the-bride movies designed to help keep the peace.

▪ *The Catered Affair* (1956)
Stars: Bette Davis, Ernest Borgnine, Debbie Reynolds, Barry Fitzgerald
Director: Richard Brooks
Writer: Gore Vidal, based on a play by Paddy Chayefsky

At first Mom's all for it, being the practical sort. Of course, she approves of you and your fiancé's plan for a simple, intimate ceremony with immediate family only. And then she starts talking to the neighbors at the fish market and listening to your fiancé's parents bragging about the big bashes they threw for their own kids. And she gets to thinking about how she never got to do her own wedding the way she wanted, and that far-too-plain dress she wore when she took her vows, and how if she stacked up the wedding presents she had to buy for other people over the years it'd dwarf the Empire State Building. Next thing you know she's promised away Dad's life savings, you've got relatives coming from all corners of the globe, and Mom is attempting to work out thirty years of repressed anger over her own disappointments by turning into the Mussolini of wedding planners.

If your own mom is starting to resemble Bette Davis on a mission, maybe you two should postpone the meeting with the ice sculptress and take time out to watch *The Catered*

Affair. Afterward, you can have a nice little chat about expectations, boundaries, compromise, and your fears of her going all Miss D on you.

▪ *Steel Magnolias* (1989)
Stars: Sally Field, Shirley MacLaine, Julia Roberts, Daryl Hannah, Dolly Parton
Director: Herbert Ross
Writer: Robert Harling

This southern slice-of-life movie about the blood, sweat, tears, love, laughter, and prenuptial cutting and styling that goes on in Truvy's (Dolly Parton) Beauty Parlor reminds us that particularly on your wedding day, a beauty parlor really is a metaphor for life. So you better be nice to your mom, because in this symbolic salon, she's the head stylist.

The movie begins on the morning of Shelby's (Julia Roberts) wedding. Shelby, who is the prettiest girl in town (well, she'd have to be, she's played by Julia Roberts), has a passion for pink, so much so that she's chosen two shades, blush and bashful, as her wedding colors. Now M'Lynn (Sally Field), Shelby's mom, has no particular argument with pink itself, but feels that two contrasting shades in the same wedding is a tad over the top. And of course, as moms are wont to do, she informs the entire tonsorial crowd at Truvy's that the chapel looks like it's been hosed down in Pepto-Bismol. Does this sort of bridal design criticism when it's too late to do anything about it sound familiar? We thought so.

While the wedding does go off without a hitch, and the chapel is indeed way too pink, sparks fly between mom and daughter throughout Shelby's young married life. They are often at odds about crucial issues, like shades of pink and family planning. But we come to realize throughout the course of this movie that criticism is not hostility, but affection and a reaffirmation of the familial bond. We also come to understand that M'Lynn's frustration, just like that of a lot of moms in real life, is her inability to protect her daughter any longer, not only from her overweening passion for pink, but from the consequences of her own excessive and often foolhardy thirst for life.

This is a great movie to watch with your mom when she's taking exception to your color-me-beautiful scheme. It'll remind you both that no matter how fierce the battle

between you two becomes, there's nothing that can't be repaired with a little understanding, love, laughter, and a really good mousse, and that the love between moms and daughters is the gel fix that keeps the whole hairstyle of family life in a perfect upsweep.

When Dad Isn't Going Along with Your Program

Moms aren't the only ones who can morph into alien creatures when you announce your engagement. Weddings bring up a lot of issues for dads, too, turning them into creatures who bear only a passing resemblance to the pop you once knew—you know, the pop who wasn't obsessed with details like whether sales taxes are lower three counties away where a wedding reception can be had on the cheap as long as there's no alcohol served whatsoever. Suddenly, he's trying to host a Rainbow Room reception on a basement-of-the-Elks-Club budget, or grumbling that you're not old enough to be making such a huge life decision even though you're thirty-six and run your own business with a staff of sixteen employees.

When Dad's puzzling prenuptial behavior has you wondering just who's going to be walking down the aisle with you—him, or The Creature from the Black Lagoon—pop in one of these movies about dads who need a little extra time to adjust to the new atmosphere.

■ *Betsy's Wedding* (1990)
 *Stars: Alan Alda, Molly Ringwald, Madeline Kahn,
 Ally Sheedy, Joe Pesci, Catherine O'Hara, Dylan Walsh*
 Director and Writer: Alan Alda

Sometimes it's not Mom who turns control freak when you get a ring on your finger, it's Dad. And as this movie shows, things will get bad enough when he starts overloading his credit card to give his princess "the wedding she deserves," but if he starts borrowing money and favors from his mafioso in-laws who resemble Joe Pesci, you'd better tell him to budget for a bulletproof vest.

Betsy (Molly Ringwald) may be marrying an investment banker whose parents live on Sutton Place in Manhattan, but all she and her fiancé, Jake (Dylan Walsh), want is just a quiet little affair with close friends and family instead of a glitzy extravaganza. Unfortunately, Betsy's father (Alan Alda), emboldened by a few too many snifters of fine brandy and intimidated by his new in-laws' wealth and power and their lavish bridal gifts, starts putting into motion a plan that will make Princess Diana's nuptials look low rent. Next thing you know, Betsy and her mom (Madeline Kahn) are all caught up in the mania. Eventually Betsy and Jake figure out that people who are mature enough to be married ought to be mature enough to stand up to their parents. This realization proves invaluable for their own marital happiness as well as the health and well-being of Betsy's dad, who is suddenly dodging bullets from a drive-by in front of a little Italian restaurant courtesy of the "business associates" of his uncle Oscar (Joe Pesci).

If your dad is using your nuptials as an excuse to reinvent his public image, why not take a break from negotiating about whether all the third cousins once removed have to be invited and enjoy *Betsy's Wedding* together? Maybe he'll take the hint and start listening a little more closely to your ideas for the big day.

Passive-Aggressive Mom Moments

Mrs. Pascal (Geneviève Bujold): Oh, my God, I sounded just like a mother! Didn't I sound just like a mother?

Marty (Josh Hamilton): You are a mother.

Mrs. Pascal: I know, but I still can't believe it. I look at you people and wonder, how did you ever fit in my womb?

★ from *The House of Yes*

▪ *Father of the Bride* (1950)
Stars: *Spencer Tracy, Elizabeth Taylor, Joan Bennett, Don Taylor*
Director: *Vincente Minnelli*
Writers: *Frances Goodrich, Albert Hackett,*
 based on the novel by Edward Streeter

Okay, so at least he's not insisting that you put milk-fed veal on the reception menu to please the elderly Italian in-laws when you've got a vegan smorgasbord all planned, or insisting that you save postage and hand-deliver all the invitations to guests within the tricounty area. But sometimes Dad's reluctance to let go of his little girl and let her make her own decisions manifests as a sort of universal grumpiness characterized by a pained look and inaudible grumble whenever you mention the "W" word, or your fiancé's name. In short, Dad has morphed into that classic father of the bride, Spencer Tracy, whose ambivalence about his daughter's pending nuptials has him acting the curmudgeon.

It's true, daughter Kay (Elizabeth Taylor) looks like she just got out of pigtails and overalls about three days ago, and she has far too much of an adolescent sparkle and softness about her chin to make her look like a woman ready to take the big leap. Is she headed for lifelong bliss, or a tabloidesque track record of a half dozen failed marriages? As Stanley (Spencer Tracy) reluctantly goes through with all the prewedding rituals, from meeting his new in-laws to viewing the garish display of loot mom and daughter have piled up in the dining room so that they can start the thank-you card list, we hear his running internal dialogue as he works his way to acceptance, pride, and happiness for his daughter.

When you're feeling that it's Dad who's got cold feet, take some time out to watch this classic dad/daughter film and see if it doesn't reassure him that prewedding jitters are normal for fathers too.

◎◎ *So Nice They Made It Twice:* In the remake, Steve Martin definitely had his moments, but the goofy, slapstick tone makes it far less warm and poignant than the original.

The Shirley MacLaine Trilogy of Terror

We don't know what it is about Shirley MacLaine, but she has made a career out of playing really, really Freudian moms, who remind us that even the most difficult of mother/daughter bonds are bonds of love, and that compared to Aurora Greenway or Doris Mann, you and your mom don't really have it so bad.

So when you need a megadose of mom-issue movie medicine, why not pull out the big guns and watch this triple feature, guaranteed to bring out the best in both of you?

Terms of Endearment (1983)
Stars: *Shirley MacLaine, Debra Winger, Jack Nicholson,*
 Danny DeVito, Jeff Daniels
Director: *James L. Brooks*
Writer: *James L. Brooks, based on the novel*
 by Larry McMurtry

This is an epic mom/daughter saga about how just because your mom has pulled head trips on you for, like, your whole life, or at least your whole life since you advanced beyond the preverbal stage, it doesn't mean that you don't love each other. Aurora Greenway (Shirley MacLaine) is an aging, suburban Scarlett O'Hara, whose daughter, Emma Horton (Debra Winger), seems more like a character out of *The Bad News Bears* than *Gone With the Wind*. Needless to say, dramatic and comedic conflict follows. You name it and Aurora and Emma face it in this sweeping mother-issue movie: love, money, parenting, aging, unfaithful husbands, and terminal illness—they run the gamut. And

continued . . .

through it all, they bicker at each other constantly but love and support each other with an unshakable devotion that will leave both you and your mom crying into your cherry Cokes and remembering when. So if your mom has been putting the belle in antebellum lately, and you're ready to strap on your musket and drive old Dixie down, watch *Terms of Endearment* together and preserve the union.

Postcards from the Edge (1990)
Stars: Meryl Streep, Shirley MacLaine, Dennis Quaid,
 Gene Hackman, Richard Dreyfuss
Director: Mike Nichols
Writer: Carrie Fisher, based on her book

If you think that your mom has been a little pushy ever since you said yes, and has been standing in your light during your wedding close-up, walk a mile in Suzanne Vale's (Meryl Streep) shoes in this movie about a daughter who has to outshine one of the brightest stars in Hollywood in order to get star billing in her own life. You'll feel much better about your own prima donna by comparison. Because nobody, but nobody, can out prima this donna.

Loosely based on the life of Carrie Fisher (who is Debbie Reynolds's daughter), this daughter-coming-of-age pic follows Suzanne's tentative and often emotional gravity-defying climb up the tree of maturity and self-acceptance. Suzanne's mom, Doris Mann (Shirley MacLaine), who is one of those screen legends that never dies but instead dons a turban and heavy eyeliner, and lives on as a gay icon, constantly rustles Suzanne's branches and does her legendary best to shake all the apples from her daughter's tree. In the end, though, because this is a Shirley MacLaine movie after all, Suzanne finds her own spotlight when she finds herself, and discovers that her mom is and always has been her biggest fan.

continued . . .

The Turning Point (1977)
Stars: *Shirley MacLaine, Anne Bancroft, Mikhail Baryshnikov, Leslie Browne*
Director: *Herbert Ross*
Writer: *Arthur Laurents*

There's nothing like watching a delicate and vulnerable prepubescent ballet protégée get knocked off her toe shoes by her mom's ballet blues to make you feel better about the maternal prima ballerina in your own life. Deedee (Shirley MacLaine) and Emma (Anne Bancroft) were both dancers of great promise. Emma went on to become a prima ballerina, while Deedee gave it all up to become a wife and mom. Ironically, Deedee gives birth to her own unrealized aspirations. Emma taps Deedee's daughter Emilia (Leslie Browne) to live out the life her mother should have had, and then sparks, fists, and self-images fly in an emotional *Swan Lake* that threatens to clip everybody's wings. But, of course, because this is a Shirley MacLaine movie, Deedee manages to make peace with herself and her daughter and her best friend. And Emilia manages to find her way onto the grand stage of life, taking her own place in this prodigious line of maternal swans who really do love their cygnets.

Shirley's Sugar Cookies

Don't worship me until I've earned it.
★ Shirley MacLaine as Aurora Greenway in *Terms of Endearment*

Now you go home and rethink your clothing.
★ Shirley MacLaine as Aurora Greenway in *The Evening Star*

I'm not crazy. I've just been in a very bad mood for the last forty years.
★ Shirley MacLaine as Ouiser Boudreaux in *Steel Magnolias*

Meet-the-Parents Panic

You were counting on tea for two, but add in your in-laws and you can start to feel like you number in the triple digits. When you march down that aisle and forge a brand-new family unit, you're going to have to face the fact that there is no avoiding your respective families of origin. In-laws are major players on the marital periodic table of elements, and no family chemistry is possible without them. But particularly around wedding time, they can be a pretty volatile and unpredictable substance. So if you've got the prewedding "Oh my God I'm not marrying a person I'm marrying a small metropolis" jitters, watch one of these Meet-the-Parents Panic Movies about in-laws who have learned to get the lions to lie down with the lambs.

■ **Meet the Parents** (2000)
 Stars: *Robert De Niro, Ben Stiller, Teri Polo,*
 Blythe Danner, Owen Wilson
 Director: *Jay Roach*
 Writers: *Jim Herzfeld, John Hamburg,*
 based on a story by Greg Glienna and Mary Ruth Clarke

If you're nervous about winning over the affections of your new in-laws, this movie will reassure you that even if every joke you tell falls to the floor with a thud, even if you lose their beloved cat, start a major fire, and desecrate their loved one's ashes, you can still be welcomed as part of one big happy family.

The unfortunately named Greg Focker (Ben Stiller), visiting his in-laws-to-be for the first time, is eager to crack a smile on the face of his fiancée's father, Jack Byrnes (Robert De Niro). However, he soon discovers that Jack is the kind of fellow who can suck all the air out of a joke or a room with just one of his confused looks. Moreover, Jack is the king of passive-aggressiveness, and his wife (Blythe Danner) and daughter, Pam (Teri Polo), are oblivious to just how excruciatingly tense the man can render any situation. No matter how hard Greg tries to please, he ends up saying exactly the wrong thing, plagiarizing *Godspell* lyrics when fumbling to say grace, or utterly humiliating himself in public. To top it off, Greg meets Pam's ex-boyfriend (Owen Wilson), a blond demigod who can do no wrong and who clearly is good buddies with Greg's nemesis, Jack. Will Greg ever enter what Jack likes to refer to as "the Byrnes family circle of trust"? Or will he be forever stuck sleeping in their basement, trying to remember that when he uses the guest bathroom he shouldn't flush lest he cause a septic overflow?

When you're facing your new in-laws for the first time, this is the perfect preparation. But should you decide it'd be a fun ice-breaker to view with them, you might want to take a cue from the beleaguered Greg and check out their sense of humor first.

Passive-Aggressive In-Law Moments

Jack Byrnes (Robert De Niro): I'm just curious, did you pick the color of the car?

Greg Focker (Ben Stiller): Uh no, the guy at the window did, why?

Jack Byrnes: Well, they say geniuses pick green.

Greg Focker: Oh.

Jack Byrnes: But you didn't pick it.

★　from *Meet the Parents*

I Do? I Do and Elvis Too

Planning a wedding soon? You and your
honey might want to take a cue from the stylish
on-screen weddings in movies like *Father of the
Bride* and *My Best Friend's Wedding*. Then again,
given some of the on-screen wedding horrors in
films over the years, maybe you want to turn elsewhere for inspiration . . .

Most Pathetic Proposal
✳ Danny Aiello's stumbling entreaty in *Moonstruck*, as coached by
his controlling bride-to-be.

Most Creative and Charming Proposal
✳ Sneaking onto her commercial flight and singing his original
love song, about how he'll fix the furnace and do the dishes for her,
over the plane's PA system, in *The Wedding Singer*.

Most Creative and Charming Proposal That Came Free
with Dinner
✳ A rigged fortune cookie in *Mickey Blue Eyes* (even if the waitress
does screw up and gives the would-be bride the wrong cookie!).

Worst Self-Penned Vows
✳ The goofy Dr. Seuss–inspired vows in *Miami Rhapsody*, to wit:
And will you love Leslie in the dark / and will you love her in the
park / and will you love her on a train / and will you love her in
the rain?

continued . . .

Worst Engagement Ring
✳ The carved napkin ring in *Miami Rhapsody*—even if it did belong to the groom's mother.

Worst Wedding Ring
✳ The huge, plastic multicolored heart that best man Hugh Grant borrows from a friend when he discovers that—bugger!— he's forgotten to bring the rings, in *Four Weddings and a Funeral.*

Worst Suggestion for Use of the Bridal Color Scheme
✳ Dyeing mashed potatoes blue, as suggested in *True Love.*

Most Gratuitous Wedding Accessories
✳ The three live swans for decorating the lawn in the remake of *Father of the Bride,* which get lost among the cars and snow.

Worst Wedding Gift
✳ The *Venus de Milo* statue with a clock in her belly, in *Father of the Bride* (both versions—how *did* they find two of these hideous pieces of kitsch?).

Worst Best Man's Toast
✳ Steve Buscemi's overly revelatory drunken rambling about the Puerto Rican prostitutes he and the groom entertained, in *The Wedding Singer.*

Best Best Man's Toast
✳ The one whispered into the best man's earpiece by ever- efficient, ever-eloquent, ever-tactful, and ever-sober wedding planner Jennifer Lopez in *The Wedding Planner.*

continued . . .

Worst Wedding Disaster
* The leaky outdoor tent in *Betsy's Wedding* that has everyone wading in mud.

Most Surreal Wedding Entertainment
* The rapping grandma in *The Wedding Singer*.

Worst Bridal Personal Hygiene
* Ivy's underarm statement in *Making Mr. Right,* which is a bit too Berkeley-in-the-seventies for our tastes.

Worst Walking-Down-the-Aisle Moment
* The bride in *Sixteen Candles*, who took a few too many "muscle relaxants."

Tackiest Wedding Dress
* That sparkly white, asymmetrical, poufy minidress with cleavage-bearing bodice and unstructured satin overskirt, accented with a cheap white silk top hat and white cowboy boots, in *Betsy's Wedding*.

Tackiest Bridesmaid Dresses
* The frothy pink satin hoopskirts with humongous flounces that make the bride's attendants look more like cupcakes than humans, in *Making Mr. Right*.

Most Dubious Substitution for Throwing Rice
* Leaflets thanking New York City for its support of the couple, dropped from a hot-air balloon rising over Central Park, in *It Could Happen to You*. Wouldn't a check made out to the Central Park Conservancy have been more environmentally sound?

■ *The House of Yes* (1997)
Stars: *Parker Posey, Josh Hamilton, Tori Spelling,*
 Geneviève Bujold, Freddie Prinze Jr.
Director: *Mark S. Waters*
Writer: *Mark S. Waters, based on the play by Wendy MacLeod*

Sometimes the best way to get a grip and get a little perspective on your meet-the-parents panic is to watch a movie about somebody who is in way worse shape than you are. And this new twist on *The House of Usher* is a movie about what happens when all of your most horrible Freudian nightmares come true, and the worst really does happen. Marty (Josh Hamilton), a young scion of the upper classes, takes his fiancée, Lesly (Tori Spelling), who is like a waitress in a doughnut shop or something, home to meet the family. From the moment their engagement is announced, Lesly is the target of a supernatural psychodrama involving Marty's sleek, elegant, sensual, and completely insane sister, Jackie-O (Parker Posey), who is passionate about her brother, pillbox hats, and pink Chanel-inspired suits circa 1963, in that order. And then there is Mrs. Pascal (Geneviève Bujold), Marty's freeze-dried, jaw-breakingly elegant, and teeth-crackingly controlled

Parker's Parfaits

I watch soap operas. I bake brownies. Normalcy is
coursing through my veins.
 ★ Parker Posey as Jackie-O in *The House of Yes*

I can sit there and do nothing as good as anyone.
 ★ Parker Posey as Margaret in *Clockwatchers*

Goo is what tape is all about. Goo is what makes it tape. Without
goo, it would just be paper.
 ★ Parker Posey as Jackie-O in *The House of Yes*

mother, who despite her masterful skills of manipulation cannot manage to keep hell from breaking loose. If you're experiencing a few archetypal phobias of your own, spend the night with the Pascals and thank your lucky stars that you're not walking the last mile in a pillbox hat.

■ *Mickey Blue Eyes* (1999)
Stars: *Hugh Grant, James Caan, Jeanne Tripplehorn, Burt Young, James Fox, Joe Viterelli, John Ventimiglia*
Director: *Kelly Makin*
Writers: *Adam Scheinman, Robert Kuhn*

Janet Vitale (Jeanne Tripplehorn) knows that her charming, veddy British, and unfailingly polite fiancé, Michael Felgate (Hugh Grant), is an accommodating kind of guy, and she also knows that when it comes to boundaries, her family is the equivalent of a herd of mad buffalo. This, of course, is a recipe for wedding disaster. But try as she might to head things off at the pass, Janet can't prevent Michael from trying to ingratiate himself to his future father-in-law (James Caan). Next thing you know, Michael is laundering money for the mob, burying dead bodies near the East River in the middle of the night, adopting the moniker "Mickey Blue Eyes" and a Brooklyn-meets-Elmer-Fudd accent, and plotting an FBI sting to be carried out at his and Janet's wedding. He'd like to untangle himself from his commitments to Dad, cousin Johnny (John Ventimiglia), and Vinnie "The Shrimp" D'Agostino (Joe Viterelli), but apparently it's going to take the assistance of an entire team of special agents. Well, it's true, Janet didn't make things any easier when she put a bullet in the head of her own cousin, but, you know, you get married, you're in it together, aren't you?

This is a great movie to watch when both sets of in-laws are starting to beat the war drums over your wedding plans, if only to have a good laugh while reminding yourselves that if you do end up having to compromise on a few issues, at least you won't have to commit federal offenses just to keep the peace.

Chapter 8

Is This the Party to Whom I Am Speaking?:
Crisis of Communication Movies

Communication across the gender gap can prove to be a formidable chasm to bridge. It's not really that guys are communication challenged. It's just that guys and gals have different ways of expressing themselves. And for women, guyspeak can sometimes come off sounding really ... well ... stupid, pigheaded, and ill-advised, not to mention self-centered, insensitive, and perennially adolescent. And to guys, galspeak can come off as a tad intrusive, relentless, and candy coated in guilt, which is, of course, a total misreading of our intentions, and obviously says more about their pervasive defensiveness than our efforts to save them from themselves. But clearly, without an interpreter present to decipher the negotiations, diplomatic relations can get a little strained. So if you say "tomayto" and he says "tomahto," you say "Take out the garbage" and he says "Tomorrow," and you're both ready to call the whole thing off, watch one of these Crisis of Communication Movies and bridge the communication gap that separates you, using trust, intimacy, and good listening skills, and learn how to get through to each other without wielding a blunt object.

▪ *What Lies Beneath* (2000)
Stars: Harrison Ford, Michelle Pfeiffer, Diana Scarwid
Director: Robert Zemeckis
Writers: Sarah Kernochan, Clark Gregg

She's got the perfect home and the perfect husband, and the perfect dog, and the perfect kids, and the perfect waffle iron, and the perfect cheekbones, and she's so thin that sometimes, on a sunny morning, you can hold her up to the light and see right through her. But things just haven't been right for Claire Spenser (Michelle Pfeiffer) since that car accident last year that robbed her of her sense of safety, her emotional stability, and big blocks of her recent memory. And now, just as she's getting back on her feet emotionally, random and unsettling events start occurring. Doors start swinging open of their own accord, spigots turn on and flood the house with water, and before she knows it, Freudian metaphors for uncontrollable emotion and buried pain start manifesting all over the cozy lake cottage. Then apparitions of young dead college students begin appearing beneath the pristine confluences of the overflowing Italian porcelain, Pottery Barn–accessorized claw-foot bathtub. What's a haunted housewife to do? Why, get a Ouija board, of course, and ask the spirit world for answers. Actually, what she should really do is make her husband, Norman (Harrison Ford), who's been walking around with that look on his face like he's been constipated for the last six weeks, sit down and explain just what he's been up to during those late office hours over at Blond Coed University.

Of course, as this movie clearly illustrates, it's not easy to communicate with a man who expresses himself in guttural monosyllables, smoldering looks, and an occasional and barely perceptible fluttering of his mastic muscles when he's under extreme stress. And so Claire begins to use more visceral forms of communication to get to the heart of the matter, like jumping into the lake at sunset and coming up with a muddy key, and channeling the Lolita-esque sexual advances of a deceased but still kittenish coed. But in the end, faced with the stone wall of Norman's minimalist communication style, she is forced to resort to blunt force with a sharp object.

When you feel like there's something going on beneath the surface, plumb the depths with *What Lies Beneath* and remember, just as everything that goes up must come down, everything that sinks will eventually surface, and when it does, it will come looking for you,

even if you are in the comfort and safety of your own claw-foot bathtub. So instead of weighing down your secrets with concrete overshoes, bring them up into the fresh air and talk things through. Because the truth will set you free, even if it nets somebody else ten to twenty years of hard labor.

Feminine Laments

You speak so many bloody languages, and you never want to talk.

★ Kristin Scott Thomas as Katharine Clifton
in *The English Patient*

▪ *Wit* (2001)
Stars: Emma Thompson, Christopher Lloyd, Jonathan M. Woodward,
 Audra McDonald
Director: Mike Nichols
Writers: Emma Thompson, Mike Nichols,
 based on the play by Margaret Edson

Having an unsurpassed command of the English language may earn you tenure as a professor of seventeenth-century poetry, but as this movie points out, when you use wit and sarcasm as defenses against your vulnerability it can be a major barrier to true communication, human connection, and healing.

Emma Thompson plays Vivian Bearing, a hyperarticulate professor who can explain in great detail why there is a comma in the last line of a John Donne poem as opposed to a semicolon. Medical jargon isn't beyond her either—she can follow all that stuff about "nephrotoxicity," "myelosuppression," and "treatment modalities for invasive epithelial carcinomas," so she understands exactly what is happening to her as a stage-four ovarian cancer patient undergoing experimental chemotherapy—and it ain't pretty. Vivian's

ultracivilized and satrical manner very much suits her doctor (Christopher Lloyd), who is all business. It also suits his assistant (Jonathan M. Woodward), a former student of Vivian's who is far more interested in cancer cell replication than human interaction, and has the annoying habit of asking her "How are you feeling today?" in a most distracted and disinterested way. Obviously the answer is "As miserable as can be and ready to retch once again," and yet all Vivian can reply is "Fine," because she is afraid to tell anyone the truth about her pain and fear. With hours to spend alone in an airless, windowless hospital room, she has plenty of time to reflect on how her mastery of language has served her well—and badly. Eventually, as her condition deteriorates, she befriends a kindly, salt-of-the-earth nurse (Audra McDonald), and Vivian comes to see that the most beautiful poems are often those that have no words but are made up of simple acts of compassion.

This is a great movie to watch with your mate when one or both of you have been caught up in verbal swordplay and eloquent defensiveness. See if it doesn't inspire you to lay down your arms and surrender to honest expressions of difficult feelings.

Tallulah's Toffees

I read Shakespeare and the Bible, and I can shoot dice.
 That's what I call a liberal education.

★ Tallulah Bankhead

I'm as pure as the driven slush.

★ Tallulah Bankhead

It's the good girls who keep diaries. The bad girls never have
 the time.

★ Tallulah Bankhead

Manly, Yes, but Ladies Like It Too: The Reluctant Hero

The reluctant hero is just an ordinary, mild-mannered, hardworking guy who is forced to become extraordinary due to extenuating circumstances—although, by his account, he's not doing anything more than taking out the recyclables. In the world of the reluctant hero, shit happens. There he is, just minding his own business, not saying a word, and then, out of the blue, the evil empire decides to blow up the world or something, and suddenly our average Joe is forced to don the hero's mantle and save the planet. So if you've been wondering lately whether your guy's walk matches his talk, watch one of these Reluctant Hero Movies and remember that inside every ordinary tight-lipped guy beats the heart of a hero.

Star Wars (1977)
Stars: Mark Hamill, Harrison Ford, Carrie Fisher,
* Alec Guinness, James Earl Jones (as the voice of Darth Vader)*
Director and Writer: George Lucas

We were dazzled by the special effects, and we cheered for the intergalactic Jedi knight in a shining kung-fu-inspired ensemble and a really amazing utility belt, Luke Skywalker (Mark Hamill), but it's that Wookiee-loving, tool-belt-wearing, wisecracking, tin-can-flying, son-of-a-top-gun Han Solo (Harrison Ford) who stole our hearts away. There's just something about a slightly tarnished, mercenary, rough-and-ready cowboy who grumbles his way to greatness that makes us all feel a little closer to the heroic, because if Han Solo can see the light and become a soldier for truth, justice, and the Force, then so can your cranky star warrior.

continued . . .

Lethal Weapon (1987)
Stars: *Mel Gibson, Danny Glover, Gary Busey, Darlene Love*
Director: *Richard Donner*
Writer: *Shane Black*

Det. Martin Riggs (Mel Gibson) is so distraught over the death of his young wife that he holds a daily debate with his own hollow-point bullet about whether he should get out of bed and go to work or suck on the barrel of his .44 Magnum and end it all. And he cries a lot, which is a really endearing quality in an irreverent and unorthodox cowboy of a cop with eyes as blue as the azure skies of deepest summer.

For obvious reasons, nobody wants to partner with Riggs, but when a prostitute, who turns out to be the daughter of a bank president, is murdered, Det. Sgt. Roger Murtaugh (Danny Glover) reluctantly joins forces with Riggs to catch the killer and drop the net on a sinister ring of heroin smugglers.

Detective Riggs reminds us all that if this morally conflicted, psychically injured, and vulnerable crusader can find a way to rise above his personal conflicts and perform epic acts of heroic redemption, then so can your lethal weapon.

Men in Black (1997)
Stars: *Will Smith, Tommy Lee Jones, Linda Fiorentino,*
 Vincent D'Onofrio, Rip Torn
Director: *Barry Sonnenfeld*
Writer: *Ed Solomon, based on the comic*
 by Lowell Cunningham

Rookie agent J. Edwards (Will Smith) is skeptical about the new job that has been thrust upon him. Well, it's difficult for a wisecracking, down-

continued . . .

to-earth beat cop like Edwards to accept that there are aliens walking around the streets of Manhattan masquerading as normal earthlings and just waiting until the time is right to take control of Gotham. And he's pretty nonplussed by all the new equipment he's forced to learn to manipulate too, like neuralyzers and reverberating carbonizers, and such. But despite his skepticism, Agent J manages to suspend his disbelief and save the world from the evil intergalactic intent of a sinister alien force. Which is reassuring because it's nice to know that even the class clown can save the world if he has to, because one of the best weapons in the hero's arsenal is a healthy sense of humor.

You Can Say That Again

Traveling through hyperspace ain't like dusting crops, boy.

★ Harrison Ford as Han Solo in *Star Wars*

I've just been down the gut of an interstellar cockroach. That's one of a million memories I don't want.

★ Tommy Lee Jones as Agent K in *Men in Black*

The more you tighten your grip, Tarkin, the more star systems will slip through your fingers.

★ Carrie Fisher as Princess Leia in *Star Wars*

Words to Live By

To love oneself is the start of a lifelong romance.
★ Rupert Everett as Lord Arthur Goring in *An Ideal Husband*

Sucking all the marrow out of life doesn't mean
choking on the bone.
★ Robin Williams as John Keating in *Dead Poets Society*

To look at a thing is quite different from seeing a thing, for one
does not see a thing until one sees its beauty.
★ Minnie Driver as Mabel Chiltern in *An Ideal Husband*

As long as the roots are not severed, all is well. And all will be well
in the garden.
★ Peter Sellers as Chance the Gardener in *Being There*

■ *The Story of Us* (1999)
Stars: Bruce Willis, Michelle Pfeiffer, Paul Reiser,
Rita Wilson, Rob Reiner, Julie Hagerty
Director: Rob Reiner
Writers: Alan Zweibel, Jessie Nelson

Ben (Bruce Willis) and Katie Jordan (Michelle Pfeiffer) have textbook case complaints about their marriage, and after fifteen years of being ground down by each other's character flaws, they're ready to separate. But as this movie shows, if you're willing to open the lines of communication, be honest with yourself about your own failings, and for goodness' sake, say "I'm sorry" already, there may still be hope.

The kids are about to go off to camp for the summer, so Ben and Katie have decided a

trial separation is in order. They figure that while they're living apart for a few months, it's best to put on happy camper faces for the kids and pretend everything's all milk and cookies (a psychologically dubious course of action, but we'll let it pass for now). Ben is an old-fashioned romantic who keeps reaching out to Katie to make peace but is oblivious to how burdened she is by taking on all the boring responsibilities, like getting the kids to the bus on time or remembering to refill the washer fluid in the car. Katie, a hyperorganized cruciverbalist, would like to rediscover the fun-loving girl she was all those years ago, but years of playing Wendy to his Peter Pan have her ready to abandon ship.

Over the course of the summer Katie and Ben listen to the advice of their clueless friends, try to remember anything of value that the parade of marriage counselors they've seen have offered, and figure out if there's enough left between them—aside from their commitment to the kids—to keep the marriage going. Can they let go of their resentments, apologize, and move forward? Or will they have to keep finding quiet corners where they can cry as a sorrowful little Eric Clapton tune plays?

Although there are some frustratingly unhealthy little remarks that pop up here and there—like Katie's revelation that she fears her playful self won't come back unless Ben's in the picture, or that repetitive Clapton lyric about being "nothing without you"—overall this movie celebrates the triumph of communication over assumptions, and reminds us that being right is not always as important as being together.

> ⚠ Warning Label: *The poignant scenes are set off by plenty of humorous ones, but for some strange reason nearly all of the jokes are obnoxiously vulgar, whether they're told by the fellas or the gals. Frankly, we started thinking Silent Bob and Jay were gonna show up any minute.*

■ *Dog Day Afternoon* (1975)

Stars: Al Pacino, Penelope Allen, John Cazale, Charles Durning,
 Carol Kane, Chris Sarandon
Director: Sidney Lumet
Writer: Frank Pierson, based on the novel by P. F. Kluge and Thomas Moore

Never has the devastating potential of garbled communications been more pyrotechnically realized than in Sidney Lumet's black comedy, based on a true story about one of the world's most incompetent bank robbers.

Sonny (Al Pacino) is a down-on-his-luck Brooklyn guy gone wrong, who is married with children *and* attempting to fund a sex-change operation for his transsexual lover, Leon (Chris Sarandon). Straddling the horns of a dilemma like that is not easy, granted. But neither is the cockamamie scheme that Sonny cooks up along with his handpicked band of down-and-outers. Among them is the serenely clueless Sal (John Cazale)—who really doesn't know how to handle anything more complicated than a hot dog on a bun—who lands Sonny in the middle of a two-day hostage situation. Within minutes Sonny winds up surrounded by police and a crowd of spirited, Brooklyn-in-the-sixties-inspired extras, and a blizzard of media. Hounded and cheered on by the maelstrom outside, and the unfolding soap opera inside the bank, Sonny steers his way, slowly but surely, down a collision course with his own tragic, twisted, and just plain stupid destiny. And all because, like most guys, he couldn't find a way to say, "I'm sorry, darling, I was wrong, you were right as you usually are, and I'll never, never do it again." Oh, and, "You're going to have to find a way to fund your own sex-change operation, though, because I can't afford it" probably would have been an important boundary to communicate also.

So when your hero has stumbled and you're worried he might have permanently fractured his confidence, but he refuses to tell you where it hurts, lock the vault and watch *Dog Day Afternoon* with him in the middle of the day, when you're both supposed to be doing something more productive. There's nothing like playing hooky together, and having a good laugh at the total futility of somebody else's existence, to pick you up when you're feeling ineffectual and alienated from the world. And Sonny's crisis of communication will remind you both that even the most incendiary situations can be handled calmly and peacefully, and without bloodshed, as long as you talk things through one step at a time, and nobody tries to board a private jet to Costa Rica.

Can I Get That Printed on a Coffee Mug?

Flattery will get you nowhere . . . but don't stop trying.

★ Lois Maxwell as Miss Moneypenny in *Dr. No*

I once asked this literary agent what writing paid the best, and he said, "ransom notes."

★ Gene Hackman as Harry Zimm in *Get Shorty*

Hoopskirt Dreams

When it comes to expressing themselves through clothing, these female characters say volumes with their choice of garments—and what they say is that they're creative and whimsical, brave and vulnerable, sexy and playful. See if they don't inspire you to make fashion statements that are true to the real you.

Living Out Loud (1998)

In *Living Out Loud*, Queen Latifah dons one clingy silk chanteuse gown after another, each more sensual than the last, and every one of them shows off her delicious curves and generous assets. She belts out standards while wearing a bright scarlet, long-sleeve, bare-shoulders sheath; or a mandarin-inspired halter top gown in chartreuse silk embossed with roses; or a golden dress draped Grecian-style around her formidable breasts. Sheesh, even her *bras* are breath-

continued . . .

taking. With this wardobe, any woman could go out and conquer the world—although if you want to belt out torch songs at your local club, we suggest you lip-synch if you have to follow the Queen's act. *Costumes by Jeffrey Kurland.*

Dream Wife (1953)

In *Dream Wife*, Deborah Kerr plays the unflappable Effie, whose fiancé threatens to dump her for a more pliable girl. Effie just keeps her cool and continues to show up in delicious dresses like a gown with a clingy black lace bodice and black net overskirt on top of layers of petticoats, and a little black dress with leopard-skin collar and cuff. And, oh, that black-and-white polka-dot strapless with silk sash and diamond brooch at the waist! When a gal looks this fabulous and confident, *he* ought to be the one walking five paces behind. *Costumes by Herschel McCoy and Helen Rose.*

The Dress Code (2000) (a k a Bruno)

Angela (Stacy Halprin), a dress designer, has the sort of figure you don't often see in movies in this era of underfed fashion models, but her unapologetic clothing statements are an inspiration to any woman, oversized or not. She favors bold, bright reds and royal blues, with matching headbands. We especially liked the scarlet pantsuit with black faux ostrich feather cuffs and black flapper beads and crucifix necklace. And what accessories—we'd love to get a copy of her Barbie-pink bag with pompons and feather boa trim. But our favorite has to be the royal blue silk pantsuit topped with a yellow silk robe that has a huge peacock on the back, which actually matches her Cadillac convertible (hot pink interior, yellow exterior with a peacock feather decal stretching from bumper to bumper). With a mom like this for a role model, it's no wonder her son, Bruno, starts donning Bob Mackie–esque vestments to wear to spelling bees. *Costumes by Natasha Landau.*

continued . . .

Forever, Darling (1956)

Lucille Ball as Susan Vega is bored with her marriage and her life, but her clothes capture her adventurousness, sensuality, and playfulness. She sleeps in a gossamer white negligee, entertains over a simple meal while wearing a blue flowered silk dress with a stiff off-the-shoulder collar accented by diamond earrings and necklace, and lounges around the house in a white with black-and-blue Pollock-esque flower print dress with floppy bow neckline. The cake topper, however, is that outfit with satin lavender pants and a lime, short-sleeve overdress with a flower-and-leaves garland print at the waist, which she wears in the backyard and which actually matches her lawn furniture! With clothes like this, what on earth is she doing moping around the house? *Costumes by Eloise Jensson.*

The Bliss of Mrs. Blossom (1968)

Mrs. Blossom (Shirley MacLaine) has a little secret that makes her feel all tingly inside, and it inspires her to wear one beautifully whimsical Carnaby street getup after another. There's that orange, mustard, and fuschia chiffon pleated minidress with cleavage-bearing scoopneck; the art nouveau–inspired, empire-waisted, jade maxidress; and the green, pink, and red abstract design cape that cascades over her purple tunic and tights and floods the floor. She even putters around the kitchen in a silver flapper dress and a taxicab-yellow feather boa. With these outfits, Harriet's a walking billboard for sensual self-expression. *Costumes by Jocelyn Rickards.*

Ghost World (2001)

Enid (Thora Birch) is a directionless teen in search of authenticity, and her clothes scream outcast—but she doesn't realize that her quirky fashion

continued . . .

sense is exactly what makes *her* an original. Enid pairs a rust-colored miniskirt with a green suede vintage jacket and white Gilligan cap, or blue-and-kelly-green plaid miniskirt with an iron-transfer dinosaur T-shirt, a big shaggy red purse, black Doc Martens, and black plastic science-teacher glasses to match her black Louise Brooks bobbed hair. Whether or not she gets to art school, we're convinced that Enid's bold creativity will serve her well and eventually reach an appreciative audience. *Costumes by Mary Zophres.*

■ *The Perfect Storm* (2000)
Stars: George Clooney, Mark Wahlberg, Diane Lane,
 Karen Allen, Mary Elizabeth Mastrantonio
Director: Wolfgang Petersen
Writers: Sebastian Junger, Bill Wittliff, based on the book by Sebastian Junger

This film offers another classic example of a guy who refuses to communicate his actual situation, or his hidden agenda, and doesn't demonstrate very effective listening skills either, but insists instead on swaggering, cocksure, intent on doing exactly what you told him not to do. And where does he end up? Why, in the teeth of the monster, of course, just like his girlfriend—as well as most meteorological experts and the U. S. Coast Guard—knew that he would.

Billy Tyne (George Clooney) is a Gloucester, Massachusetts, sword-boat captain whose repertoire is limited to a ten-mile stare, a wistful grin, poetic non sequiturs, and catching fish. So when the fish stop biting, Billy gets a little itchy, and after uttering a string of poetic non sequiturs while staring out to sea with a wistful grin, he points the *Andrea Gale* into the distant horizon and winds up in the teeth of the storm.

Billy's crew is similarly thematically monofocused and linear masculist. There's Bobby (Mark Wahlberg), who is an embodiment of the sailor's dilemma, passionately in love with a woman and the sea; Murph, devoted to his ex-wife and child, and the sea; Bugsy, the embodiment of the isolation of the sea when there is no love on shore; and Sully, who's pissed off a lot at the sea and just about everything else. Together they spit in the eye of their detractors, who don't think they've got what it takes to catch the big fish anymore, but

wind up spitting into the gale-force winds of the perfect storm instead. Which, as you know, comes back at you twice as hard. Many suspense-filled, special-effect-laden disaster sequences ensue, as Skipper Billy Tyne gazes off into the distance with a wistful grin and a string of poetic non sequiturs.

Meanwhile, back on shore, the same women, meteorologists, and Coast Guard who told them not to sail off in the first place have to sit around and wait for the disastrous consequences of Billy Tyne's hubris to strike.

Watch this one with your sword-boat captain when he is threatening to steer toward the Grand Banks in October in order to prove his manhood and stops responding to your emergency weather alerts. It'll remind him that when a woman says something on his emergency frequency like, "Turn around, you're headed right into the eye of the monster," she isn't just whistling "Dixie," and he should probably just listen and turn around if he ever expects to survive the perfect storm.

Eye Candy Alert: This is also a great movie to watch while he's away at sea, because George Clooney looks totally hot in a skipper's cap and that adorable twenty-four-hour shadow, as he gazes distractedly out to sea, grinning wistfully and whispering poetic non sequiturs as the sun sinks slowly into the deep-green sea.

Stupid Guy Quotes

Bobby Shatford (Mark Wahlberg): I got a woman
who I can't stand to be two feet away from.
Capt. Billy Tyne (George Clooney): Congratulations.
Bobby Shatford: Then again, I love to fish.
★ from *The Perfect Storm*

Andy Kaufman (Jim Carrey): You don't know the real me.
Lynne Margulies (Courtney Love): There isn't a real you.
Andy Kaufman: Oh, yeah, I forgot. ★ from *Man on the Moon*

Misty Man Movies

One of the magical things about movies is that even a guy who remains stoic at his own father's funeral can access his tears when he views an emotionally intense film—especially one that touches on a bunch of guy issues. If your man managed to stay dry-eyed through *Beaches* and *Love Story*, and he badly needs to irrigate, watch one of these Misty Man Movies that will turn on the taps.

Misty Man Movie	Floodgate Opening Scene
Brian's Song	when Gayle has to tell the fellas in the locker room the bad news about Brian Piccolo
One Flew Over the Cuckoo's Nest	when the Chief throws that huge sink through the window
Gladiator	when Russell Crowe goes toward the light
Spartacus	when everyone starts claiming to be Spartacus
The Grapes of Wrath	when Tom Joad tells Maw where she can find him in the future
Mr. Holland's Opus	when Mr. Holland sings "Beautiful Boy" to his deaf son
Mr. Smith Goes to Washington	oh, that filibuster!
Saving Private Ryan	when Tom Hanks asks Matt Damon to return a few favors by living a full, rich life

continued . . .

Old Yeller	when the little boy has to send Old Yeller to that big, beautiful meadow in the sky
Field of Dreams	when Kevin Costner asks his dad, long dead but come back thanks to the magic of Ray's cornfield baseball diamond, if he wants to play catch
The Pride of the Yankees	when Lou hits that homer for the little boy in the hospital bed, and again when the dying Lou pronounces himself a "lucky" man
Shane	when Shane at last leaves town, knowing his duty is done
Rocky	when Rocky cries out for Adrian, having lost the battle but won his war for self-respect
Star Trek II	hey, any man who can stay dry-eyed after Spock expires *has* to be a Vulcan

■ *The Naked Edge* (1961)
 Stars: Gary Cooper, Deborah Kerr
 Director: Michael Anderson
 Writer: Joseph Stefano, based on
 the novel *First Train to Babylon* by Max Ehrlich

Let's face it: at some point in any romantic relationship you're going to have a few suspicions about something, but as *The Naked Edge* points out, better to insist on clearing the air and receiving solid proof of his innocence than reconcile yourself to accepting the worst.

This is particularly true if the worst means spending your days with a man who plotted and carried out a classic film noir murder complete with unrecovered cash and a working-class stooge to pin it all on. Hey, just because he looks like a demigod of the silver screen when he puts on that wounded look doesn't mean you have to make nice and stop asking questions.

Deborah Kerr plays Martha Radcliffe, wife to a tight-lipped businessman named George (Gary Cooper), whose reluctant testimony sent a man to prison for a botched burglary at their workplace. She desperately wants to believe there's a reasonable explanation for her husband's mysterious wanderings and sudden post-robbery prosperity. When she finally confronts him, after years of silence on the subject, George gets all huffy and insists there is a simple explanation for everything—it's just that, well, you know, it was all so long ago and he can't remember where he filed all his bank statements. Martha smiles apologetically, and then sneaks off once again to squint at the microfilm of the trial transcripts. She then starts checking out his story with his friends, business associates, and even strangers, in a vain attempt to avoid upsetting him, but the more she creeps about, the angrier he gets—and the more we wonder if he's a brilliantly sinister murderer or just intensely stupid about the importance of good marital communication.

Next time your own fellow turns into the strong and silent type, have him watch *The Naked Edge* with you. Maybe then he'll see that the Gary Cooper guess-what-I'm-thinking act works great for keeping the suspense high in a classic whodunit movie, but in real life it's gonna drive you bonkers.

Nancy's Momentous Minutiae: Crocodile Tears

When a director wanted her to cry in a scene, child star Margaret O'Brien asked whether she ought to let the tears roll all the way down her face or stop them halfway down her cheeks.

Joan Crawford could not only cry on cue, she could cry out of one eye if she wanted to.

■ *Man on the Moon* (1999)
Stars: Jim Carrey, Courtney Love, Danny DeVito
Director: Miloš Forman
Writers: Scott Alexander, Larry Karaszewski

Okay, this is a good movie to watch because it reassures us that if there was somebody out there who could communicate with Andy Kaufman, a comedian who was quite literally on the moon in every emotional and psychological sense of the word, then you're bound to be able to get past your guy's communication breakdowns, because at least you don't have to communicate with an emotional extraterrestrial who has made being annoying into a career.

Jim Carrey (of course) stars as Andy Kaufman in this biopic of the offbeat comedian of *Taxi* fame, who began his career doing freakish and often really irritating stunts in an attempt to point an unflattering and accusatory finger at the absurdity of modern life. Then he became lovable Latka and everybody forgave him, until he got into the wrestling thing and everybody got pissed off again. But beneath that squeaky voiced exterior was an insular and eccentric man who found it difficult to communicate except through the use of grotesque pop culture symbols and rigid dietary constraints. Try getting a guy like this to respond to simple commands or express his vulnerability.

So if your man has been in outer space lately, bring him back down to earth with *Man on the Moon*, and remind him that if he expects to keep his relationship here on earth a healthy one, he's going to have to climb out of his space capsule every now and again, and tell you what's on his mind.

■ *What Women Want* (2000)
Stars: Mel Gibson, Helen Hunt, Marisa Tomei, Ashley Johnson, Bette Midler
Director: Nancy Meyers
Writers: Josh Goldsmith, Cathy Yuspa, based on a story by
Josh Goldsmith, Cathy Yuspa, and Diane Drake

In this whimsical movie about a caveman civilized by the influence of women, a sexist ad man named Nick (Mel Gibson) magically develops the ability to hear women's inner

thoughts, and once he stops exploiting the information for his own personal gain he actually becomes a better lover, father, co-worker, and human being. The unanswered question is, once he loses his mind-reading ability, will he bother to start asking the women in his life what they're thinking, or will he just assume he knows, based on past experience?

Nick's teenage daughter, Alexandra (Ashley Johnson), is pleasantly shocked that her absentee father suddenly has taken an interest in her life and prom plans; his lover, Lola (Marisa Tomei), is thrilled that this slow-starter has turned out to be a sex god after all; and his work rival, Darcy McGuire (Helen Hunt), can't figure out how he comes up with her exact ideas a split second before she expresses them to their boss. Eventually, Nick recognizes the responsibility that comes with knowing more than he ought, finds his noblest self, and even uses his new powers to rescue a suicidal underling (in a particularly preposterous scene). Yes, he has found the Grail and returned it to the Lady of the Lake, rediscovered his yin and balanced it with his yang, learned the fine art of listening rather than just hearing, and speaks with a new respect for women.

This is a great movie to watch with your own mind reader, who will probably be surprised to discover what kinds of thoughts really buzz around in women's brains. Then you can promise him that you won't expect him to guess what's in your head if he promises not to make assumptions and to really listen.

Chapter 9

Balancing Your Bottom Line: Money Issue Movies

It can be difficult for somebody who wields a charge card like a machete in the rain forest of life to understand someone who tosses pennies around like they're manhole covers. And it's just as hard for someone whose dream house has a north wing, a south wing, and an indoor Jacuzzi to live with the idea that it's going to take six months of budgeting just to save up for a dishwasher. We all have different expectations where money is concerned, and we all struggle, both as individuals and as couples, to live happily within our means. And sometimes, no matter how hard we try, we wind up a day late, a dollar short, and pointing our counting finger at our significant others, looking for payback. At times like this, it's important to remember that your profit margin is measured not in marks, yen, or dollars and cents, but in affection, cooperation, and mutual goodwill.

So when that clinking clanking banking sound is disturbing the peace and quiet of your domestic utopia, and your columns just aren't adding up, watch one of these Money Issue Movies about couples who have learned to rise above their money issues and realized that the richest person in town is the one who is rich in love.

■ *Startup.com* (2001)
Stars: Kaleil Isaza Tuzman, Tom Herman
Directors: Chris Hegedus, Jehane Noujaim

From the guys who brought us *The War Room*, this documentary is like a true-life *Fast Times at Ridgemont High* for the digital age. Twentynothingers Kaleil something something Tuzman (his name alone plays a starring role) and his buddy from high school, Tom Herman, get all kinds of people who are a lot older than them, and who really should know better, to invest way too much money way too quickly. Eventually they wind up in deep water and must either learn to care for each other, or drown.

This movie gives all of us poor snail mail slobs who are attempting to manage our lives without a broadband connection the chance we've been waiting for. Yes, finally we have an opportunity to shake our fingers and say "I told you so" to the point-and-click plutocrats of the alley and valley, who got sloppy drunk on millennium-minded venture capital, only to hit the inevitable hangover of the good old-fashioned bottom line. The cyber flameout of govWorks has all of the elements of a Shakespearean revenge tragedy: a hero with a tragic flaw, high-stakes political maneuvering for control of the kingdom, deceitful allies, smiling villains, prosaic soliloquies, star-crossed queens, and corrupt kings. And when profit margins plummet, the woods of Dunsinane start closing in, and something becomes rotten in the state of Denmark, the brutal politics of the battlefield take over and Kaleil and Tom must show what their stock as human beings is really worth. Are they blue chip, or merely overinflated vaporware?

If you're tired of stretching a dollar and ready to cyberlaunch yourself into a higher tax bracket—or if your life partner is spending so much time trying to generate a dollar that he's lost all common sense—watch *Startup.com* and remember, the real payoff in life comes when we realize that our relationships with people are a commodity that will never devalue, and that feelings are more important than bank balances.

Eye Candy Alert: Kaleil Tuzman may be hell on wheels in the boardroom but he's heaven on two legs in the eye candy department.

■ *It Could Happen to You* (1994)
Stars: Bridget Fonda, Nicolas Cage, Rosie Perez, Isaac Hayes
Director: Andrew Bergman
Writer: Jane Anderson

Sometimes the more money you have, the more headaches you have. This movie's a great reminder that we are all more secure when we are rich in love than when we possess winning lottery tickets.

Short a tip, local cop Charlie Lang (Nicolas Cage) promises his coffee shop waitress, Yvonne (Bridget Fonda), that he'll split the winnings with her if the lottery ticket he just bought pays off. Yvonne's string of bad luck is broken when Charlie's ticket nets $4 million the next day, but there is a snag—a small one, about five feet two, with a shrill Bronx accent and major attitude. Yes, Charlie's wife, Muriel (Rosie Perez), isn't particularly keen on splitting her ticket to paradise just because of her husband's impetuous promise. And as is often the case when there's too much or too little money to go around, Charlie and Muriel find that all their differences, which they've managed to avoid discussing all these years, keep coming to the surface. She's just not the type to spend the afternoon playing ball with the local kids, and he's just not interested in commissioning humongous oil paintings of himself for their living room. Yvonne, however, has all the goodness of heart Charlie does, and in their own Capra-esque way they end up rich, happy, and together.

Watch this when you're thinking that winning the lottery is going to solve all your problems. It's a great reminder that windfalls bring their own set of troubles, so you might as well start by learning to handle the money you already have.

Reel to Real

Gina Cunningham, the wife of Robert Cunningham, the real-life cop who split their lottery winnings with a waitress, remained married to him, and the waitress's marriage remained intact too.

■ *The Money Pit* (1986)

Stars: *Shelley Long, Tom Hanks, Alexander Godunov,*
 Joe Mantegna
Director: *Richard Benjamin*
Writer: *David Giler*

If you're in the red, there's nothing like watching somebody else's sense of security fall down around his ears to make you feel better, because strapped though you may be, at least you have walls.

Walter (Tom Hanks) and his girlfriend, Anna (Shelley Long), buy a mansion in the burbs for a steal. Little do they know that it's been trashed by some *Mad Max*–inspired head-banging band, who treated their house like they treated their livers and have all but totaled the joint. But, much like its former owners, structurally unsound though it may be, the house looks like a real nice place on the outside after you slap on a coat of paint and plant a few geraniums in the flower boxes.

From the moment Walter and Anna move in, however, the devastation that lies beneath the surface of any bargain basement dream house begins to emerge, and the house becomes a character in the movie—and it is an actor with an amazing instinct for physical comedy. As the stairs collapse, the floors cave in, the plumbing convulses, roasting turkeys fly, and electrical systems ignite, Walter and Anna begin hemorrhaging money and wind up at each other's throat.

We'll let you discover for yourselves whether the strength of Walter and Anna's love is sufficient to withstand their fixer-upper hell, but we will let you in on one secret: if you're feeling like the floor is giving out from under you, watch *The Money Pit* and remember that you can survive anything, even renovation hell, if you stick together, and always remember to tell your creditors and your contractors how beautiful, talented, and appreciated they are. Or, better yet, before investing in a dream house, pay a surveyor to look before you leap.

Bev's Culinarytherapy: Feeding Champagne Tastes on a Beer Budget

Have you been craving an exotic and expensive repast—like, for instance, a buckwheat blini slathered with a jeweled cluster of the finest caviar, harvested after sundown from the midnight waters of the upper Volga, or a filet mignon that melts in your mouth like butter? If you can't find any coupons for Kobe beef or Siberian Sevruga in your local Food Mart, then try out this recipe for Puttin' on the Ritz Pie. It's a meal fit for a princess that won't turn you into a pauper, and, besides, as everyone knows, everything is better when it sits on a Ritz.

Puttin' on the Ritz Pie

1 box Ritz crackers
3 tablespoons melted butter
1 pound skinless and boneless chicken breasts
4 tablespoons butter
4 tablespoons flour
¼ cup milk or half-and-half
½ cup Parmesan cheese
¼ cup chicken stock
salt, pepper, paprika, cayenne, nutmeg

Put a bunch of Ritz crackers in a plastic bag and roll over them with a rolling pin until they're the size of large cracker crumbs.

continued . . .

Put the Ritz cracker crumbs in a bowl and pour the melted butter over them and blend until all the crumbs are moist. Reserve a few of the crumbs and press the rest into a pie dish to make a crust and bake at 350° for about 10 minutes until the crumbs are light brown.

Next, dice the chicken into bite-size pieces. If you're feeling really decadent, you can cut the chicken into diamond-shaped pieces, because diamonds are a girl's best friend, even if they are four-karat poultry. Sauté the chicken diamonds in 1 tablespoon of the butter, but don't overcook because that would be extremely déclassé. Chicken diamonds should be tender and juicy, and just slightly golden. Remove the chicken diamonds from the pan and set aside.

In the same pan, melt the 3 remaining tablespoons of butter, whisk in 3 tablespoons of the flour, and then gradually add milk and chicken stock. This is called a roux, which is French and therefore fancy by definition. Next, add half the Parmesan cheese (reserving a few table-spoons for the top of the pie) and simmer for 50 minutes, stirring constantly, or until the cheese roux thickens.

Finally, add the chicken and seasonings to taste. Simmer for five more minutes and pour into the pie shell. Top with remaining cheese and Ritz cracker crumbs and bake at 350° for 15 to 20 minutes. Serve with a field green salad, and garnish with a large price tag.

■ *The Great Gatsby* (1974)
 Stars: Robert Redford, Mia Farrow, Bruce Dern
 Director: Jack Clayton
 Writer: Francis Ford Coppola,
 based on the book by F. Scott Fitzgerald

This adaptation of Fitzgerald's classic novel is set in the Jazz Age when people made extravagance an art form, and Jay Gatsby (Robert Redford) was a nouveau riche king among kings. Everything in Gatsby's palatial estate is breathtakingly executed and bank-breakingly expensive—even the closets. And his wardrobe, well . . . let's just say that his shirts alone are of sufficient quality and rareness of hue to make women weep. But while his shirts are top shelf, the man underneath comes from the bottom drawer. And no matter how much he spends, he never quite manages to get over feeling a little like cotton in a world of raw silk.

Gatsby's shadowy past and utter isolation in a crowd to which he does not genuinely belong make him an enigmatic figure. And nobody is quite sure how he made his fortune. But that doesn't stop the neighbors from showing up and partying until dawn at his lavish soirees. Well, it was open bar, after all, and this was Prohibition.

The mythic Gatsby, however, has one tragic flaw. He's obsessed with the ephemeral and equally enigmatic Daisy Buchanan (Mia Farrow), the girl who got away. Years before, Daisy refused to marry Gatsby because he just wasn't rich enough for her blood. And so Gatsby spends the rest of his life amassing a morally questionable fortune, in the hopes that Daisy will at last agree to marry him. Trouble is, Daisy's already married. And, what's worse, Daisy is way less attractive live than in Memorex. And so what happens is what always happens when you dedicate your life to an illusion you can never possess, and focus on the love that isn't in your life, rather than the love that is . . . pure Fitzgeraldian disillusionment, accompanied by the slaughter of a few innocents along the way.

If you need reassurance that money can't buy you love, self-esteem, or highway safety, then pop in *The Great Gatsby* and let Jay's tragic tale make you appreciate the look and the feel of cotton rather than hungering for imported silk. Although, on a side note, if you're in the mood to rub elbows with the blue bloods but don't want to put on a dress for dinner, this is one of the best vicarious wealth movies available. So dine with Gatsby, drink bath-

tub gin in crystal goblets with lots of fancy garnishes, and eat caviar on toast 'til dawn. And in the morning, you won't have to pay the tax man, bribe petty officials to look the other way, or even tip the waiters.

▪ *Lost in America* (1985)
Stars: Albert Brooks, Julie Hagerty
Director: Albert Brooks
Writers: Albert Brooks, Monica Johnson

We readily admit that Albert Brooks is not to everyone's taste, and here he plays an insufferably whiny yuppie, but for those of us who aren't brooding about the lack of a tennis court in our new $450,000 house, there's something deliciously compelling about watching a materialistic ad man get his but good.

When David Howard (Albert Brooks) discovers he hasn't gotten the promotion he was counting on to fund the linear growth of his bottom line, he throws a primo hissy fit, tells his wife to quit her job, and vows to live the *Easy Rider* lifestyle for a year or two—albeit substituting a fully equipped Winnebago for a Harley. His wife, Linda (Julie Hagerty), who has spent far too much time wearing gray blouses and brown skirts and working at a job that's as predictably dull as her sex life with David, agrees to liquidate their assets and put their entire nest egg in one basket. Unfortunately, as soon as they are cash rich and giddy with freedom, she makes the fatal mistake of suggesting they spend a night in Vegas. Next thing you know, Linda's familiarizing herself with french fry machines and polyester uniforms, and David's starting to think that egotism is a luxury that is probably out of his price range at this juncture.

Are the two of you feeling bogged down by your financial responsibilities? Does it seem like someone else—like your boss—is driving the car? Here's a movie that'll remind you that if you're lusting after the full-leather interior but prefer to stay out of the money-grubbing fast lane, you might want to reconsider your position on Naugahyde.

The Immortal Words of Gum-Cracking Dames

Hop into your mink, Carolyn. It's dollar day down at Kahn's and I've got a dollar.

★ Helen Broderick as Mattie Dodson
in *The Bride Walks Out*

▪ *Mr. Blandings Builds His Dream House* (1948)
Stars: Cary Grant, Myrna Loy, Melvyn Douglas
Director: H. C. Potter
Writers: Norman Panama, Melvin Frank,
 based on the novel by Eric Hodgins

When it comes to purchasing a dream home, "It's like a fine painting—you buy it with your heart, not your head," Mr. Blandings (Cary Grant) patiently explains to his lawyer (Melvyn Douglas). As you might guess, Blandings—and his wife (Myrna Loy)—learn the hard way that when it comes to money, you'd better put your common sense ahead of your emotions unless you want to become as deeply in debt as you are in love with that cute little house in the country.

One bright morning, Jim Blandings decides he's had enough of cramped New York City apartment living (although we think anyone who can afford a three-bedroom apartment with a fireplace, and a live-in maid, on one person's salary has nothing to whine about) and gets the idea to move his wife, servant, and two daughters to a charming home in the Connecticut countryside. You know, the one that's over the river, through the woods, and just past that cozy covered bridge? Unfortunately, both Mr. and Mrs. Blandings quickly become blinded by the trout stream filled with sparkling mountain water, the extensive closet space, and the glamour of owning their own piece of American history ("General Gates stopped right here to water his horses!" enthuses their real estate agent).

Inevitably, their bank account goes from black to red to deep crimson. "I refuse to endanger the health of my children in a house with less than three bathrooms," she proclaims, while he, after finally being forced to tear down the "charming" old farmhouse on the property, tries to console himself that they have the nicest vacant lot in all of Connecticut. Next thing you know, he's falling behind at work, fighting with the builders, getting all jealous about his wife and his omnipresent lawyer, and marital harmony threatens to become as scarce as honest contractors.

When your own unexpected financial disasters are making you and hubby cranky, pop in *Mr. Blandings Builds His Dream House* and learn the high cost of letting your dreams obscure your bottom line.

Mrs. Blandings (Myrna Loy): Jim, I wish you wouldn't discuss money in front of the children.

Mr. Blandings (Cary Grant): Why not? They spend enough of it.

★ from *Mr. Blandings Builds His Dream House*

▪ *The House of Mirth* (2000)

Stars: Gillian Anderson, Dan Aykroyd, Anthony LaPaglia, Laura Linney, Elizabeth McGovern, Eric Stoltz

Director: Terence Davies

Writer: Terence Davies, based on the novel by Edith Wharton

This is a cautionary tale about the disastrous things that can happen to even the most beautiful and desirable of socialites when they let money, rather than love and fulfillment, govern their lives.

Lily Bart (Gillian Anderson), the belle of Gilded Age New York's social circuit, is beautiful, well bred, charming, and rich. So it's no wonder that she has her pick of the gentleman callers who line up, hearts on their sleeves, to win her hand in marriage. Unfortunately, Lily is interested in winning another kind of hand. For underneath all those buttons and bows, Lily Bart is the female equivalent of Minnesota Fats, and she plays people and cards with a reckless and high-stakes passion that ultimately costs her dearly. Perhaps the most devastating loss in this adaptation of Edith Wharton's novel, however, is the sacrifice of Lily's indomitable spirit. Lily has an uncompromising and unusual independence that turns against itself, keeping her bound through money to the power of men, because she cannot bring herself to walk away from the table and follow her heart.

So if you're contemplating a high-stakes game of emotional poker, and you're afraid you're going to lose your shirt, learn from Lily Bart what every great card player in the game of life has to know: when to hold 'em, when to fold 'em, when to stroll nonchalantly away, and when to run like hell to your nearest broker and diversify your portfolio before you get yourself into any more trouble.

La La Land

You see, Sammy, in California everybody needs a car. I got a friend who bought a Mercedes just to get to the bathroom.

★ Leland Palmer as Audrey Paris in *All That Jazz*

I was just thinking what an interesting concept it is to eliminate the writer from the artistic process. If we could just get rid of these actors and directors, maybe we've got something here.

★ Tim Robbins as Griffin Mill in *The Player*

continued . . .

La La Land

*I know you're seeing other agents. And I think it's good you're
seeing other agents. But if you hire me as your agent, you'll
be getting more than an agent. You'll be getting three people
[holds up four fingers]: You'll be getting an agent, a mother,
a father, a shoulder to cry on, and someone who knows this
business inside and out. And if anybody tries to cross you,
I'll grab their balls and squeeze 'til they're dead.*
> ★ Martin Short as Neil Sussman in *The Big Picture*

*Avoid women directors. They ovulate. Do you have any idea what
that does to an eight-month shoot?*
> ★ Kevin Spacey as Buddy Ackerman in *Swimming with Sharks*

*Say this one time with me: "Would you like that in a pump or a
loafer?" . . . Good. Now memorize it, because starting tomorrow,
the only job that you're going to be able to get is selling SHOES!*
> ★ Kevin Spacey as Buddy Ackerman in *Swimming with Sharks*

■ *Christmas in July* (1940)
Stars: Dick Powell, Ellen Drew, Raymond Walburn
Writer and Director: Preston Sturges

While you're waiting for your Pick-4 to pay off, this movie is a fun reminder that the daily grind doesn't have to wear you down while you're working your way up, and that the windfall you're seeking is more likely to come about as a result of your own hard work instead of dumb luck.

There seems to be no end to the Depression, so one night, a frustrated Jimmy MacDonald (Dick Powell) urges his girlfriend, Betty Casey (Ellen Drew), to look out for herself finan-

cially and forget about marrying him. After all, they'll only barely scrape by all their lives. Then again, maybe he'll win one of those contests he's always entering. Is there any harm in dreaming? Betty wonders.

Well, no, but when Jimmy finds out he's won $25,000 by coming up with the new slogan for Maxford House Coffee, he unfortunately forgets the number-one rule of capitalism: don't spend the money until the check clears. It seems that a few of his buddies in the typing pool have played a practical joke on him and faked the telegram informing him of his stroke of good luck. Because they're too sheepish to admit it, and Jimmy has no reason to believe he hasn't won, he cleans out the local department store buying gifts for everyone in the neighborhood except himself before you can say, "Have that davenport delivered to my mom in Brooklyn pronto." His boss even promotes him because he's so impressed by Jimmy's "obvious" talent for creating clever advertising slogans like "If you don't sleep at night, it isn't the coffee, it's the bunk." (Don't worry—Betty doesn't get it either, but hey, it netted her a diamond ring and a fur jacket, so she's not about to argue.)

Watch this movie when you need a little inspiration to believe in your ability to create wealth without having to rely on lucky long shots.

> Warning Label: *As with most Preston Sturges films, unfortunately, you'll have to brace yourself for the racist depiction of African Americans as deliriously happy to serve white folks.*

 ## Capitalist Coffee Cup Sayings

*I'm no genius. I didn't hang on to my father's
money backing my own judgment, you know.*
★ Ernest Truex as Mr. Baxter in *Christmas in July*

▪ *Indecent Proposal* (1993)
Stars: Demi Moore, Robert Redford, Woody Harrelson
Director: Adrian Lyne
Writer: Amy Holden Jones,
* based on the novel by Jack Engelhard*

This movie asks us all if we would be willing to compromise our wedding vows for a million bucks and the chance to wear a really great black cocktail dress and hang out in cool hotel rooms with some rich guy who looks like Robert Redford. Well? Would you?

Diana Murphy (Demi Moore) and her husband, David (Woody Harrelson), are down on their luck and hard up for cash. So they put their heads together and come up with a real brainstorm: they decide to go to Vegas and bet their last remaining dollars to win the big haul. And surprise!!! They lose . . . big time. Faced with sure disaster, they turn from the table only to run into elegance and corrupt redemption personified, John Gage (Robert Redford), who offers the couple $1 million if they'll let him sleep with Diana.

Now, let's get this straight. Option number one: Robert Redford in a tux, a great little black dress with a neckline that looks like a Frank Stella masterpiece during his protractor period, a penthouse suite, expensive champagne, and a million bucks in the morning. Option number two: Woody Harrelson in a T-shirt with empty pockets and a long-neck Bud and no credit line. Hmm. What's a married girl to do?

At first the couple is all for the easy bucks, but in the end they learn, much like we all do, that redemption doesn't come cheap and neither do designer black dresses. So if you're feeling hemmed in and wishing for a miracle, remember that the only true security comes when you learn you can get in and out of debt together without the help of outside consultants with ulterior motives.

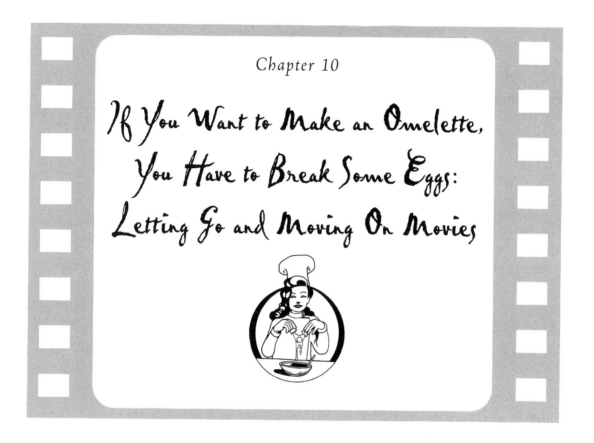

Chapter 10

If You Want to Make an Omelette, You Have to Break Some Eggs: Letting Go and Moving On Movies

You can't say yes until you can say no, and you can't say hello to love without at some point saying good-bye. Knowing how to let go and move on is as important an intimacy skill as knowing how to commit. And, generally speaking, this is an emotional omelette that you can only make by breaking a lot of eggs. Let's face it, letting go is no fun, and moving on is worse, particularly in a buyer's market with two kids, a dog, a cat, and a saltwater aquarium, not to mention a broken heart.

While there's no way to avoid the heartache, you can find some insight and comfort during a bad breakup *Cinematherapy* style, by watching one of these Letting Go and Moving On Movies and learning one of life's most difficult but important lessons: that you can and *will* survive.

■ *Return to Me* (2000)

 Stars: David Duchovny, Minnie Driver, Carroll O'Connor,
 Robert Loggia, Bonnie Hunt, Joely Richardson,
 James Belushi, David Alan Grier
 Director: Bonnie Hunt
 Writers: Bonnie Hunt, Don Lake

This is an uplifting allegory that reminds us that as long as there is life there is love, and that no matter how bad your heartache over the loss of your former paramour, love will find you again and be just as beautiful as your lost love, only with darker, curlier hair and maybe a Brooklyn accent.

Bob and Elizabeth Reuland (David Duchovny and Joely Richardson) are basking in the flow of upwardly mobile and politically correct yuppie love. He's an environmentally responsible architect and she's a zoologist working to save the great apes, and they both have enormous respect for each other and their respective causes and they always say please and thank you and never, ever call each other names.

Tragically, given all this new-generation nuclear family promise, after a stirring speech designed to raise funds to build a habitat for her favorite gorilla, Simon, Elizabeth is killed in a car accident. Her heart is donated to a young, down-to-earth, and beautiful heart patient named Grace Briggs (Minnie Driver), who has dark curly hair, and a really cute grandfather, Marty (Carroll O'Connor in his last role), who watches over her like a guardian angel.

And, of course, as one would expect in an uplifting allegory, Grace and Bob Reuland meet by chance at the zoo, and when Simon the gorilla recognizes Elizabeth's heart in Grace's shining smile and Bob sees that, well . . . this is a Hollywood allegory, so you do the math.

Is it sappy? Definitely. But it's just the ticket when you need to be reminded that you never know what's around the next corner, and that as long as you love, you will be loved in return.

Offers We Can Refuse

I love you. You complete me.

★ Tom Cruise as Jerry Maguire in *Jerry Maguire*

If I can't make it with you, then I can't make it with anyone.

★ Hugh Grant as Daniel Cleaver in *Bridget Jones's Diary*

■ *It Happened One Night* (1934)
Stars: Clark Gable, Claudette Colbert
Director: Frank Capra
Writer: Robert Riskin,
* based on the story "Night Bus" by Samuel Hopkins Adams*

This madcap adventurous romance reassures us that if we're willing to leave a bad relationship, take the plunge into the ocean of uncertainty, and travel by bus on a journey toward self-discovery, we'll end up with the right man.

Claudette Colbert plays Ellie Andrews, an heiress who had impulsively decided to marry King Westley, a playboy and aviator, but now has come to realize that he's less the wind beneath her wings than an albatross around her neck. Feeling trapped by her impending nuptials, she dives off a steamship and swims away into an anonymous life of bus stations, campgrounds, and hitchhiking along the highway. Drawn to this brave and plucky soul, Peter Warne (Clark Gable), an incognito reporter, talks Ellie into allowing him to accompany her. But as much as Peter *thinks* he's tagging along in order to get a story, he comes to realize that this savvy, headstrong, and daring woman means far more to him than just a chance to nab a byline. Yep, he's even willing to construct the walls of Jericho in order to respect her need for privacy (okay, so it's a temporary room divider consisting of a blanket over a rope, but symbolically it's the very foundation of respect). Ellie, on the other hand, learns to stop acting like a child and basing her life decisions on whether or not she's going to irritate her father, and instead starts listening to what her heart and her head tell

her is best for her. And if that means she's got to make a life-affirming dash across a field with full cathedral train trailing behind her—thereby creating movie magic that'll stand up even in the DVD age—well, so be it!

Watch this one when you think it's too complicated and scary to walk out now. We think it will help you realize that spending a little time on your own rediscovering who you are will surely make everything clear as a blast from Gabriel's trumpet.

> **Warning Label:** *The writer might have thought Peter's line about "taking a sock at" Ellie was funny in 1934, but we have a feeling audiences didn't find it any more hilarious then than we do now.*

Feminine Laments

I used to be dangerous. I don't know what happened.

★ Holly Hunter as Judith Nelson in *Living Out Loud*

Cricket (Callie Thorne): Don't you just hate men?

Erin Castleton (Hope Davis): Oh, God, I wish I did. That would make my life so much easier.

★ from *Next Stop Wonderland*

I always thought if I ever got married the one thing I'd never be anymore was lonesome. But the funny thing is, you can be it in the same bedroom with a husband.

★ Judy Holliday as Florence Keefer in *The Marrying Kind*

■ *The Object of My Affection* (1998)
 Stars: Jennifer Aniston, Paul Rudd, Allison Janney,
 Alan Alda, John Pankow, Amo Gulinello
 Director: Nicholas Hytner
 Writer: Wendy Wasserstein,
 based on the novel by Stephen McCauley

While a love story about a gay man and a straight woman raising a child together might seem like a strange choice to reaffirm your faith in marriage, this movie is a wonderful reassurance to us all that while no situation is perfect, and in the course of any long-term relationship many things will change, the one thing that always remains the same is that love is love is love is love.

Nina (Jennifer Aniston) and George (Paul Rudd), who are both in transitional phases of their lives, move in together and find out that they are perfectly matched. They both love tuna casserole, old movies, full-fat ice cream, ballroom dancing, and each other. So when Nina becomes pregnant with her boyfriend Vince's (John Pankow) baby, and decides she doesn't love him, it seems like the most obvious choice in the world to get out of her dead-end relationship and raise her child with the man she truly loves . . . George.

The only trouble is, George is gay. But this doesn't change the fact that George and Nina love each other, and so they resolve to throw out all the rules and write a new book of love based on the mutual caring and support of two best friends raising a child together.

Nina and George both agree from the get-go that they're not married, but simply best friends, and are therefore free to date other people. But eventually, Nina, who is pregnant and living with the object of her affection, starts doing what comes naturally to her as a straight woman . . . like hanging out with other guys. And she is heartbroken when George starts doing what comes naturally to him as a gay man . . . like hanging out with other guys.

Nina struggles to reconcile her own needs as a straight woman with her love for George and tries to deny the very real pain that the situation is causing her. And George struggles to reconcile his needs as a gay man with his love for Nina, and tries to deny the very real pain that he's inadvertently causing his best friend.

Then George meets Frank (Amo Gulinello), a young actor with whom he falls in love. And it finally becomes clear that nobody can rewrite the book of love, that the old rules still apply, and Nina and George can't make their impossible dream come true without severely compromising themselves.

But, surprisingly, this movie has a happy ending, because what Nina and George discover at the end of their experiment in new-millennium love is that letting go doesn't mean losing anything but the heartache of holding on to unrealistic expectations.

So if you're feeling buffeted about by the winds of change in your long-term relationship, and are afraid that they are going to huff and puff until they blow your house down, watch *The Object of My Affection* and be reassured that true love, no matter how our circumstances may change, and regardless of the form or source, endures forever.

Can I Get That Printed on a Coffee Mug?

Freud didn't know dick about women.

★ Jennifer Aniston as Nina in
The Object of My Affection

■ *The Story of Adèle H.* (1975)
Stars: Isabelle Adjani, Bruce Robinson
Director: François Truffaut
Writers: Jan Dawson, Jean Gruault, Suzanne Schiffman, François Truffaut,
 based on a story by Frances Vernor Guille and the diaries of Adèle Hugo

Fighting the urge to call your ex on some flimsy pretense in the hope that he'll do a 180 and change his mind about your future together? We think you'll find the courage to stop

yourself after watching this movie about a woman whose desperate clinging to false hope results in total humiliation, public scandal, zombielike wanderings through the backstreets of a foreign country, and complete annihilation of her sense of self.

Based on the diaries of Adèle Hugo, daughter of famed author Victor Hugo, *The Story of Adèle H.* starts in Halifax, Nova Scotia, in 1863, where Adèle (Isabelle Adjani) has come to track down her errant lover, Lieutenant Pinson (Bruce Robinson). She's certain if she can just talk to him in person he will suddenly remember that he is consumed by love for her, drop to his knees begging her for her hand, and they'll both live happily ever after. Lieutenant Pinson, however, proves far less malleable than she'd hoped, and a bigger cad than she ever imagined. Undeterred, Adèle vows that "if love will not smile, I'll submit to its grimace" and begins an aggressive campaign to win him back using embarrassment, threats, pleading, bargaining, public scenes, bribery, and all manner of utterly pathetic tools until she loses any vestige of self-respect. Soon she has spent every penny her father has sent her for passage home to France, and is at the mercy of strangers on the street who, it seems, will have to sign, seal, and deliver her to Daddy because she obviously can't take care of herself. And yes, it gets worse from there.

So put down that phone already, take his e-mail address out of your address book and IM list, watch *The Story of Adèle H.*, and be glad you're not that desperate.

Get a Grip, Hon

It can't be true. Ashley loves me!
★ Vivien Leigh as Scarlett O'Hara in
Gone With the Wind

■ *Funny Girl* (1968)
 Stars: Barbra Streisand, Omar Sharif, Kay Medford,
 Anne Francis, Walter Pidgeon
 Director: William Wyler
 Writer: Isobel Lennart,
 based on the play by Isobel Lennart and Bob Merrill

This fictionalized autobiography of comedienne Fanny Brice marks Barbra Streisand's film debut as the iconoclastic, funny-at-all-costs Fanny, who refuses to conform to the feminine standards of her time, mostly because she can't meet them. But rather than hide behind the ice sculpture on the buffet table of life because she is "a bagel on a plate full of onion rolls" and doesn't fit in with finer fare, Fanny insists on being the main course, complete with a secondhand rose garnish.

Even in the face of the creative prejudices of the mighty Mr. Ziegfeld himself, Fanny stands up for herself and her own unique gifts. Fanny's self-effacing humor helps us all to laugh at our awkward moments, to forgive ourselves our human imperfections, and to realize the folly of trying to live up to an unattainable Ziegfeld vision of feminine grace and beauty, which in the end is much more boring than a real-life, three-dimensional woman with a face that could stop a clock and a voice that could move mountains.

Fanny is a woman who will not compromise, who is honest about her strengths and weaknesses, and has the courage to insist on being herself. That is, until she meets the darkly handsome and irresistibly naughty Nicky Arnstein (Omar Sharif), a man with flashing eyes, capable hands, a passionate heart, a really well sculpted and meticulously maintained pencil mustache, and a gambling problem. Unfortunately, the confidence that Fanny has in herself creatively does not extend to her personal life. Fanny is so amazed that a handsome man would fall for a Plain Jane like herself that she falls right into step behind Nick, marching to his drummer in a parade headed straight for heartache.

And despite Nick's malignant envy of her success, gambling debts that could sink the *Titanic*, a questionable moral character, and his stint upriver for embezzlement, Fanny stands by her fancy man and even decides to give up her career if it means she can hold on to her husband. Even after he gets sprung from jail, and she realizes that for him the

love is gone and she must let him go, she resolves, in a final, totally Barbra-esque closing number, to remain Nick's forevermore.

Now, while we appreciate that marriage is for better and worse, and Nick is really, really handsome in that dashing "I can see you lying on a bed of satin" Omar Sharif kind of way, and that mustache really is amazing, we think it's a shame that Fanny, who made her mark by loving herself, chooses to stand by a man who can't really love her because he's unable to love himself.

Watch this movie when you're wondering whether or not it's time to get off the bus at the next stop or keep riding. Let Fanny's doomed love story caution you that if standing by your man means sacrificing everything that is special about you, it's probably best for you both if you get off at the very next stop and start heading in a more positive direction before you reach the end of the line.

World-Class Wrecks

Alas, monsieur. At ten o'clock I have a more attractive offer. Her Majesty has asked me to delouse her spaniel.

★ Uma Thurman as Mademoiselle, lady in waiting, in *Vatel*

If you gave her a penny for her thoughts, you'd get change.

★ Greg Germann as Vince in *Sweet November*

Dorothy, this guy would go home with a gardening tool if it showed interest.

★ Bonnie Hunt as Laurel Boyd in *Jerry Maguire*

Stop annoying the livestock.

★ Clark Gable as Michael Anthony in *Love on the Run*

▪ *All That Jazz (1979)*
Stars: Roy Scheider, Leland Palmer, Ann Reinking, Ben Vereen,
 Jessica Lange, Erzsebet Foldi
Director: Bob Fosse
Writers: Robert Alan Arthur, Bob Fosse

This musical, which is loosely based on the life of its writer and director, Bob Fosse, is like a scorned woman's wet dream, where a powerful man who's gotten away with murder—particularly where women are concerned—finally has to face judgment day and gets what's coming to him.

Joe Gideon (Roy Scheider) is a successful stage and screen director and choreographer, who pops amphetamines and women like they're candy and moves on before the curtain can ever come down on his bad behavior. But death, personified as a beautiful woman called Angelique (Jessica Lange), who is dressed all in white lace and crowned with an antebellum bonnet worthy of Scarlett O'Hara before the fall, finally gets to Joe's heart the way no woman ever could . . . through his blocked coronary arteries.

The movie traces Joe's progress through Elisabeth Kübler-Ross's stages of accepting death. And, of course, because this is Fosse, these stages are all beautifully choreographed with lots of undulating arms and torsos. First comes denial, as Joe tries to go on living his life playing to a cheering but naive crowd, and then leaving town before the bad reviews hit. Gradually, as his health deteriorates, we watch Joe work through anger, bargaining, and finally mourning, as he faces what his love-them-and-leave-them lifestyle has cost him. Joe begins to appreciate the women in his life whom he has compromised: his ex-wife, Audrey (Leland Palmer), his long-suffering girlfriend, Kate (Ann Reinking), and his preteen daughter, Michelle (Erzsebet Foldi), whom he will never get to see grow up and who will no doubt fall in love with a man as emotionally unavailable as her father was.

The finale of this scorned woman's revenge buffet is a Busby Berkeley–style extravaganza, with all of the women that Joe has loved and left like so much flotsam in his wake high-kicking in a chorus line of retribution, dressed in white feathered headdresses and Sally Rand fans, singing, "You've had your way, now you must pay. Who's sorry now?" Who could ask for anything more?

Watch this one when your dance captain has recast your role in the big production number of his romantic life. There's nothing like watching a world-class player tap-dance his way to self-awareness to reassure us all that even the most charismatic of minstrels eventually has to pay the piper.

Can I Get That Printed on a Coffee Mug?

There's nothing like a love song to give you a good laugh.

★ Ingrid Bergman as
Alicia Huberman in *Notorious*

I've had a perfectly wonderful evening . . . but this wasn't it.

★ Groucho Marx

▪ *The Color of Paradise* (1999)
Stars: Hossein Mahjoub, Mohsen Ramezani, Salime Feizi
Director and Writer: Majid Majidi

If you know you've been spending too much time fretting about what's long gone and grumbling about what should've been, and you're ready to rediscover the good in your life, here's an allegorical movie that'll reopen your heart and convince you that love can help you transcend the deepest disappointments—like, say, your ex.

Mohammad (Mohsen Ramezani), a blind Iranian boy, is so filled with love and spirit, "seeing" God with his hands as he touches the natural world's wonders all around him, that he's sort of a junior Doctor Doolittle–cum–forest sprite in a straw hat and Ray-Bans. In addition to hearing the messages of the birds, little Mohammad listens to the brooks, the flowers, and the fields, spreading love and sunshine from mountain to forest. Frankly,

Mohammad's goodness runs so deep that before you know it, every time he stretches out his hand to touch the wind or the wheat you'll find yourself weeping again. And when he tearfully reveals his secret for maintaining a sunny outlook despite his own sorrow, which is fathoms deep, you'll be scrambling for the tissue box—and rethinking your perspective on your own problems.

Unfortunately, Mohammad's sensitivity to life and to God's voice in the world around him is utterly lost on his father (Hossein Mahjoub), a man crippled by anger, shame, despair, and a host of other dark emotions because his wife died, he's broke, and his son is handicapped. Dad dwells in a desert even as he walks through the verdant fields and forests of salubrious Iran. Will this father ever open his eyes to the great treasure that is his son? Will he ever discover, as his child has, that despite our losses, life is always worth living? Will he rediscover the importance of *all* his personal relationships, and come to his senses, literally and figuratively? Or will he forevermore remain so self-absorbed in his grief about not having the perfect family he thinks he deserves that he forgets to pick his kid up from school?

When you're ready to renew your optimism about what life has in store for you, watch *The Color of Paradise* and be inspired to let go of all that bitterness that's been distracting you and rejoice in the beauty that surrounds you.

Nancy's Momentous Minutiae: Never Say Diet

A Hollywood diet fad in the studio system era was to call a particular diet guru after a meal, and lean back while waiting for said guru to send out psychic waves to "improve digestion," which was thought to help the body shed extra pounds.

Mario Lanza once ate nothing but three tomatoes and six eggs a day for six weeks in order to lose weight.

continued . . .

Louis B. Mayer, head of MGM, sent orders to the studio's commissary that no matter what teenage Judy Garland ordered, she was to be served a diet of chicken soup and cottage cheese to slim her down.

After suffering a serious infection that hospitalized her during the filming of *Cleopatra*, Liz Taylor began consuming beer and chili, so much so that they had to refit her costumes.

▪ *Center Stage* (2000)
Stars: Peter Gallagher, Amanda Schull, Zoe Saldana, Susan May Pratt,
 Donna Murphy, Debra Monk
Director: Nicholas Hytner
Writer: Carol Heikkinen

Sometimes the hardest part about letting go of a love affair is letting go of your dreams of what you thought your love affair was going to be like. But sometimes, as we learn in *Center Stage*, life demands that we let go of even lifelong dreams in order to embrace our true destiny and become who and what we're meant to be.

All of her life Jody Sawyer (Amanda Schull) has dreamed of becoming a ballerina in the American Ballet Company in the Big Apple. So imagine her elation when she is accepted as one of twelve out of the entire country to be part of the ABC class from which the new company members will be chosen.

Although Jody gives her all to making her dreams come true, she must ultimately face the fact that she hasn't got the right stuff to be a classical ballerina. But with the help of ABC's director (Peter Gallagher), she discovers that she does have what it takes to be a principal dancer in a more innovative company that is more in harmony with her jazz-hot style.

Meanwhile, Maureen (Susan May Pratt), who has all the right stuff to become ABC's new prima ballerina, is increasingly unhappy and unhealthy being tied to a dream that isn't

even hers but rather her mother's. Maureen too must realize that just because you're good at something doesn't mean it's going to make you happy, and has to decide if there's another path that is in line with her own well-being and fulfillment.

This is a great movie to watch when your beautiful dream is turning into a real nightmare. Let these young ballerinas remind you that you can't dance to a new and better tune until you're strong enough to say good-bye to the old sad songs.

Norma's Nuggets

I've heard of platonic love, but I didn't know there was such a thing as platonic jewelry.
★ Norma Shearer as Jerry in *The Divorcée*

What you feel for me is not love. It's the love of the gorilla calling to its mate.
★ Norma Shearer as Jerry in *The Divorcée*

Helen (Florence Eldridge): Congratulations, my darling. You're free. You're exactly as you were before you were married.
Jerry (Norma Shearer): Exactly. All I need is a complete set of young illusions and an innocent expression.
★ from *The Divorcée*

- **The Godfather** (1972)
 Stars: *Marlon Brando, Al Pacino, James Caan, Robert Duvall,*
 Talia Shire, Diane Keaton
 Director: *Francis Ford Coppola*
 Writer: *Francis Ford Coppola, based on the novel by Mario Puzo*

While on the surface this is a story about the inner workings of the Mafia in New York in the forties and fifties, this movie is also a very good study of the dubious sacrifices that women make to stand by their men.

The Godfather is packed full of weddings and marriages that go awry no matter how much mascarpone cream you stuff inside to help the medicine go down. The movie begins with the lavish wedding of the godfather's (Marlon Brando) daughter, Connie (Talia Shire). And believe us, we're not just whistling the tarantella here when we say this is the wedding to end all weddings. There are tents, and boats, and fireworks, and movie stars. They even get the cinematic equivalent of Frank Sinatra to croon to the bride. Yet not even forty screen minutes later, Connie's vision of married bliss is looking like a Lifetime abuse-issue movie starring Judith Light. And then of course there's Kay (Diane Keaton), Michael Corleone's (Al Pacino) WASPish, sensible fiancée, who makes the mistake of believing that you can marry a man without marrying his family, and that you can change history if you just concentrate really, really hard. This, of course, results in a very messy situation in the sequel . . . well, doesn't it always? Finally, there's the wife of the godfather himself, who has managed to survive her marriage through a superhuman capacity for denial that divides her from her daughter, and herself.

In some senses this movie shows a history and tradition that glorifies marriage and family. But what lies beneath the mirrored waters of this family pool is a dark undercurrent of ruthless men, frightened children, and women who must constantly reinvent reality, because they don't have the power to acknowledge the truth, let go, and move on.

This movie, as well as its sequel, *Godfather 2*, reminds us all that painful though it may be, we are lucky to live in a world where we have the power to make the tough decisions, to act on our own behalf, acknowledge reality, and get while the getting is good.

World-Class Wrecks

Go! And never darken my towels again!

★ Groucho Marx as
Rufus T. Firefly in *Duck Soup*

Chapter 11

For Better or Worse:
Rediscovering Your Dream Movies

Maintaining peace, harmony, and a sense of humor, remembering why you came together in the first place, remaining true to your shared goals, and keeping the romance alive through the years is a tall bill to fill, even for Hollywood. Maybe this is why so many cinematic happily ever after movies end at the altar, before the new Mr. and Mrs. Charming actually have to share a castle with only one bathroom and bad water pressure.

Admit it, we've all had those surreal mornings when we look over at the person sleeping next to us and think, who are you? What are you doing in my bed? And how does your hair manage to do that in a world governed by the principles of gravity? At times like this, it's comforting to watch a Rediscovering Your Dream Movie and remember that while

emotions may shift from day to day, your commitment to each other and to your common vision remains constant.

So if the clouds of adversity have been obscuring your vision of a couple's paradise, watch one of these Rediscovering Your Dream Movies about couples who have found their way to higher ground, and learn to rise above.

■ *The War of the Roses* (1989)
Stars: Danny DeVito, Kathleen Turner, Michael Douglas
Director: Danny DeVito
Writer: Michael Leeson,
 based on the novel by Warren Adler

There's nothing like watching a married couple locked in a domestic dispute to the death to scare you and your significant other straight and remind you both that when you cling to a position and refuse to compromise, all you wind up with is a broken chandelier in the foyer of your emotional dream house—and that there is a very thin line between love and hate, especially when you're going through renovations.

It's a familiar story to many of us. Oliver (Michael Douglas) and Barbara Rose (Kathleen Turner) fall in love and marry for all the right reasons. They make each other laugh, they have common interests and values, they share a vision of the future, and the sex is phenomenal. But as life goes on, Oliver becomes absorbed in his thriving career as an attorney on a partner track. And Barbara, a former gymnast, throws all of her energy, flexibility, and endurance into the creation of their dream house, which turns out to be a masterpiece of interior design where every drape, chair, and knickknack is gracefully coordinated and perfectly placed.

But soon the Roses' tastefully appointed dream becomes a Dali-esque nightmare because they are both so single-minded that they can't see each other anymore. Oliver becomes so obsessed with his own success that he starts treating his wife like the hired help, and Barbara starts working on a mountain of resentment as altitudinous and potentially volatile as Mt. Fuji. And of course, eventually, the volcano erupts.

The Roses find themselves entrenched in an ugly divorce process that escalates into full-out guerrilla warfare, when neither party will concede to give up or sell off the dream house. Much calisthenic and incendiary infighting, and priceless Staffordshire pottery smashing, ensues, and in the end, as is always the case in battles between people who deep down really love each other, nobody wins.

If you're feeling like there's a tempest brewing in your Staffordshire teapot, lock up the breakables, pop a little popcorn instead of blowing your lid, and watch *The War of the Roses* with your sparring partner for life. Barbara and Oliver will remind you of the wisdom of that old bumper sticker slogan: make love, not war.

■ *Manhattan Murder Mystery* (1993)
Stars: *Woody Allen, Diane Keaton, Anjelica Huston, Alan Alda,*
 Joy Behar, Jerry Adler, Lynn Cohen
Director: *Woody Allen*
Writers: *Woody Allen, Marshall Brickman*

As the years go by, if you're not careful, your passion for living, exploring, trying new things, and discovering each other can be replaced by a stagnant swamp of boredom. As *Manhattan Murder Mystery* shows, if you're willing to dip your toe into the ocean of new experiences, you might find yourselves swimming in the warm, pacific waters of a renewed attraction to each other.

Larry (Woody Allen) and Carol (Diane Keaton) are in a rut, going to bed early and dully sitting through each other's hockey games and operas out of a sense of marital duty. But on a lark one day, Carol takes up their neighbor's offer to stop in for a quick drink. Now, Paul (Jerry Adler) and Lillian House (Lynn Cohen) make Larry and Carol look positively sizzling by comparison, and Larry can't wait until he can escape their chatter about stamp collecting and twin cemetery plots. But a few days later, Lillian dies, her widower starts acting mysterious, and Carol is convinced that poor Lillian has been murdered. She tries unsuccessfully to draw Larry into spying on Paul with her, then coaxes their friend Ted (Alan Alda), who's always had a thing for Carol, into accompanying her on her

stakeouts. Larry scoffs at first, which irritates Carol to no end, and they both start casting suspicions on each other's fidelity. But as Larry and Carol eventually discover, when you go exploring together, you end up discovering new things about each other that make you fall in love all over again.

Watch this one when you're feeling dull as dishwater and want to find yourselves a pool of new possibilities.

The Married Life

There's no room in marriage for what used to be known as "the little woman." She's got to be as big as the man is. Sharing—that's what it takes to make a marriage, keep a marriage from getting sick of all the duties and responsibilities and . . . and troubles. Listen, no part of marriage is the exclusive province of any one sex.

★ Katharine Hepburn
as Amanda Bonner in *Adam's Rib*

I look at marriage sort of the same way I look at Miami. You know, it's hot and it's stormy and it's, you know, it's occasionally a little dangerous, but if it's really so awful, then why is there still so much traffic?

★ Sarah Jessica Parker
as Gwen in *Miami Rhapsody*

■ *Pollock* (2000)
 Stars: Ed Harris, Marcia Gay Harden, Amy Madigan
 Director: Ed Harris
 Writers: Barbara Turner, Susan Emshwiller,
 based on the book by Steven Naifeh and Gregory White Smith

This lovingly crafted biopic of the bad boy darling of the New York art world, Jackson Pollock (Ed Harris), is as much the story of a great marriage as it is the story of a great painter. While on the surface the marriage between Jackson Pollock and Lee Krasner (Marcia Gay Harden) looks like a reenactment of some personal Waterloo, in fact, the conflicts between them provided the sparks of creative fusion that made both partners in this unlikely coupling feel connected and alive. The result was a staggering body of work that fulfilled them both creatively, and wound up enriching the world as well. Like Napoléon and Josephine, Vincent and Theo, or Ricky and Lucy, you just couldn't have one without the other.

From the moment that Jackson and Lee meet in 1941, when they are featured together in an exhibit of new abstract expressionist painters in New York, they are inexorably drawn to one another. Lee immediately recognizes Jackson's talent and his air of vintage elegance, as well as a marked tendency toward depression, not to mention an epic capacity for alcohol. And like many of us before her have done when confronted with a tortured but talented artist with more Freudian conflict than you can shake a stick at, she moves in with him and eventually talks him into marrying her. And for the next ten years Lee makes it her business to see to Jackson's every need, nurse his hangovers, encourage his creative development, and make the world stand up and take notice of his revolutionary aesthetic vision.

Now, we admit that on the surface, this relationship breaks just about every rule in the book of love. But Jackson and Lee really loved each other and were able to endure the hardships of their personal problems because of a shared commitment to something larger than themselves . . . from which they both derived great personal and aesthetic satisfaction.

This is a powerful movie to watch when you need to take a step back and gain some perspective on your marital masterpiece in progress. Let Jackson and Lee remind you that your bond can transcend poverty, death, bad reviews, and even horrifying table manners as long as you are creating something that you both consider to be of important and lasting beauty.

Can't We All Just Get Along?

He's everything you ever dreamed of, and you feel intoxicated with joy whenever you're with him. Unfortunately, the kids are not nearly as starry eyed as you and your mate are. In fact, they'd much prefer it if you'd just wave that magic mom wand you keep in your purse and re-create their idyllic original family—which never actually existed, but which they're convinced you can conjure up for them.

When you're struggling to get your mate and you on the same page when it comes to discipline, stalled in your negotiations with a sullen stepdaughter who insists that her real mom wouldn't dream of making her empty the dishwasher, or trying to get your two squabbling broods to give peace a chance, check out these Can't We All Just Get Along Movies that will ease some of the tension and maybe even give you all something to bond over.

Stepmom (1998)
Stars: Susan Sarandon, Julia Roberts, Ed Harris,
 Liam Aiken, Jena Malone
Director: Chris Columbus
Writers: Gigi Levangie, Jessie Nelson, Steven Rogers,
 Karen Leigh Hopkins, Ron Bass, based on a story by Gigi Levangie

If you're caught up in an unpleasant dynamic with steps and exes and second wives, this movie will get you back in touch with your higher self—the one that chooses kindness and understanding over flippant insults.

Jackie (Susan Sarandon) isn't by nature the catty sort, but after years of marriage she really wasn't ready for her ex, Luke (Ed Harris), to rush out and shack up with a highly successful young thing who's about a size two and has a blinding Julia Roberts smile. Isabel (Julia Roberts) is rapidly

continued. . . .

making an enemy of stepdaughter Anna (Jena Malone) by forgetting that it's purple shirt day at school, thereby ruining her social life for the season. But then, thanks to her enormous efforts, Isabel finally starts winning over Anna's affections, and Jackie has to reassess. Can she let go of her envy and fear and allow Isabel to play a maternal role with her Anna and her brother Ben? Will Isabel and Luke's marriage survive the strain of all this conflict? And will they please stop cranking up "Ain't No Mountain High Enough" by Marvin and Tammy so we can stop sobbing at the intensity of maternal love?

Watch this when you need to let go of some repressed feelings and let the waterworks flow.

Parenthood (1989)

Stars: *Steve Martin, Mary Steenburgen, Dianne Wiest, Rick Moranis, Harley Jane Kozak, Tom Hulce, Martha Plimpton, Jason Robards, Keanu Reeves, Joaquin "Leaf" Phoenix, Jasen Fisher, Ivyann Schwan*
Director: *Ron Howard*
Writers: *Lowell Ganz, Babaloo Mandel, based on a story by Lowell Ganz, Babaloo Mandel, and Ron Howard*

If you and your mate have been clashing over parenting styles and need reassurance that there's more than one way to get it right, and there's margin for error, this ensemble piece is fun, poignant, and ultimately comforting.

Gil Buckman (Steve Martin) has always considered himself the runt of the litter. And his father, Frank Buckman (Jason Robards), loves to validate Gil's feelings of total inadequacy. Gil doesn't have a lot of respect for his father's parenting style, but deep down he wishes he could get the old man's approval just once. No wonder Gil winces in embarrassment and frustration every time his oldest son, Kevin (Jasen Fisher), who has all the nervous tics and insecurity Gil did as a boy, gets that pouty look on his face. And it doesn't help Gil's

continued . . .

confidence much to observe his sister, Susan (Harley Jane Kozak), and brother-in-law, Nathan (Rick Moranis), doting on their ever-perfect four-year-old (Ivyann Schwan), who knows Tae Kwan Do and basic Japanese, and can figure out the square root of any three-digit integer in two seconds flat. At least Gil's sister Helen (Dianne Wiest) has a wacky brood that challenges her parenting abilities too. But eventually, Gil comes to realize, as we all must, that overly anxious, uptight, confused, neurotic, and dysfunctional parents don't necessarily royally screw up their children. Watch this one with your mate and see if it doesn't give you confidence that you can work it all out.

Yours, Mine and Ours (1968)
Stars: Lucille Ball, Henry Fonda, Van Johnson
Director: Melville Shavelson
Writers: Melville Shavelson, Mort Lachman,
 based on a story by Madelyn Davis and Bob Carroll Jr.

This precursor to the *Brady Bunch* TV series is a seminal contributor to the myth that blended families go together like bologna and Wonder bread and as such is a major hazard to your psychological health if taken without a huge hunk of salt. And even so, it'll probably clog your emotional arteries. But it is definitely a hoot to watch when you're struggling with your own less-than-cooperative stepbrood.

Henry Fonda plays a newly widowed navy dad who falls for a navy widow (Lucille Ball), but when they do the math they realize they have eighteen kids between them. Can this group somehow form a family? Well, after a few slapstick hijinks featuring the entire bratty clan, patriarchal discipline is restored and all the kids happily participate in their assembly line lives in a big old Victorian. And how does the family become cemented once and for all? Why, with the introduction of a new baby, which, as we all know, is the perfect cure-all for family dysfunction and sibling rivalry . . .

continued . . .

When tension is high in your own blended household, gather the warring factions, break open the Bugles and Goldfish, pour yourselves some soda pop, then share a laugh over the sugary naïveté of this surreal gem.

Dysfunctional Family Jewels

By the third kid, you know, you let 'em juggle knives.

★ Mary Steenburgen as Karen Buckman in *Parenthood*

Tod (Keanu Reeves): Where's my wife?

Helen (Dianne Wiest): She's still at school. She's got cheerleading practice.

Tod: Bitchin'.

★ from *Parenthood*

■ *What Dreams May Come* (1998)
Stars: Robin Williams, Annabella Sciorra, Cuba Gooding Jr., Max von Sydow
Director: Vincent Ward
Writer: Ronald Bass, based on the novel by Richard Matheson

This is a really great movie to watch with your partner when he's been a little too wrapped up in himself lately, and needs to be reminded that he should make your relationship more of a priority, because if God forbid anything should ever happen to you, he's going to feel really, really bad about not paying more attention to you while he had the chance. He will then probably have to travel to hell and back just to tell you how much he

loves you, so he should probably just get his priorities straight now, while he has the chance, skip the trip across the river Styx, and straighten up and fly right before it's too late.

Dr. Chris Nielsen (Robin Williams) and his wife, Annie (Annabella Sciorra), see more than their share of trouble and strife in a very short period of time. In fact, they are definitely up there in a league with Job. First, their two children are killed in a car accident. Then, just as they are managing to pick up the pieces and move forward, Chris himself is killed in a car crash, leaving Annie in utter despair with only her easel and brushes to ease the unendurable pain. And she definitely starts walking to work. Chris, on the other hand, finds himself in the afterlife, which turns out to be a paradise of his own making. Chris's heaven changes, along with Annie's emotions, as she tries to paint her way out of her grief back on earth.

But while Chris can still see and feel Annie, Annie doesn't realize that Chris still exists and finally, unable to endure the pain of her life any longer, she kills herself. It is then up to Chris to go and rescue Annie from the hell of her own guilt, and bring her into a new paradise made just for them, which, oddly enough, looks a lot like New Jersey.

It is unfortunate that this couple has to discover the value of their love—and that life is what you make it—after they have both died. This movie is still an excellent reminder, though, to rise above the petty irritations of the daily grind, cherish what is truly important to you in this life, and work every day on creating and maintaining a paradise on earth with your soulmate, while you still have the chance.

Jersey Jokes

I found you in hell. I'll find you in New Jersey.
★ Robin Williams as Chris Nielsen
in *What Dreams May Come*

You can stay here 'til Hoboken freezes over!
★ Raymond Walburn as Dr. Maxford in *Christmas in July*

▪ *The Marrying Kind* (1952)
 Stars: Judy Holliday, Aldo Ray
 Director: George Cukor
 Writers: Ruth Gordon, Garson Kanin

What brings Florence (Judy Holliday) and Chet Keefer (Aldo Ray) to divorce court? A confusing mix of disillusionment, some bad luck, a few terrible rows, and the unshakable feeling that the fun got left behind somewhere around the time the bills for the payment-plan furniture started piling up. But before granting a divorce, a wise judge gets them to sit down at a table and share their he said/she said version of their seven years in marriage-land. They discover that maybe what needs changing is not their marital status but their perceptions, attitudes, and expectations—because, after all, it takes two to tango, and two to tangle.

At first, Florence can only recall Chet's constant preoccupation with making the big bucks, while Chet complains about having had the burden of all the worrying, and feeling unappreciated as the hardworking breadwinner slogging away at a post office job. She talks about supporting him in his wild schemes to get rich, and he speaks painfully about feeling he was failing her. And that night he ended up doing the rumba with that floozy at the party? Forget about getting them to agree on what *that* was all about.

The line between where he ends and she begins gets blurred, and when a big emotional loss engulfs Florence and Chet, everything gets very confused. Instead of pulling together, they drift apart: hence, *Keefer v. Keefer* is on the docket.

But, as the judge helps them to discover, when you share your pain instead of stewing silently, acknowledge your own mistakes, focus on each other's good points and your mutual love, and keep reminding yourselves of why you wanted to be together in the first place, then you may find that instead of just floating along aimlessly from day to day, you're headed toward a better marriage.

Alternately funny and poignant, this is the perfect movie to share with your husband some night when you need to reconnect. Afterward you can bond over your own memories—just don't be too quick to correct each other's telling of the story.

Reel to Real

Ruth Gordon and Garson Kanin were an Oscar-nominated husband-and-wife screenwriting team who wrote five movies together, including two Hepburn/Tracy vehicles; in fact, they modeled the Hepburn/Tracy on-screen relationship after their own. However, Gordon and Kanin also discovered that unless they wanted to get into major screamfests they had to write in separate rooms, and eventually stopped writing together in order to save their marriage, which lasted forty-three years until Ruth Gordon's death at age ninety-one.

■ *Windhorse* (1998)

Stars: Jampa Kelsang, Dadon, Richard Chang, Taije Silverman,
* and a host of actors who were afraid to be credited due to possible reprisals*
* from the Chinese government*
Director: Paul Wagner
Writers: Julia Elliot, Thupten Tsering, Paul Wagner

When bad things happen, you and your mate may respond in wildly different ways and find yourselves pulling apart. But as this Tibetan film shows, if you both can find the courage to set aside your defense mechanisms and focus on what's really important, you may discover that you'd rather be united than divided.

Years after the brutal murder of their grandfather, Dolkar (Dadon) had immersed herself in her career as a pop singer of treacly Chinese love songs, and her brother Dorjee (Jampa Kelsang) fills his days hanging around the snooker hall, smokin', drinkin', feeling sorry for himself, and generally doing his best wounded James Dean act. Meanwhile, their cousin Pema (name withheld) has gotten religion and joined a nunnery, which on the

surface seems like a positive response to trauma, but we soon learn that Pema too has a whole lotta repression going on.

Dorjee's buddy Lobsang (name withheld) offers a cause for his rebellious friend to embrace—Tibetan independence—after all, the occupying Chinese murdered Dorjee's grandfather. But Dorjee figures it's a hopeless cause, so someone else can get his butt thrown in a Chinese jail and become yet another name on Amnesty International's list. Meanwhile, Dorjee's sister Dolkar is furious at her deadbeat brother for mooching off of her hard work, but then when she finally gets a chance at stardom she's expected to warble cloying Chinese pop-style songs about her love for Chairman Mao. Will she sell out everything her family has ever believed in, and turn away from her own cousin Pema? Or will she gather round the family troops for their own personal war of independence—and interdependence?

This is a great movie to watch when you're feeling you and your mate's common ground has been confiscated by some larger, external force and you think his response is dysfunctional while yours is the very height of psychological health. Maybe you'll see that you both could modify your behavior a bit and build upon the common ground you still share.

■ *Irreconcilable Differences* (1984)
 Stars: Shelley Long, Ryan O'Neal,
 Drew Barrymore, Sharon Stone
 Director: Charles Shyer
 Writers: Nancy Meyers, Charles Shyer

We all get sidetracked sometimes and forget to nourish our relationship, but, as this movie points out, when you get to the point where you're tackling each other on the front lawn and your child has to sue the two of you for divorce, it's probably time to reassess your priorities.

Lucy (Shelley Long) and Albert (Ryan O'Neal) start out as many couples do: young, bright-eyed, infatuated with each other's special qualities, willing to stand up to a square-

headed, three-hundred-pound marine named Binx to declare to each other the depth of their love. The two of them end up in L.A., where Albert gets a shot at directing a motion picture, and Lucy rescues him from disaster by co-writing the script. Enormous success follows for both of them, as do the trappings of the Hollywood lifestyle: the maid, the BMW, the Rodeo Drive clothes, and the complete deterioration of their ethical core. Well, okay, they aren't *total* slouches, but they do lose track of what's really important and their communication breaks down completely. She becomes jealous of the accolades he receives for their joint project, he neglects to deal with her difficult feelings, a bimbo (Sharon Stone) with the hots for Albert enters the picture, and soon they are divorced and in a full-scale war against each other. Their daughter, Casey (Drew Barrymore), tired of being in the shuffle or used as a pawn, finally blows the whistle and forces her parents to grow up already.

If you and your guy have been caught up in a spiral of anger and blame of late, and your exploits are starting to sound a little too much like something you'd hear about on *Montel Williams*, this movie will encourage you to stop the insanity before you turn tabloid.

Manly, Yes, but Ladies Like It Too: The Pacifist Warrior

We all love a man who is willing to sacrifice all for what is right—but sometimes we have to wonder if guys always have to blow stuff up and smack people around to do so. When you and your man tire of heroism being confined to explosive war movies and want a quieter hero, check out these Pacifist Warrior Movies.

continued . . .

Billy Jack (1971)
Stars: Tom Laughlin, Delores Taylor, Howard Hesseman
Director: Tom Laughlin
Writers: Tom Laughlin, Delores Taylor

Billy Jack (Tom Laughlin), who is half white and half Indian, much prefers his Indian half, which is understandable given that all the whites in his neighborhood are a bunch of mean-spirited bigots. With his ramrod backbone, antiviolence philosophy, and martial arts training (just in case, you know), Billy Jack thinks he's prepared for any kind of trouble. But when Billy sees a few townspeople mistreat some local Indian children, he reacts by just . . . going . . . ber-SERK. His girlfriend, the indomitable Jeannie (Delores Taylor), tosses Billy Jack off the tower of his arrogance and forces him to consider a more constructive and nonviolent way to effect change—like, say, enlightening the bigots through bad Cheech-and-Chong-esque performance art, as his hippie-dippie friend (Howard Hesseman) in maroon velvet hip-huggers creates. Billy Jack truly wants to be a pacifist and, with Jeannie's help, he begins to develop some impulse control, surrenders his violent ways, and even puts his faith in democratic justice. Well, he does manage to get in some groovy barefoot sidekicks and kung fu chops in his righteous battle against the Establishment first. Watch this when you need a fun reminder of the difficulty of harnessing the force of one's anger to do good.

Bless the Beasts and Children (1971)
Stars: Bill Mumy, Barry Robins, Ken Swofford
Director: Stanley Kramer
Writer: Mac Benoff, based on the novel by Glendon Swarthout

At a summer camp somewhere out west, hypermasculinized counselors like "Wheaties" (Ken Swofford) urge campers to emotionally torture a gentle soul named Teft (Bill Mumy) and the other misfit boys in his cabin, all

continued . . .

the better to train them for the "real world." While his fellow cabinmates cry, wet their beds, or fantasize about joining the marines in order to prove their manhood once and for all, Teft reacts to such affronts by quietly planning an extremely ethical revenge plot. Teft's fragile, boyish frame, girlish hair, and wine-colored faux leather jacket that is oh-so-Stella McCartney belie the fact that he is so smart, psychologically astute, and morally centered that he stands as a beacon of hope in a world drunk on power, greed, fear, violence, and hatred. Teft proves that even a scrawny kid in a pair of tightie whities can make a difference.

I try, I really try . . . but when I see this girl of such a beautiful spirit suffer this indignity . . . I just go BERSERK!

★ Tom Laughlin as *Billy Jack*

■ *The Opposite of Sex* (1998)

Stars: Christina Ricci, Martin Donovan, Lisa Kudrow, Ivan Sergei

Director and Writer: Don Roos

Sixteen-year-old Dedee Truitt (Christina Ricci) leaves her southern backwater town of origin and heads for Ohio to live with her gay half-brother, Bill (Martin Donovan). And as is usually the case when a teenage girl arrives on your doorstep with a used one-way bus ticket, a pair of platform pumps, no notice, and a knapsack, havoc ensues—but in the end this movie only reminds us that the bonds of love are indeed hard to loose.

Bill, who has recently lost his lover to AIDS, is living with his gorgeous but empty-headed new lover, Matt (Ivan Sergei), but is preoccupied with his quasi-marriage to his dead lover's sister, Lucia (Lisa Kudrow). Bill and Lucia hold on to each other so that they can hold on to the man they both loved and lost. Which leaves Matt and Dedee free to get into all kinds of trouble while the adults aren't looking. And they do. Lots of it.

Dedee confuses Matt (which isn't hard) into believing he's bisexual, and they have an affair. Dedee turns up pregnant, says the baby is Matt's, and together they steal ten thousand of Bill's dollars as well as the dead lover's ashes, and head for sunny California. When another boyfriend of Matt's shows up looking for him, and threatens to make trouble unless Bill can produce the missing hunk, Bill and Lucia finally have to realize that something is happening in the present that demands their attention. So they pull themselves reluctantly out of the past and go in hot pursuit of their future.

Larceny, betrayal, infidelity, blackmail, and breakups follow, but, in the end, the bonds of love that exist between the members of this unlikely family remain strong. They rise above their squabbles, and reunite for the birth of the newest member of their family. Even our errant sixteen-year-old girl who has sworn never to reform discovers that love and relationships, no matter how trying, are what give shape and substance and joy to life.

This is a great movie to watch when you're feeling fed up with all the hard work that a relationship requires. This movie is like a pep talk for the soul, and reminds us all that no matter how many laws we break, love will find a way.

Eye Candy Alert: Ivan Sergei is like a visual triple-scoop ice-cream sundae with the works in this movie. So watch it with some whipped cream and a few sprinkles handy.

▪ *Made for Each Other* (1939)
Stars: James Stewart, Carole Lombard, Charles Coburn, Lucile Watson
Director: John Cromwell
Writer: Jo Swerling, based on a story by Rose Franken

A lot of the situations in this movie are so dated they seem utterly bizarre, but every couple who has ever made it through that difficult first year of marriage can relate to Jane and Johnny's newlywed naïveté—particularly when it comes to meddling in-laws, screaming babies, and cramped quarters. *Oh Johnny, I just know we'll manage somehow!*

For Jane (Carole Lombard) and Johnny (James Stewart), it's marriage at first sight, having met and gotten hitched within forty-eight hours. Returning to his hometown of New York City, they cheerily set up household in a small apartment with his disapproving mom (Lucile Watson), whose mission in life is, apparently, to make Jane feel like a blathering idiot. Now, Jane is a sprightly gal, who encourages Johnny to pressure his boss (Charles

Coburn) for a well-deserved raise, does her wifely best to host a lovely dinner party for the big cheese, bites her tongue when his mother indulges in passive-aggressive bitching, and handles every new challenge by clinging to a faith that everything will turn out just dandy. And Johnny appreciates Jane's Nancy Reagan gazes and desperately wants to do right by her, but before long it seems he's turned her into a household drudge and failed her as a provider. And then when they finally get a chance to renew their belief in each other, one of those absurd melodramatic plot twists that audiences just loved in the Depression era has to plop itself into the story line and make them wonder if they really can survive life's hard knocks together.

This is a cute movie to watch when you and your husband are feeling kicked around by the melodramas, big and small, in your own lives, and you need a little overly sunny, Depression-era pluck to cheer you up and get you all nostalgic about your own early days.

Nicole's Nougats

You know Mr. Gorbachev, the guy that ran Russia for so long? I am a firm believer that he would still be in power today if he had had that ugly purple thing taken off his head.

★ Nicole Kidman as
Suzanne Moretto Stone in *To Die For*

It's nice to live in a country where life, liberty, and all the rest of it, still stand for something.

★ Nicole Kidman as
Suzanne Moretto Stone in *To Die For*

■ *Troublesome Creek: A Midwestern* (1995)
Stars: Russel Jordan, Mary Jane Jordan
Directors and Writers: Jeanne Jordan, Steven Ascher

Wondering if the two of you are going to make it through your latest crisis? This documentary about an Iowa farm couple in their twilight years might make you feel a little more optimistic about your own survival prospects, and give you a few ideas on how to cope with the closing of a chapter.

Russel and Mary Jane Jordan, who met back when she was Iowa State 4-H president and he was an aspiring farmer, are getting on in years and need to clean up $70,000 in accumulated debts and pay off a $150,000 bank loan in the next few months. First thing on their to-do list: gather emotional and practical support from their children and friends. Next: maintain their sense of humor, even when strange people start swarming like vultures in their backyard to pick over their belongings, and their loan manager at the bank ties himself in verbal knots explaining the ins and outs of "risk ratings" and "collateral margins" instead of just admitting he's afraid they are gonna keel over before they pay up and he'll have to answer for it.

Sadly, Russel and Mary Jane must auction off everything they've acquired over a lifetime together in order to make their payments. But even though everything, including their Ethan Allen dining room table around which they and their children gathered so many times over the years, is hauled off in someone's pickup one frigid winter morning, Russel and Mary Jane have clearly learned that no one can ever take away their happy memories. And whenever they can, the two of them make a point of bonding over watching old Western movies where the good guys wore white hats, the bad guys wore black, and Shane refused to leave town on principle until everybody and everything was safe at last. Would that life were so simple.

This is one of those movies that makes you realize that even in the coldest January days of your life, if you make an effort to keep reconnecting, you will make it through to another spring. And when you move to a little place around the corner from the Chat and Chew, you can bring into your new home all that is truly important: your love, commitment, mutual rituals, and laughter.

Happily Never After

Somewhere in Time (1980)
Stars: Jane Seymour, Christopher Reeve
Director: Jeannot Szwarc
Writer: Richard Matheson, based on his novel
 Bid Time Return

How can we help sighing and getting all sniffly over a guy who's willing to pursue a woman across the expanse of time? A man (Christopher Reeve) who freely gives up his career, his friends, and modern sanitary conditions to travel back to the preantibiotics age, where awaits a mysteriously romantic actress (Jane Seymour) and a dreamy, Vaseline-lensed existence scored by a classic music box tune? So what if the moment reality enters into their magical love story he is forced to starve himself to death in some hotel room who-knows-where, in order to be with her again?

Face it: the whole reason we love *Somewhere in Time* is that it fits into our twisted notions that true love means total sacrifice of the self, and defiance of the laws of reality. While that might work on a screen, once you add the third dimension you realize that when you really love someone, you ought to think about how to conjoin your two worlds instead of having one partner erase his or her identity.

■ ***Being There*** (1979)
 Stars: Peter Sellers, Shirley MacLaine, Melvyn Douglas,
 Jack Warden
 Director: Hal Ashby
 Writer: Jerzy Kosinski, based on his novel

Being There is an allegory about a simpleminded groundskeeper with a knack for repeating catchy TV clichés and gardening tips, which even the highest powers in the land mistake for profundity. Which just goes to show you, when we hear only what we want to

hear, we can wind up with an earful of nothing, but in a superficial media world, where mere appearance masquerades as meaning, ignorance really can be bliss.

Chance (Peter Sellers) is a gardener who has spent his entire life within the gracious confines of a Victorian gentleman's home, without ever once venturing outside the walls of his carefully tended garden. When the old man dies, Chance is put out into a modern—and far less well landscaped—Washington, D.C., with only the navigational knowledge he has gained from watching TV and gardening to direct his sail. And ironically, his unself-conscious and naive TV gospel falls on fertile soil.

Through a series of "chance" encounters, Chance is taken into the home of Benjamin Rand (Melvyn Douglas), a wealthy, elderly, and ailing plutocrat, and his wife, Eve (Shirley MacLaine). Chance ultimately winds up becoming an adviser to the president, the apple of Eve and Ben's eye, and a media darling to a public so hungry for meaning that they find it in meaninglessness.

Chance the gardener is like nature itself . . . a metaphorical lily of the field, who toils not, neither spins, and yet winds up arrayed in splendor. Chance reminds us of the miracles that are possible when one is completely content with the here and now, because of a blind but abiding faith that the future will take care of itself.

When you're worried that the blossoms will never return to the garden of your relationship, let Chance the gardener remind you that after spring and summer comes fall and winter, and then spring and summer again, and that as long as we listen for the stirrings of new growth beneath the soil, there will always be life in the garden.

World-Class Rants

It's for sure a white man's world in America. Look here: I raised that boy since he was the size of a pissant. And I'll say right now, he never learned to read and write. No, sir. Had no brains at all. Was stuffed with rice pudding between th' ears. Shortchanged by the Lord, and dumb as a jackass. Look at him now! Yes, sir, all you've gotta be is white in America, to get whatever you want. Gobbledy-gook! ★ Ruth Attaway as Louise in *Being There*

▪ *Another Thin Man* (1939)
Stars: *William Powell, Myrna Loy, C. Aubrey Smith, Virginia Grey, Asta*
Director: *W. S. Van Dyke II*
Writers: *Frances Goodrich, Albert Hackett,*
 based on an original story by Dashiell Hammett

Are the two of you feeling like a couple of drudges? Just because you're staying in for the evening and renting a video doesn't mean you both aren't wonderfully witty, brilliant, stylish, and sexy, sharing your own set of private rituals and in-jokes, and head over well-maintained heels in love—and the Thin Man movies will remind you of how fabulous you really are.

In this particular movie, the third out of six in the series, William Powell and Myrna Loy, as usual, play Nick and Nora Charles, a wealthy, urbane couple who love solving mysteries, playing with their dog, Asta, drinking martinis, and setting off sexual sparks with their clever banter. And yes, they are married. They even have a newborn baby, although thanks to the magic of scriptwriters and Hollywood directors, he rarely cries or wakes at inconvenient hours, is attended to by an affordable private nurse, and never, but never, needs a diaper change. Yep, we sure wish we lived in Nick and Nora's world!

And as in every Thin Man movie, somewhere along the way a dead body turns up and Nick starts investigating. Suspicious people pop in and out of the picture, complicating the plot, and our loving couple spends considerable amounts of time trading one-liners and hilarious comebacks, knocking back martinis, flirting with each other, and pretending in public that they're strangers meeting for the first time. Oh sure, eventually they solve the mystery (even though, after several viewings, we can still never keep straight all the plot threads, but who cares?). Mostly, Nick and Nora spend their time connecting and reconnecting, protecting and defending each other from various vicissitudes, and making marriage look like glamorous, invigorating, everlasting fun.

Our suggestion? The two of you should park those kids with a nurse somewhere, shake up a few martinis, put on some fabulously stylish lounging clothes, and watch *Another Thin*

Man, or any of the other films in this series, together. Then get in touch with your inner Nick and Nora.

👀 *So Nice They Made It Six Times:* The other movies in this series—*The Thin Man, After the Thin Man, Shadow of the Thin Man, The Thin Man Goes Home,* and *Song of the Thin Man*—follow the same formula and there isn't a clunker in the bunch.

How many times have I told you I hated you, and believed it in my heart? How many times have you said you were sick and tired of me, that we were all washed up? How many times have we had to fall in love all over again?

 ★ Milly (Myrna Loy) to her husband, Al (Fredric March),
in *The Best Years of Our Lives*

Index